FIRE STRIKES
STRIKES
— THE —
CHICAGO
STOCK YARDS

FIRE STRIKES
—— THE ——
CHICAGO STOCK YARDS

A HISTORY OF FLAME AND FOLLY IN THE JUNGLE

JOHN F. HOGAN AND ALEX A. BURKHOLDER

Charleston · London

THE
History
PRESS

Published by The History Press
Charleston, SC 29403
www.historypress.net

First published 2013

Manufactured in the United States

ISBN 978.1.60949.907.5

Library of Congress CIP data applied for.

If there were any plan in the universe at all, if there were any pattern in human life,
surely it would be discovered mysteriously latent in those lives so suddenly cut off.
Either we live by accident and die by accident, or we live by plan and die by plan.

—*Thornton Wilder,* The Bridge of San Luis Rey

CONTENTS

FOREWORD

As a young boy growing up in the 1950s in Elmwood Park, a western suburb directly adjacent to the city of Chicago, I did most of the things young boys did, such as play football, baseball and alley basketball and ride bikes. However, being the son of an Elmwood Park firefighter, Martin J. Lacey, I spent many hours in the firehouse. Things that some would find mundane, I found to be great fun. Scrubbing the apparatus floor, shoveling the walks in winter and cleaning windows all made a young boy feel like one of the guys. And, of course, riding the rigs on calls! They were great times, and I got to spend them with my dad. He retired as captain in 1979, and I will always cherish those days at the firehouse.

On those Saturdays when my dad was not on duty, I occasionally went with him on one of the side jobs he worked. One such job was delivering flowers for a florist in neighboring Oak Park. One Saturday morning, I came to learn the story of the 1910 Union Stock Yards fire.

With the Saturday morning Irish radio station on in the truck, we headed for Sixty-third and Halsted Streets on Chicago's South Side. Before making the delivery, my dad took me on a side trip to what was left of the Union Stock Yards. The Stock Yard Inn, the main gate and a few scattered buildings, such as Darling's rendering business, were still to be seen, but little else. The smell of livestock pens now long gone was still readily apparent.

My dad told me of his uncle, Martin Lacey, who was chief of the Chicago Fire Department's Eleventh Battalion in 1910. He had responded to the fire and eventual collapse of the Nelson Morris warehouse that resulted in the

deaths of twenty-one firefighters, including Chief of Brigade James Horan. I came to learn that my grandfather, Edward Lacey, and another great-uncle, Joseph Lacey, both Chicago firefighters, were also at this disaster.

Before heading farther south, we went past the one-time home of Martin Lacey at 4506 South Emerald Avenue, half a block east of Halsted and directly across from the yards and, at that time, O'Leary's Saloon, whose owner was the son of Mrs. O'Leary of Great Chicago Fire fame.

Martin Lacey lived here with his wife, Mary, an O'Malley from County Mayo, Ireland, and their daughter, Helen, known as Nell. Two other daughters had died in the 1890s of diseases we no longer see—diphtheria and typhoid fever. Mary was to pass away in 1913 at the young age of forty-six. There is an old Irish saying that there is no guarantee the young will outlive the old. This was never more evident than in Martin Lacey's family.

Over the years, I have read a few articles on this fire—one was authored by "Sully" Kolomay, retired from the Chicago Fire Department's Engine Company 98 and a former Stock Yards firefighter. Recently deceased, Sully was a great guy and a fine historian.

It goes without saying that I was quite excited when I was contacted by Alex and told of what he and John were planning. This was true for more than one reason—the obvious one being the family connection to Martin Lacey—but also being able to discuss this long-ago incident with the authors, men as respected in their profession as Martin Lacey was in his. While there have been some fine books written on the fire, I believe John and Alex have offered the reader not only an in-depth analysis of the fire and the yards but also peripheral issues of politics and personalities that have created their unique perspective on the 1910 Stock Yards fire.

In closing, I congratulate the authors on their efforts and recommend this book to all. Whether a historian, a fire service or Chicago history buff, a firefighter or perhaps a descendant of those brave men whose lives were lost that morning, consider this book a must-read—go back in time in Chicago history.

Edward M. Lacey
October 2012

Lacey is the retired chief of the Schaumburg, Illinois fire department. His eldest son, Patrick, currently serves as a firefighter/paramedic for the City of St. Charles, Illinois.

PREFACE

Maybe it's true that one door never closes without another opening. A novel I'd been trying to write about the early twentieth-century Chicago Stock Yards—the setting depicted in Upton Sinclair's *The Jungle*—was going nowhere. However, I remained convinced that another story worth telling could be found among the pens and the cattle and the slaughterhouses.

A key element of the abortive project, perhaps the conclusion, was to have been the 1910 Stock Yards fire that killed twenty-one firemen and three civilians. I was beginning to realize that this tragic and gripping slice of Chicago history needed no fictional embellishment about the same time that I attended a broadcasters' reunion and met up with a former colleague I hadn't seen in years. One unforgettable distinction about Alex Burkholder is his extensive knowledge of firefighting and lifelong love affair with the Chicago Fire Department. Before the evening was over, ideas that would lead to *Fire Strikes the Chicago Stock Yards* were starting to take shape.

Soon after the reunion, and by fortunate coincidence, members of the Chicago Fire Department community held a two-months-early commemoration of the 1910 fire's 100th anniversary. Among the gathering at the Fire Department Training Academy were a number of individuals who would come to provide invaluable assistance in the writing of this book. Alex had known many of them for years. I didn't know a soul, but that would quickly change.

While the venerable encyclopedia might have become passé in the digital age, Ken Little, the fire fan's trove of insider knowledge, is still going

strong. Ken's font of anecdotes and facts, along with his sharp editing eye, was critical. Any errors of name, date, place or other fact are the sole responsibility of the authors.

Speaking of human encyclopedias, fire buffs can thank not only Ken but also his co-author, Father John McNalis, for the four-volume *History of Chicago Fire Houses*, each book the size of a big-city telephone directory. If Ken has a peer in the realm of Chicago fire history, it's Father John. His assistance in compiling and screening the illustrations in the book also proved invaluable.

Another fire historian whose contributions proved vital was retired Chicago firefighter M.G. "Sully" Kolomay. Probably the most vivid first-person accounts of the 1910 fire came from Chief Jim Horan's drivers, firefighters William Moore and Joseph Mackey. Years after the fire, Sully Kolomay transcribed their detailed recollections and graciously shared them with us. Sully's death on September 27, 2012, represented a great loss to the firefighting community.

Jeff Stern, like Ken and Father John, is a director of the Fire Museum of Greater Chicago. Jeff's excellent presentation on the 1910 fire at the centennial commemoration provided the actual kick-start for this book. He gladly shared this and other material from his personal collection.

Descendants of the key figures who fought the historic fire were generous in providing family memories, documents, photos and encouragement. These benefactors include John Rice and Don Thompson, great-grandson and great-great-grandson, respectively, of Chief Horan. Both have researched and written about their legendary ancestor and willingly shared their thoughts and work. Another Horan great-grandson, Mark Conerty, who died in 2012, provided us with information from his exhaustive study of the family's genealogy.

Bob Chisholm, grandson of Chief William Burroughs, and his wife, Linda, shared family history as well, as did the grandnephew of Battalion Chief Martin Lacey, retired Schaumburg, Illinois fire chief Edward Lacey. Not only did Chief Lacey agree to write the book's foreword, but during one visit to his home, he treated the authors to some unforgettable firehouse chili.

Having a next-door neighbor and friend who doubles as a professional book editor is an unbeatable combination. So a double-barreled thank-you goes to Andrea Swank, as well as to her spouse, attorney Harlan Powell, who was generous with his legal counsel.

My editor-in-chief and unerring compass, Judy Brady, my wife, has been down this path before and somehow manages to retain her sanity and sense

of humor (most of the time). Alex is grateful for the same unflagging support from his wife, Barbara, especially during the time when the book was moving toward publication.

Friend and published author Lisa Maroski added her editing skills, while the staffs of the Municipal Reference Division of the Chicago Public Library, Chicago's Newberry Library and the Chicago History Museum were unfailingly helpful. The Fire Museum of Greater Chicago is a treasure unto itself. President Bill Kugelman and Secretary Jack Connors were of particular assistance.

Longtime friend and vintage car enthusiast John Maxson provided information and obtained photos of early twentieth-century vehicles.

Finally, thanks to Ben Gibson, commissioning editor at The History Press, for his confidence and guidance. One never knows where a visit to a Chicago book fair may lead.

–J.F.H.

INTRODUCTION

Does history, in fact, repeat with some inexorable force? Or do humans cause it to repeat, out of sloth, stupidity or ignorance? One fire doesn't necessarily lead to another. They can be taken as separate events or considered in multiples, over a span of forty years or more, allowing us to examine patterns, trends, clues and missed opportunities that suggest looming catastrophes—warning signals that go unheeded and cause the same cycle of neglect, ignorance and disasters that surely follow in their wake to be repeated over and over.

In the early morning hours of Thursday, December 22, 1910, twenty-one Chicago firefighters and three civilians met death in a very small place. That small place was part of a much broader expanse where, to the end of the previous century, some 400 million cattle, hogs and sheep had met their end. The livestock obviously hadn't known what awaited them. Whatever their apprehensions, neither did the firemen. The animals were herded from pens covering half of the one-square-mile Union Stock Yards complex to killing floors as far as a mile away. The firemen were moved into position alongside a burning warehouse, where the finished products of the recently slaughtered animals awaited a train ride to stores and dinner tables around the nation. Rail cars lined the tracks immediately next to the warehouse to accept that morning's shipment. A canopy-covered platform stood between the cars and the burning structure.

Long after the flames had gained a running start, the men were ordered onto the platform to conduct the fight. Was this the right strategy? Should

they have been deployed to this narrow space, confined on one side by a burning six-story building whose walls might collapse and a string of rail cars on another? Was a senior officer's recommendation to withdraw the men ignored—or countermanded—by his chief? Who escaped and how? Who didn't and why? The deaths of the twenty-one represented the greatest loss of life among professional firefighting personnel in the United States and probably the world prior to September 11, 2001.

As Chicago prepared to celebrate Christmas in 1910, the John M. Smyth store was advertising Victor Talking Machines—"the most interesting of all the startling miracles of our time"—for twenty-five dollars, with two hundred needles included.

Siegel Cooper & Co. was offering Christmas cards and calendars for as little as a penny apiece.

Randolph Market and Grocery declared itself "ready with the biggest consignment of turkeys for Christmas Day ever known."

Lloyd's Bargain Store sought to interest the frugal in "damaged, mussed and soiled taffeta silk petticoats" for one dollar.

John D. Rockefeller donated $10 million to the University of Chicago, his largest contribution to the Hyde Park institution.

A Pennsylvania Railroad passenger train filled with Chicagoans bound for New York collided with a switch engine at Fifty-seventh Street, injuring at least a dozen.

Englishman Cecil Grace flew across the English Channel in both directions in hopes of winning a $20,000 prize.

In society news, Hazel Newhall was preparing to marry William Harvey Stark the evening of December 22 in her family's Glencoe home.

On the last night of Chief Fire Marshal James Horan's (HOR-uhn) life, one of his two drivers, Engineer William Moore, experienced a frightening dream. Asleep in the bunk quarters of the chief's annex, attached to the rear of Engine Company 103's firehouse at Laflin and Harrison Streets, southwest of downtown, Moore dreamed that he "was out on the lake in a tugboat which hit a brick wall and sank. I was the only one saved of the many on board, and I found myself sitting on the wall which the boat had collided with." He was awakened about 4:00 a.m. by an alarm from Box 2162 at Forty-third and Loomis Streets, some four miles to the southeast, in the sprawling Nelson Morris & Co. meatpacking operation. The box alarm had come across the "register," an instrument like a ticker tape in the chief's annex. Unlike ticker tapes that, by telegraphy, printed out words, letters of the alphabet or numerals, the fire department's register printed a series of

red-ink dashes with pauses that, when tallied, provided the identification numbers of fire alarm boxes. Meanwhile, a tapper bell provided the same information. The signal was transmitted by the alarm offices to every firehouse in the city, at which point the officers and firemen on watch would determine whether the companies in their houses were due to respond. That could be determined quite readily by glancing up at the "running board" on the wall above the "Joker Stand" in every firehouse. The board had the numbers and locations of every box to which the companies in a particular house would respond. Things became a bit more complicated if an extra alarm (2-11, 3-11, etc.) was being sent over the tape. The box alarm number for the extra would be matched with the appropriate "response card" listing its location and the companies responding on each extra alarm. A complete set of cards for every alarm box in the city was located in a cabinet near the Joker Stand.

Since he wasn't being called out, Moore fell back asleep, and his disturbing dreams continued. This time, he envisioned Horan's head, severed at the shoulders, "standing on the ground, talking to [him]." About forty-five minutes later, Moore again was awakened when Box 2162 went to a 4-11 alarm. He immediately realized something big was up when he heard the authorization code, "1-2-3," the signature of Second Assistant Fire Marshal William Burroughs. Time to rouse the boss.

Moore's partner, Lieutenant Joseph Mackey, Horan's primary chauffeur, was already awake, having been notified of the fire at the yards by the fireman on watch. Mackey waited a few moments and then called the fire alarm office for more information. The man who answered replied that they had received an ADT (American District Telegraph) alarm from the Nelson Morris beef house (Warehouse 6) and had transmitted the number of the closest Chicago fire alarm box about a block away from the warehouse. Now extra alarms had been requested.

While the fire alarm people waited for a progress report, Mackey and Moore set out for the Horan home at 722 South Ashland Avenue, a five-minute drive in the fire department's first and possibly only motorized vehicle. The chief's car was a two-cylinder 1906 Buick that Horan, Mackey and Moore had purchased on the spur of the moment that year after being ignored by a salesman at the classier dealership next door. Department lore has it that Big Jim, a horse lover, bought the car because he felt sorry for any animal that had to pull his formidable frame. Assistant Chief Charles Seyferlich also traveled by auto at that time, but it may have been his personal car. On the brief run to Horan's house, Mackey drove while Moore sat in back.

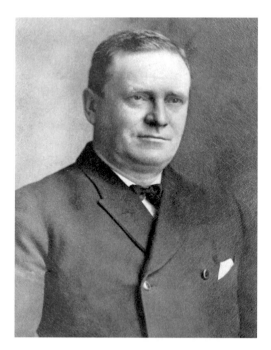

Chief Fire Marshal James Horan, who died with twenty of his officers and firemen on December 22, 1910. *Courtesy of John Rice.*

Jim Horan hadn't slept well either that night. He told his wife he could smell the Stock Yards and was having premonitions about a fire there. Call it firefighter's intuition—an eerie parallel to Moore's dreams. Horan's apprehensions were confirmed when Moore went to the basement door of the Horan home and rang a secret bell that sounded in the chief's bedroom. Horan hauled his six-four, 250-pound frame out of bed and went to the door, where his driver told him of the 4-11 in the yards. The chief asked for an additional minute to put on extra clothing against the twenty-six-degree temperature. Moore overheard Horan's wife, Margaret, ask, "What's the matter, Jimmie?" He replied, "Nothing, dear. There's just another fire at the yards," and said goodbye.

Margaret Mahoney was a fire department stenographer when she met widower Jim Horan. From the beginning, they shared at least one thing in common: Horan's mother's birth name was Mahoney, though he and Margaret weren't related. At least fifteen—or was it seventeen or nineteen—years his junior, Margaret became the chief's second wife in 1903. Curiously, the marriage license lists Horan's age as forty, when according to his birth date, he clearly would have been forty-four. Was he trying to fudge the age difference? Did a clerk make an error? Margaret stated her age as twenty-five, but according to her birth record, she would have been twenty-seven. Horan's first wife, Katie Ryan Horan, died in 1895 of a heart attack at age thirty-five. Now, in 1910, Big Jim had a twenty-three-year-old son and an eighteen-year-old daughter from his first marriage and a three-year-old son and two-year-old daughter with Margaret. Jim and Katie had lost a fourteen-month-old son, John, in 1891. Heartbreak visited the chief's second family in 1906 when an unnamed baby boy died soon after birth.

Although he'd witnessed many tragedies, the only time Horan was known to have shed a tear away from his family occurred at the conclusion of a particularly stubborn fire. He grudgingly admitted to a colleague that this call to duty had kept him from attending his daughter's high school graduation, and despite her assurances to the contrary, he felt that he'd let her down.

In what would seem a chapter in an unintended chronicle of a death foretold, Horan responded to a *Tribune* query in 1906 regarding what sort of woman is best suited to be the wife of a fireman. Primarily, he suggested, she should be someone who doesn't worry about him. "I have known firemen who were almost driven to distraction by their wives' habits of worrying about them," he remarked. Horan stated his belief that "a man with this sort of a wife will not take even reasonable chances at a fire for fear of injuring himself. They do not fear the injury so much themselves, but they dislike contemplating its effect on their wives. The woman who can sleep…when she knows her husband is on his way to a fire and that he may be buried under a falling wall is the sort that make the ideal wives for firemen."

According to driver Moore, the boss took a little longer than usual to get out to the waiting car. Perhaps he was upset about the interrupted sleep. Chicago Fire Department historian and author Ken Little maintains that senior officers had been known to consider some middle-of-the-night calls overreactions and think—if not outright tell immediate subordinates—"It's your fire; you fight it." Little offers another possible reason for Horan moving a step slower, as well as for his later belligerence at the fire. For years, unconfirmed rumors have circulated that Big Jim had been drinking. Debunkers, and there are many, have asserted that he wasn't much of a drinker, if he drank at all. Horan's great-grandson, John Rice, says the chief made a vow early in life not to smoke or drink but doesn't know whether he kept it. Rice adds that Horan was a devout Catholic and daily communicant who went out of his way each morning to pick up a cook named Mary and take her to Mass. Little and fellow fire historian Father John McNalis add their voices to those who don't believe Horan was drunk the night of the fire. Father McNalis thinks the rumor might have been started by someone acting out of ill will. Even if he'd had a few, he would have slept them off by 4:00 a.m., the defense goes. Whatever Big Jim's condition, he and his companions pushed ahead through the cold night air for their rendezvous with fate, Horan cautioning Mackey to drive carefully on the icy streets.

Chapter 1
LIFE IN THE JUNGLE

Historians and social critics have written volumes about the notorious working and living conditions in the Chicago Union Stock Yards and surrounding neighborhoods. Upton Sinclair's 1906 exposé *The Jungle* riveted the nation's attention on the inhuman and inhumane environment, impelling President Theodore Roosevelt to initiate action that resulted in the Pure Food and Drug Act. One hazard that seems to have evaded similar scrutiny, not to mention significant remedial attention, was the continuous threat of serious fire.

Chicago's Union Stock Yards arguably constituted the most combustible urban square mile in the United States, if not the entire planet. From its earliest days, sections of the yards regularly went up in flames. The meatpackers seemed to consider fire a way of life, a cost of doing business. "It's all right, we're fully covered" became a typical reaction.

From 1889, when Chicago annexed the suburban town of Lake that contained the yards, until the horrendous fire of December 1910, the Chicago Fire Department responded to 68 extra alarms alone, nearly half in the vicinity of the 1910 fire site. Lessons learned? Steps taken? The record speaks for itself. After 1910, 224 extra alarms occurred in the yards, including some that happened after packing operations ceased in 1971, but the buildings remained, vacant or utilized in other ways. The total 292 extra-alarm fires include the 1934 inferno that was stopped just short of replicating the Great Fire of 1871. The Great Fire spared the yards, which conducted business as usual, seemingly oblivious that the center city was

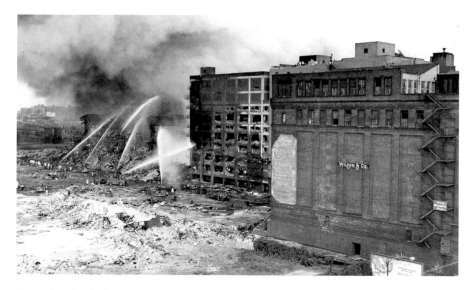

Even after the closing of the Union Stock Yards in 1971, major fires were fought in buildings under demolition. *Courtesy of the Chicago Fire Department.*

burning to the ground. The number of all fires in Stock Yards history is incalculable because "still and box" alarms, those transmitted by "snap boxes," telephone or other means that didn't summon additional manpower, normally didn't get recorded. In other situations, proud, headstrong officers at the scene refused to concede the need for extra help. How many non-extras broke out can only be imagined.

Over the years, recommendations for improvements in fire protection, firefighting and water supply were greeted with the same indifference as those for improvements in meeting basic human needs, such as a living wage, sanitation, adequate nutrition, housing, child welfare and so on. The packers showed greater reliance on a taxpayer-financed fire department than on costly investments to lessen fire hazards. "A pervasive desire to make money tainted the city's culture and philosophy," observes Robert A. Slayton in *Back of the Yards—The Making of a Local Democracy*. Thomas J. Jablonsky, author of *Pride in the Jungle—Community and Everyday Life in Back of the Yards Chicago*, notes, "The focus for at least the first half-century [of the yards' existence] was on developing that enterprise. As for the poor unfortunates who lived nearby, they simply had to take their chances." As did the firemen who had to respond to the all-too-frequent alarms.

Fire safety in the yards, even for those who worked there, took a back seat to more urgent grievances of "the poor unfortunates." They found themselves

afflicted—day in, day out, with no break on Sundays—by the Four Horsemen of the Packingtown Apocalypse: smoke, stench, noise and pathogens.

Sinclair described his Lithuanian immigrant characters arriving in Packingtown to find "half a dozen chimneys, tall as the tallest buildings, touching the very sky—and leaping from them half a dozen columns of smoke, thick, oily and black as night. It was inexhaustible; one stared, waiting to see it stop, but still the great streams rolled out. They spread in vast clouds overhead, writhing, curling, then, uniting in one giant river, they streamed away down from the sky, stretching a black pall as far as the eye could see." With his graphic descriptions, Sinclair hardly seemed given to understatement, but in this instance, his mention of "six chimneys" falls a bit short. The skyline was dotted with giant brick smokestacks, starting with the twin towers of the yards' power plant at Thirty-ninth Street. Along with a never-ending haze came an equally constant downpour of soot.

The haze and soot mingled with the odor of dozens of slaughterhouses; tens of thousands of penned cattle, hogs, sheep and horses; fertilizer plants; rendering vats; garbage dumps; tanneries; and trash-filled alleys. According to Jablonsky, the most notorious source of stench was the Darling and Company rendering plant at Forty-second and Ashland, where "open wagons loaded with bone bits, damaged hides, dead cats and dogs, leftover meat from the local butcher shops, and 'big gobs of fat' collected around the main plant. The vehicles would sit in the sun, smelling up the whole neighborhood." Ironically, Sunday was the most malodorous day of the week throughout Packingtown. That was cleaning day at the packinghouses, when workers used steam blasts instead of water to cleanse the slaughterhouse floors and blood vats.

Residents tried to ignore the ongoing bombardment or at least tolerate it as best they could as the price of earning a livelihood, meager as it was. Visitors gagged and sometimes became ill. Astonishing as it may seem, the Stock Yards became a major tourist attraction. The *Tribune* wrote in 1875 that visitors to Chicago would no more think of leaving without having seen the yards as "the traveler would of visiting Egypt and not the pyramids; Rome and not the Coliseum; Pisa without the Leaning Tower." The attraction demonstrated staying power. In 1893, the year of the World's Columbian Exposition, more than one million visitors took the guided tours of the yards and packinghouses. One tourist found the experience as popular as and far more entertaining than a ride on the Ferris wheel.

A further assault on the senses that the residents came to accept was the clatter of cattle and boxcars at all hours as they brought in the livestock

and moved out the finished products. By 1910, the yards contained three hundred miles of railroad tracks to go with thirteen thousand pens, twenty-five miles of streets and fifty miles of sewers.

The largest, albeit unofficial, sewer presented the most egregious of all the environmental insults. Aptly named Bubbly Creek, this waterway constituted the South Fork of the Chicago River's South Branch. At Twenty-fifth Street, the South Branch took a swing to the southwest, where it split into two forks at Ashland. The South Fork ran along the northern end of the former Stock Yards to Western Avenue near Fortieth Street. In the early 1870s, the Stock Yard Company had this segment dredged to become the Union Stock Yard Canal Slip, which was to receive heavy cargo delivered by Lake Michigan vessels. The plan failed because the current at that point was virtually nonexistent, and therefore the slip couldn't accommodate the sailing ships of the era. So, the packers found another use.

A total of nineteen companies began dumping enormous quantities of wastes into a stream that couldn't flush itself. Year after year, the pollutants piled up, despite periodic dredging. Between 1900 and 1921, the riverbed rose at a rate of nearly half a foot a year under the accumulation of more than 130,000 pounds of "suspended matter" daily, the equivalent waste of one million humans, according to one estimate. Decaying matter at the bottom released bubbles of gas sometimes exceeding a foot in diameter—six feet, if hyperbolic accounts are to be believed—giving birth to the stream's moniker. The slimy water, home to multitudes of flies and mosquitoes, was so dense it never froze. One resident said it looked like a street that had been freshly tarred. Sometimes it caught fire and the fire department had to be called.

Following the annexation of Lake Township by the city in 1889, the offensive and dangerous gases rising from Bubbly Creek, along with the cries of outrage rising from its neighbors, became Chicago's problem. The new overseers responded the same way their predecessors did—with feigned concern but few corrective measures.

Swelled by immigration and suburban annexation, Chicago's population from 1870 to 1900 grew from just under 300,000 in a space of 35 square miles to 1.7 million living in 190 square miles. Over the next thirty years, the population doubled again. This explosion mirrored that of business at the yards. Between 1870 and 1890, Chicago's meatpacking industry grew by 900 percent and by 1900 represented the city's largest industrial employer. From thirty-nine plants with 25,000 workers at the turn of the century, the Stock Yards enterprise ballooned to forty-six plants with more than 45,000 workers by the end of World War I. Ominously, a city engineer wrote in

1901 that the explosion in area, population and manufacturing threatened to outstrip the city water distribution system's ability to keep pace.

From its earliest days, the Stock Yard Company scrambled to keep millions of gallons of water a day flowing to meet the needs of humans, animals and machines. Initially, the company sank six artesian wells. When these proved insufficient by the early 1870s, the Towns of Lake and Hyde Park teamed up to open a waterworks on the lakefront that fed the yards from two mains. Eventually, the company enlarged the mains on its property, upgraded its water storage tanks and added new pumping machinery. With annexation in 1889, the City of Chicago acquired the Lake–Hyde Park water system and the right to bill the Stock Yards for its intake and assumed primary responsibility for firefighting.

Dissatisfied with the Town of Lake's often unreliable volunteer fire department, the company in 1874 established a full-time brigade, built a fire station and bought a new fire steamer, dubbed the "Liberty Engine." According to Louise Carroll Wade, author of *Chicago's Pride: The Stockyards, Packingtown and Environs in the Nineteenth Century*, the engine and its crew "fought many a blaze in the yards, the packinghouse district to the west of the stockyard and elsewhere in Lake and even Hyde Park." Lake got around to establishing a full-time, paid fire department in 1882. A marshal and eighteen trained firefighters took over from the volunteers. At the time of annexation, the Lake department consisted of eighty-five men, seven steamers, three hook and ladders, two hose carts and forty horses.

Looking back on an era generally considered more religious than contemporary times, it's difficult to understand why a group of railroad and packing tycoons chose Christmas Day to hold the opening ceremony of a slaughterhouse operation destined to become Chicago's largest industrial employer. Most, if not all, of the founders were stalwarts of one Protestant denomination or another. (The Stock Yards workforce was overwhelmingly Catholic.) Nonetheless, on December 25, 1865, a consortium of eleven railroads and eight packing firms launched the Chicago Union Stock Yard Company, with "Yard" soon becoming pluralized in common usage. The new operation consolidated a number of smaller stockyards scattered throughout the city and surrounding towns that were providing meat for Union troops during the Civil War. Although the war effort factored into the decision to build the Union Stock Yards, the fighting had ended by Christmas Day 1865. Financially, the end of the war didn't have much impact on the new enterprise. In or out of uniform, Americans consumed meat. The yards accepted its first livestock shipment December 26, and

the arrivals continued each day, almost uninterrupted, until the place closed 106 years later. Lest someone infer any irreverence in the Christmas Day opening, a brief history of the operation, published by the Stock Yard Company in 1951, casts the founders as respectful men. Many "were close personal friends of Abraham Lincoln and set aside their activities in building the yards to accompany his body to Springfield for the final rites."

The yards got built quickly. Work began in June 1864 and proceeded through an unusually hot summer, well before the company obtained a state charter in February 1865. The site selected by the organizers was a 320-acre swampland close to the river, removed for the time being from residential districts and acquired for the reasonable price of $100,000 from Congressman and former Chicago mayor "Long John" Wentworth. The reservation extended from Thirty-ninth to Forty-seventh Streets, Halsted Street to Ashland Avenue. An additional 25 acres were added later. One extra advantage made the site attractive to its purchasers: since it fell well outside the city limits, companies could avoid paying taxes to Chicago.

Throughout 1864–65, a force of nearly one thousand workers, many recently discharged by the Union army, dug ditches and wells and constructed buildings, sheds and wooden livestock pens, including double-decker pens

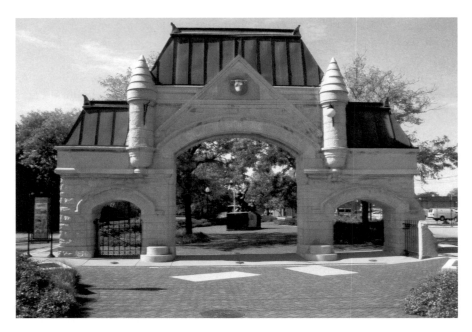

The Old Stone Gate, once the main entrance to the Union Stock Yards, is now a Chicago landmark. *John F. Hogan.*

for sheep and hogs. The pens, crisscrossed by railroad tracks, occupied roughly the eastern half of the site, between Halsted and Racine, with the packinghouses to the west, from Racine to Ashland. The livestock enclosures, crammed with thousands of animals and bales of hay, seemed to extend to the horizon. They stood separated by narrow pathways, adequate for leading livestock to slaughter but daunting to firefighters attempting to navigate the labyrinth with hoses or engines. In the judgment of the National Board of Fire Underwriters, the configuration of the pens created "very large fire areas." Most everything constructed in the yards consisted of wood, a condition that changed little throughout the years.

In its August 1912 report (nearly a half-century after the yards opened), the insurance group concluded, "The problem of wooden interior construction [in] many excessive areas, the hazardous nature of its occupancies and congestion of the section combine to create an excessive potential hazard." The probability of sweeping fires, the report determined, was reduced by the effectiveness of the yards' watch service, private protection and considerable window protection: "However, in individual [and groups of] buildings, fires involving very high and quickly consumable values in buildings and contents are probable. As the water supply for the packinghouse section is decidedly inadequate, the possibility of sweeping fire occurring is very high." In an uncanny prologue to publication of the underwriters' findings, the district's famed Transit House hotel and restaurant, a six-story brick structure, burned to the ground on January 5, 1912.

One is left to wonder who read these reports. The insurance organization's conclusions were published a year and a half after twenty-one firemen lost their lives in the Nelson Morris fire. Some of the exact sentences reappear in an underwriters' report more than ten years later! It was as if the fire of 1871 never happened or its lessons were never learned. The 1912 indictment of the yards further stated:

> *Adequate protection for the Stock Yards District by fire engines and the present facilities is hopeless; the* [water] *consumption of the packinghouses is so enormous that the mains within the District are barely sufficient for ordinary requirements and leave scant margin for fire purposes at times of unusually heavy consumption; the type of hydrant is unsatisfactory, and the crowded condition of the yards does not give room for the suitable concentration of many engines. The*

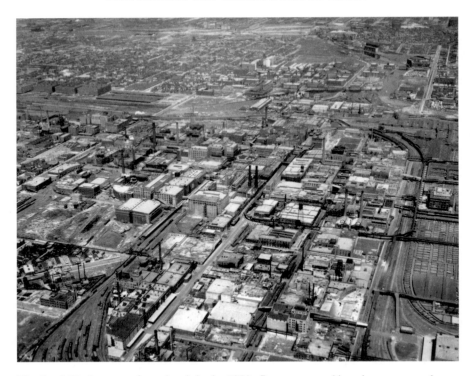

The Stock Yards as seen from the air in the 1930s. Large meatpacking plants crammed together on the west end and sprawling animal pens to the east created a perfect atmosphere for fires. *Chicago History Museum, #ICHi-04091.*

> *inflammable nature of the contents of many of the buildings makes quickness of getting into operation of prime importance.*

The underwriters urged installation of a high-pressure water system "at an early date," a step that Chief Fire Marshal Horan kept pleading for until literally hours before his death.

Water pressure continued to pose a problem for years to come, primarily due to city inertia. The packers had proposed plans to build pipes, tunnels and pumping stations so they could control their own supplies. These overtures were rejected by the city, which wanted to maintain its dominant position. In any event, the lion's share of water flowing to that part of town—seven million gallons on a hot day—continued to quench the rapacious thirst of the yards.

Readers of Sinclair's *The Jungle* recoiled as the author took them inside a Chicago packinghouse:

A History of Flame and Folly in the Jungle

There was never the least attention paid to what was cut up for sausage. There would come all the way back from Europe old sausage that had been rejected, and that was moldy and white—it would be dosed with borax and glycerine, and dumped into the hoppers, and made over again for home consumption. There would be meat that had tumbled out on the floor, in the dirt and sawdust, where the workers had tramped and spit uncounted billions of consumption germs. There would be meat stored in great piles in rooms, and the water from the leaky roofs would drip over it, and thousands of rats would race about on it. It was too dark in these storage places to see well, but a man could run his hand over these piles of meat and sweep off handfuls of the dried dung of rats.

The national revulsion, personified by President Roosevelt, produced a mini domino effect. Appalled by what he read, Roosevelt appointed a special committee to investigate conditions at the Chicago Stock Yards. Then the City of Chicago followed suit—sort of. The president sent the committee's report to Congress with a call for immediate remedial action. Describing the conditions as revolting, Roosevelt proposed a law that would empower federal inspectors to supervise the preparation of meat products "from the hoof to the can." His request resulted in speedy passage and enactment of the Pure Food and Drug Act, once Congress had digested the contents of the inspectors' findings.

The report that the president transmitted to Capitol Hill on June 4, 1906, while not specifically covering fire safety, described a massive firetrap. Wooden viaducts and platforms became the final resting places of calves, sheep and hogs that had died en route to the killing floors. "The only excuse given for the delay in removal was that so often heard—the expense," the report stated. The inspectors found the interiors of most buildings were composed of wood, as were partition walls, supports, rafters and most floors, which were often slime-coated. Everywhere they looked, they found wooden worktables, tubs and other receptacles, meat-hauling carts and "dirty, blood-soaked, rotting wooden floors." Not one establishment afforded adequate workroom ventilation. Many windowless food preparation rooms "may be best described as vaults in which the air rarely changes." Everywhere they noticed accumulations of dirt, grease and meat scraps. The inspectors found themselves particularly appalled by conditions in the employee restrooms, women's as well as men's, which often lacked separating partitions. Toilet areas usually vented into the workrooms, with no openings to allow outside air. Bathrooms that sometimes doubled as cloakrooms often bordered

lunchrooms. Since the wooden partitions that partly enclosed the toilet areas stopped short of the ceilings, workers on a meal break could receive some unattractive aromas to accompany their sandwiches. Worst of all, in the team's opinion, employees returned to food preparation work with unwashed hands. Even if they'd wanted to wash, sinks were either nonexistent or small and dirty. Besides, the places lacked soap, paper towels and toilet paper. The toilet situation presented a perfect example, the report concluded, of the companies' "general indifference to matters of cleanliness and sanitation."

Even at the turn of the twentieth century, Chicagoans didn't take kindly to negative comparisons with New York City, so they couldn't have been pleased by the report of an inspection team member who found stark contrasts between the two cities' stockyards. At the New York yards, the inspector discovered cattle pens paved with bricks and cement, brick walls, a killing floor not only paved with stone but equipped with adequate drainage, an air shaft and abundant windows. Here, as well as in other rooms, the ceiling and upper side walls were of hard cement with steel crossbeams and cement-faced steel supports. The bathrooms especially proved infinitely superior to any at the Chicago yards. Toilets actually flushed. The rooms came equipped with porcelain-lined wash basins, showers, mirrors, towels and, yes, toilet paper. Chicago should adopt the same standards, the inspector recommended, to protect the health of its workers along with the safety and quality of the food they produced. But don't hold your breath, he seemed to say, because the packers' attitude appeared to be "the workers, the public and, by extension, the Fire Department be damned."

Where the Chicago Health Department had been all these years raises an interesting question, but now that a muckraking author and the president of the United States had shined a spotlight, the city was beginning to understand that it ought to do something. Less than two weeks after the president's message to Congress, the city's chief sanitary inspector sent an official written notice to Nelson Morris ordering the company to clean up a litany of revolting health code violations. Similar directives to additional companies were to follow.

It was as if the city inspector had used *The Jungle* and the presidential message as road maps. The company was directed to: exclude rats and vermin from the meats; use special receptacles to contain meat that had fallen on the floor; provide cuspidors for employees so they wouldn't spit on the floor (the cuspidors, containing a disinfectant, were to be cleaned regularly); ensure that employees who handled food products were clean in dress and personal habits and washed their hands before, during and after

work; ensure that all "tables, tubs, carts, receptacles and tools" be cleaned daily with a hot washing solution; and increase ventilation in a number of locations. Nelson Morris's level of compliance, or the city's follow-up, remained questionable.

Another allegation dogged the packers at least as long as that of unsanitary conditions but proved more difficult to document. In the mocking elegance of the *Tribune* editorial page, "Packers and other large patrons of the Water Department…are frequently credited with an unquenchable desire to establish friendly relations with Lake Michigan without doing the proper thing by the [city] treasury." Charges of water rustling predated the Stock Yards' annexation by the city in 1889. For years, residents of the town of Lake complained about a lack of water, particularly on the second and third floors, which often remained unoccupied for that reason. Members of the younger generation were said to be moving out of the neighborhood, discontented, as were some of their elders with sponge baths upstairs. Water that should have flowed to the residential districts was being diverted in large quantities to the packinghouses, residents believed. Of course, low water pressure in homes also meant low pressure in fire hydrants. Former town employees told the Civic Federation that the packers had directed the construction of a secret pipe network, controlled by them, to bypass municipal meters. This subterfuge took place with the acquiescence of corrupt officials, the ex-employees charged, with most of the work done at night. At the time of annexation, the town supposedly turned over its maps of the Stock Yards piping system to the City of Chicago. The city later maintained it had no such maps, unlike unnamed Lake insiders who reportedly retained copies in hope of some future personal gain.

Weary of water theft allegations—never proven—the packers petitioned the city for the right to lay a pipe connecting their companies to the lake. That way, they figured, there would be no question about the source of supply. The city rejected the overture, wanting to maintain full control of the spigot. Charges of theft continued, followed by investigations of the usual suspects that didn't amount to much. In 1905, Stock Yards president John Spoor proposed a plan for a high-pressure water system for the district. The packers would build their own plant and run a tunnel to a pumping station they would construct near Bubbly Creek (after the creek had been flushed!). The city agreed that the yards should have such a system but felt that the municipality should construct it and sell water to the packinghouses. The companies demurred, and the plan got shelved until five years later— immediately after the 1910 fire.

Chapter 2
THE GREAT FIRE WAS ONLY THE START

Fire, as much as meatpacking, railroads, hardball politics or icy blasts off Lake Michigan, has defined the evolution of the city. The story of Chicago has been burned into the history books. It's been there every step of the way, telling of the birth and amazing growth of the metropolis on the prairie. The second of four stars that grace the municipal flag represents the Great Fire of 1871, an event that bifurcates the city's history the way BC and AD separate the history of Western civilization. Even today, temperatures in Chicago are compared to weather records dating back to 1871. Those records and other historical documents prior to that year were destroyed when Chicago City Hall and other buildings serving as repositories burned to the ground. Fire Prevention Week, observed nationally in October of each year, marks the anniversary of the Great Chicago Fire, not some other "great fire" in Boston, Baltimore or New York. The conflagration left a legacy of embarrassment and fear that carries even into modern times. The young, boastful city felt embarrassment when flames brought it to the brink of extinction, and the citizenry remained fearful for generations, rightfully so, that it could happen again. Not all lessons taught by the Great Fire were learned, as a devastating fire less than three years later would show and subsequent fires over many years would underscore again with tragic results. Some of Chicago's embarrassment about its Great Fire stemmed from the legend that it was started when a cow kicked over a lantern, igniting hay in a barn. Even in those days, Chicago looked upon itself as a metropolis, and that was no way for a metropolis to be brought to its knees. In a long-delayed effort to set the record straight, the

Chicago City Council, at the behest of one alderman/historian, officially exonerated the cow 130 years after the fire.

In 1812, six years before Illinois became a state and twenty-one years before Chicago could officially call itself a town, a major fire occurred in what is today the heart of downtown Chicago. A band of Potawatomi Indians, who sided with the British in the War of 1812, burned down Fort Dearborn after it had been evacuated. Hours prior to the fire, the Indians had ambushed some one hundred soldiers and women and children dependents who had fled the fort. The ambush, about two miles south of the fort, left thirty-nine men, two women and twelve children dead and some twenty wounded in what became known as the Fort Dearborn Massacre. The event is commemorated by the first star on the city flag.

By the time Chicago obtained its charter as a town in August 1833, the swampy locale consisted of a few frame buildings, home to an estimated two hundred people. The first building erected housed the Sauganash Tavern, which became the social center for the early settlers. It fell victim to fire twenty years later. The new town's first fire, however, broke out in October 1834 at the corner of La Salle and Lake Streets when someone spilled a shovelful of hot coals he was carrying from one building to another. A local newspaper charged that the situation became aggravated by the absence of a suitable fire officer to take charge. Immediately afterward, the town enacted an ordinance designating four fire wardens, each assigned to a separate district, to serve as chiefs with authority to enlist bystanders to help put out fires. Those who refused faced a five-dollar fine. Later, residents would be required to show up at fires carrying their personal buckets identified with their initials. More than a year later, the town formed its first regular volunteer fire department with the president of the board of trustees, Hiram Hugunin, chosen to don a second hat, or helmet, as it were, as chief engineer. The force consisted of a bucket brigade, an engine company and a hook and ladder company. Not until a year later, after Hugunin had been succeeded by a chief elected by the men, did the department take possession of the first of two engines. The department also acquired one thousand feet of hose, two sixteen-foot ladders, two hooks with chains and ropes, four axes and four handsaws.

More fire companies were formed after Chicago became a city in March 1837, but fire protection always seemed one step behind population growth, a complaint that would continue into the next century. From the small frontier town of the early 1830s, Chicago had grown to a city of thirty thousand by 1850, but that marked only the beginning of an explosive population

growth. Wooden buildings, approached by wooden sidewalks and plank roads, were hastily constructed to keep pace. This combustible mix would feed the flames of 1871.

The first major fire in the newly minted city occurred in October 1839 near Dearborn and Lake Streets, where the popular Tremont House hotel and seventeen other buildings went up in flames with a then staggering loss of $65,000. Early fire protection consisted of hand pumpers and bucket brigades. Volunteer manpower, usually plentiful, worked the pump handles or carried the buckets. The job definitely was not all work and no play. Firehouses doubled as clubhouses where drinking and partying were common. Competition ran rampant among the various fire companies to reach fires first and put them out first. Sometimes competition became so intense that fights broke out on the way to and at the scene of fires, often leaving the flames unchallenged.

In 1871, three fires served as harbingers of "The Big One." In January, Armour & Co.'s packinghouse at Salt Street (Hough Place) and Archer Avenue went up in flames. Nearly four thousand hogs barely escaped a premature demise, but the building and its contents, valued at $125,000, were deemed a loss. Valiant efforts by firefighters in late September saved an estimated $2 million worth of coffee, tea and sugar at a Burlington warehouse near Sixteenth and State, but damage to the building resulted in a $638,000 loss. One week later, on the eve of the Great Fire, a blaze broke out in the Lull-Holmes Planing Mill at 209 South Canal Street, a fire all but forgotten in view of the following days' tragedy but one whose significance cannot be understated.

Following a major warehouse fire on September 30, 1871, members of the undermanned department were called out multiple times daily to extinguish flames in wooden buildings made even more susceptible by a fourteen-week drought. From July 3 to October 9, the city recorded a paltry two and a half inches of rain. Firemen responded to three alarms on October 4, four on October 5 and five on October 6. The men were already dead tired when called to 209 South Canal Street to confront what Chicago Fire Department historian James McQuade called an inferno unprecedented in Chicago history for its fierce intensity. "It brought terror to the hearts of citizens, who feared that it might sweep the whole of Chicago," McQuade wrote in 1908. "The long drought and the amazing spread of the flames gave reasonable cause for such fears."

When firemen arrived in response to an alarm sounded sometime between ten and eleven o'clock on Saturday night, October 7, they found the Lull-

Holmes Planing Mill and its contents almost totally consumed. The fire had broken out in the boiler room of the operation, which stood in the center of a block filled with lumber sheds, outbuildings and homes. A stiff south wind, enabler of many fires before and after, drove the flames with unparalleled force against the wooden buildings to the north. Wood structures to the west also came under attack. In less than twenty minutes from the first alarm, the area between Adams, Jackson, Clinton and the river, approximately one square block, was ablaze. Then the fire turned south, consuming another block on its way to Van Buren Street as it maintained its grip on the stretch from Clinton to the river. A heroic stand by the men prevented the flames from crossing Adams and roaring farther north. Standing up against "the blinding drift of burning cinders, they stood their ground within a rod [16.5 feet] of the fierce flames," McQuade wrote, "frequently retiring a few paces to recover breath and strength." If it hadn't been for their heroism, according to the historian, the Great Fire would have begun then and there, instead of in the barn behind the home of Patrick and Catherine O'Leary on DeKoven Street, just southwest of the South Canal Street fire. The men had bought a little time, but the wind, drought and wooden buildings remained. Still, no one in Chicago dreamed that a much greater catastrophe would begin hours later.

The fire that destroyed a huge swath of the southwest part of the central city became so overshadowed by what happened next that no accurate damage amount got calculated. The best estimate was $750,000 to $1 million. Thoroughly exhausted and in need of rest, the men returned to quarters but didn't finish putting away their equipment until dusk on Sunday. They'd barely had time to settle back when the lookout in the watchtower spotted flames rising about six blocks north of the firehouse. He sounded the alarm, and the scorched and weary members of the Little Giant engine company harnessed the horses once again and raced to a date with Armageddon.

Chicago has claimed many distinctions in its lifetime, not all of them sought. In 1871, the municipality's 44,274 wooden buildings, most constructed of pine, made it the largest wood-built city in the world. Its population of just over 334,000 extended across thirty-six square miles, or twenty-three thousand acres. To fight the fires that were happening an average of twice a day, the city relied on a force of only 216 men, including officers, fire wardens and members of the telegraph alarm service. The department was commanded by Chief Fire Marshal Robert Williams, a forty-five-year-old native of Canada and veteran of Chicago's volunteer force. Equipment consisted of seventeen steam engines, twenty-two hose carts, four hook and ladders, two hose elevators

A History of Flame and Folly in the Jungle

(which were primitive forms of snorkels and tower ladders) and forty-eight thousand feet of not-always-reliable hose. At the start of the Great Fire, about nine o'clock Sunday night, two of the engines were in the repair shop while another had been disabled at the Canal Street fire. The Chicago Fire Department's official history calls this capability "shamefully inadequate."

The confluence of events from October 7 to 9—drought, powerful south to southwest winds, tens of thousands of wooden buildings and a worn-out fire department—created the perfect storm. When firemen arrived in the DeKoven Street shantytown, they found three barns, including O'Leary's, a paint shop and a shed burning out of control. Ironically, the O'Leary cottage had been spared. Things were already going wrong. The first watchman who spotted the flames mistakenly believed he was seeing a flare-up of Saturday night's fire and ordered a box alarm sounded for the wrong location. Two companies did respond to the right location, one after being alerted by a resident and the other following a correct reading by a second watchman. The department's two newest steamers did not respond immediately because they were not due on the box alarm. By ten o'clock, valiant but overmatched firemen found themselves trying to stem a rampage. The strong southerly wind snatched burning debris, lifted it and whisked it four blocks to the steeple of St. Paul's Catholic Church. Soon, the entire church was totally involved. Flames spread to an adjoining factory and then to a lumberyard on the river—a repository of one thousand cords of kindling, half a million feet of furniture wood and three-quarters of a million wooden shingles. Efforts by civilian volunteers proved futile. New fires broke out to the north and east. The flames built to a firestorm that swallowed building after building, block after block. By now, all firefighting equipment in the city had been mobilized to battle three separate out-of-control fires.

The flames advanced in multiple, shifting directions, sometimes outflanking firemen who tried, like so many King Canutes, to prevent their relentless onset. Flaming timbers rained down on previously untouched buildings, igniting fresh areas of fire. Flames jumped the South Branch of the river, attacked the central business district and raced east toward the lake as they gained intensity. People in the path of the fire fled their homes, leaving most of their possessions behind. Many waded into the lake for escape. Five separate fires raged downtown, creating blizzards of hot cinders while they illuminated the night sky bright as daylight. The La Salle Street financial hub burned, as did the courthouse, Palmer House hotel, McVickers Theatre and everything else along the march to the lakefront. Then the fire jumped the Main Branch of the river, attacking north.

After about six hours, the fire reached the waterworks, whose roof collapsed. With that, the lake and river offered the only water available to fight the flames. The fire department effectively had been put out of business. North of the river, the homes of the wealthy went up in smoke as indiscriminately as the shanties and cottages on the West Side. Only two dwellings survived in the north fire zone—a mansion and the modest home of a Chicago police officer. The last house to burn, on Fullerton Avenue, about three miles north of the Main Branch, went up about 10:30 p.m. on Monday, more than twenty-five hours after the start of the fire. By then, the wind had died down and scattered showers began to fall. As dawn broke, the Great Chicago Fire was under control after gutting a path four miles long and about a mile wide.

Only 120 bodies were recovered, but officials estimated that the death toll was closer to 300, given the number of persons who vanished without a trace. No Chicago firefighter lost his life. In fact, from March 5, 1869, to January 6, 1875, the department did not suffer a fatality in the line of duty, the longest such respite in its history. The Great Fire left nearly 100,000 homeless, about one of every three Chicagoans. Property damage boggled the mind. Almost 17,500 buildings were destroyed with a total loss of more than $185 million. Insurance paid only $50 million because many of the companies insuring the destroyed area went insolvent.

Whether or not the O'Leary family was responsible, the public blamed them and their cow for the conflagration. A story spread that the cow had kicked over a lantern, igniting some hay, while Mrs. O'Leary was milking the animal. She claimed she was sound asleep when the fire broke out. Later analysis would contend that the fire probably was started by neighbors who may have been smoking and drinking in the barn or by a specific neighbor, "Peg Leg" Sullivan, who came home drunk and got careless with smoking materials.

On the first anniversary of the fire, the *Tribune* offered a retrospective, pointing out that the city's geographical location, on a flat prairie open to winds from all directions, "intensified the dangers growing out of its defective construction." Unfortunately, the paper observed, the business quarter, site of the best buildings, "was on the wrong side of the city," located downwind from the tinderbox across the river. "All that was required was the concurrence of certain circumstances…a long continued dry season; a fire starting from buildings on the West Side; a negligent or worn out fire department; and a gale of wind strong enough to carry the fire-brands across the South Branch of the river. On the 9th of October they happened together."

A History of Flame and Folly in the Jungle

The nearly four-decade trajectory from the Great Fire to the 1910 Stock Yards fire stands replete with many of the same or similar harbingers of disasters to come. Themes recur again and again: fires involving packinghouses; lumberyards; grain elevators; warehouses; wooden structures; improperly designed buildings; structures lacking proper escape routes; collapsing walls, roofs, ceilings and floors; and stockpiles of highly flammable substances. A fire involving at least one or more of the above always seemed an alarm away. Chicago firemen frequently resembled forerunners of the Bill Murray character in the movie *Groundhog Day*—doomed to relive or succumb to the same events over and over again. Some conditions were correctable, some not. It's impossible to calculate the number of lives and the amount of property that could have been saved by better preventive measures, corrections in building construction and maintenance, firefighting strategy and water supply and pressure. In the history of the regular Chicago Fire Department, 565 men have lost their lives in the line of duty through 2012. (Eight volunteers—four at an 1857 fire—perished.) The first two regular firefighters killed in action fell under a collapsing wall in 1865. On December 22, 2010, 2 died under a falling roof—one hundred years to the day that Chief Horan and 20 of his men were killed by a collapsing wall in the Stock Yards. Of the department's total fatalities, 115 have occurred as a result of a falling wall, roof, ceiling or floor.

Even before the last embers of the Great Fire had flickered out, Chicago began the monumental job of rebuilding. Individual entrepreneurs set up shop, thousands of temporary dwellings were erected and construction of some two hundred permanent structures got underway. The speed of the recovery astonished the world and invoked the image of the phoenix rising from the ashes. The city council passed an ordinance banning wooden construction in the downtown area to reduce the chances of another catastrophic fire occurring there.

During the cold winter of 1879, the Stock Yards, still outside the city limits, dodged a bullet when an Armour warehouse stocked with pork and lard caught fire. The building also contained an icehouse. Although the 200- by 425-foot building was well constructed and supposedly fireproof, some of its contents were not. A careless smoker or candle user was believed to have ignited piles of sawdust used to protect the ice. The ensuing fire led to a general alarm that brought eleven Chicago engine companies and two hook and ladders to the scene in the early morning of January 25 to supplement companies from Lake and Hyde Park townships as well as Armour's private force.

After trudging through slush to get into position, the men found their way to the seat of the fire blocked by an almost insurmountable wall. By the time they reached the raging southwest section, the fire had broken out in a dozen places on the roof, putting it beyond salvation. To further complicate matters, the wind picked up, and the water supply, inadequate from the start, showed indications of drying up altogether. The Lake/Hyde Park waterworks had been paralyzed by ice.

By 3:00 a.m., observers feared that the fire would not only claim some $2.6 million in meat and lard but also that it would spread to other parts of the yards and stop who knew where. An hour later, two fortuitous events happened. Though not always dependable, the yards' artesian wells began supplying enough water to carry on the fight. Then, the building's own configuration helped. The icehouse was located on the second floor, above the meat and lard. Intense heat from the flames melted the ice, which was stacked in tiers sixteen to twenty feet high. Melting ice seeped down onto the meat and lard, preventing it from becoming fuel that would have transformed a serious fire into a catastrophe, engulfing, perhaps, not only the rest of the yards but also the neighborhood beyond.

Providence, in the trinity of artesian wells, melting ice and intrepid firemen, couldn't mask the inconvenient truth that stood so clearly in 1879 yet continued to evade recognition for decades to come: the utter inadequacy of the water supply for the Stock Yards District. Cries went up for construction of a main running from the West Side waterworks to the yards. The matter, as the Wizard of Oz might have suggested, required a little thought.

Despite an economic depression that began in 1873 and lasted most of the decade, along with the setback caused by the Great Fire, Chicago continued its rapid growth. By 1880, just over half a million people called the city home. The Stock Yards avoided serious fires for the ensuing decade, but Chicago experienced at least twenty-one occurrences that resulted in damages of $100,000 or more.

The yards, soon after becoming part of the city, saw its luck run out early on September 28, 1890, when a blaze reminiscent of the 1879 Armour fire hit the Fowler Brothers packinghouse. After a 4-11 alarm was sounded, nineteen engines converged on the building. Firemen encountered another fortress-like structure, totally engulfed by flames. Within ten minutes of the first engine's arrival, the roof collapsed. As the fire advanced, about an acre and a half burned fiercely. The packinghouse and lard refinery held up to eighty thousand cured hams, eight thousand dressed hogs, twenty tanks of lard and numerous shoulders and sides of bacon. By 4:00 a.m., everything

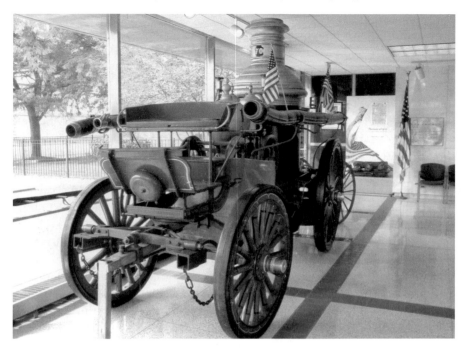

Steam pumpers fought the Great Chicago Fire of 1871. They would continue to extinguish fires in Chicago until 1923. This steamer, on display at the Chicago Fire Academy, first saw service at the Columbian Exposition in 1893 and was later donated to the Chicago Fire Department by the exposition's board. *John F. Hogan.*

had been reduced to ashes. Firemen prevented the blaze from spreading to the adjacent packinghouses of Nelson Morris, Swift and Cudahy. Arson was suspected but never proved. Earlier in the night, a small fire of suspicious origin was quickly extinguished. Loss from the bigger fire was estimated at $1.5 million. A Fowler company official said the loss was covered by insurance that was spread among many companies.

Just a month after a spectacular fire at the World's Fair in July 1893, the fertilizer plant at Nelson Morris's sprawling Stock Yards operation provided another of the portents that mark the annals of firefighting in Chicago. The episode offered a virtual dress rehearsal for the 1910 Nelson Morris fire. An electrician changing lamps inadvertently caused a flashover that ignited a dusty ceiling. Employees tried to fight the flames but were quickly overwhelmed by the alarming advance of the fire. Only a fire wall prevented the flames from spreading to other departments housed in the four-story, three-hundred- by six-hundred-foot building. Even at that, flames feeding

on oil and tallow shot through the roof and went beyond control of the firemen who responded to the 4-11 and one special call. With thirty-three engines pouring water on the blazing structure, the fight still seemed to be a loser. An oil house became enveloped. A group of firemen who had maneuvered around freight cars to train hoses on this new front saw the walls totter. (Photos of the 1910 fire show firefighters positioned behind a line of boxcars, training hoses on the Morris warehouse.) In an instant, they retreated—not a moment too soon. The top of the wall swayed and then crashed to the ground, narrowly missing the fleeing men. The next component to fall was the roof of the fertilizer plant, followed by the top floor and a tank it supported. The tank plunged through three floors, all the way to the ground, breaking a heavy steam pipe along the way. The roar of escaping steam could be heard for blocks. Fearing that his entire plant would go, company owner Nelson Morris paced an alley nearby, whittling a stick.

Next, the flames turned to an adjacent icehouse, but alert workers had shut off the valves supplying ammonia and prevented a possible explosion. This maneuver, along with the continuing protection of the fire wall and perseverance of the firefighters, marked the turning point. Four hours into the battle, the fire was brought under control about one o'clock in the afternoon. Total losses came in at $270,000, a fraction of what they would have been if the fire had spread to the slaughterhouse and an adjoining six-story warehouse with contents valued at $8 million. Nelson Morris put away his whittling and became the picture of contentment. The losses were fully covered, he explained, and "in three weeks we will have a new [fertilizing] house. The fire will not injure our business in any way. We will fill our American and European orders just as if we had had no fire." Reinforcing the boss's words, employees on the slaughterhouse side of the plant continued killing cattle, hogs and sheep without letup while the fire raged. "The destroyed part…is only a small part of our plant," Morris added.

A touch of intrigue provided a footnote. When it seemed as if the entire plant might be swept away, rival packers were suspected of sending telegrams to Morris customers, telling them it might be wise to shift their business elsewhere. The source of the wires was never identified, but when Morris got wind of the plot, he fired off his own telegrams, denying the misinformation. Morris confronted Gustavus Swift. Apparently satisfied with Swift's response, the Nelson Morris Company issued a public statement absolving its competitors of any skullduggery. In point of fact, the statement added, the other companies had shut down operations to make more water available to fight the fire.

A History of Flame and Folly in the Jungle

The less-than-one-month span between July 4 and August 2, 1894, was a period not soon forgotten by Chicago firefighters. While reduced to the role of spectators at a blaze that finished off the World's Fair buildings, they felt pushed to the limit by Stock Yards rioting and arson, brought on by the Pullman Strike, along with the challenge of fighting one of the biggest lumberyard fires in the city's history.

Members of the Army's Fifteenth Infantry Division, newly arrived at Union Station by special train from Fort Sheridan, north of the city, didn't need a map to see where they were headed. Orange flames and black smoke from scores of burning boxcars, visible for miles, marked the way. The fires bore the signatures of drunken troublemakers, using the strike as a pretext for their actions. President Cleveland had heard enough from his attorney general and federal officials in Chicago and sent in the regulars. When the troops arrived at the Stock Yards the following day, they encountered a deceiving calm. Nothing was moving in the rail yards. All tracks remained blocked. Trainmen had been chased from their jobs and some beaten by rioters. Two trainloads of beef, forty cars each, had been halted on the main tracks.

The lull didn't continue for long. Three consecutive days of rioting ensued, capped by a night that saw 160 boxcars overturned and many set on fire within a one-mile radius of the Stock Yards' main gate. Up in flames went a dozen signal towers, as well as a passenger station. Firemen who responded were allowed to run hoses before being driven off by rock throwers, who then cut the lines for good measure. Vastly outnumbered police were forced to run for their lives. Electric wires came down. In a particularly imaginative touch, rioters got hold of a handcar, loaded it with cotton, soaked the cotton with oil and ignited it. They moved the flaming car down the track to the side of a hay barn. The structure, which contained nine hundred tons of hay, became a total loss. A watchman who attempted to prevent the arson suffered a severe beating from club-wielding men. Firemen who hadn't been chased away succeeded in stopping the flames from spreading to an elevated wooden chute used to drive cattle to the killing floors. The chute, which spanned the entire yards, would have provided a conduit for fire to sweep everything in its path.

The number of fires in the rail yards kept mounting. First, one hundred cars were afire, then five hundred and, finally, more than seven hundred, many loaded with meat, furniture or other commodities. Miles of rail twisted under the intensity of the heat, and flames illuminated the sky so brightly that their glow could be seen throughout the city. Individual fires

broke out more rapidly than they could be counted. For more than a mile and a half, north to south, not a boxcar, signal tower or tool shanty withstood the onslaught. Fires extended from the yards in every direction, like so many flaming, jagged spokes. A news account described "a roaring wall of fire down the tracks from 55th to 61st Streets. [Mobs] left not a car, not a switch tower, nor signal post, nor tool shanty behind them. They cleaned up the Yards utterly. The flames of their kindling reddened the southwestern sky. [The] whole Fire Department of Chicago could have done nothing."

Given the 292 extra alarms and countless still and box calls in Stock Yards history, it's amazing that only three firemen aside from the twenty-one killed in 1910 lost their lives at the district. In the early morning of February 23, 1899, pipeman Patrick O'Neill of Engine Company 49 died and three of his engine mates were seriously injured in the collapse of a wall at Swift & Co.'s eight-story Warehouse No. 7, under construction in the heart of the yards. A Nelson Morris packing plant stood across the street. Other Swift properties, as well as operations belonging to Armour and the Chicago Packing Company, surrounded the burning building. At one point, fire officials feared that the height of the Swift warehouse, combined with high winds, would send embers raining down on the residential neighborhood and perhaps endanger the entire district. The fire did spread to another Swift building and got a toehold in three other structures, but firemen were able to check the advance. A 4-11 alarm followed by a special alarm brought out thirty-five engines, but they couldn't save Warehouse No. 7. With the fatal wall and every floor collapsed, the building was declared a total loss costing $200,000. The cause of the fire, which was discovered by a watchman making his rounds, was never determined.

The two other department fatalities happened nineteen years to the day later to members of the company whose fate, by geographic design, would be linked forever to fires in the jungle—Engine 53. On July 22, 1936, firefighter Thomas Fitzgerald was electrocuted while fighting a blaze at 1537 West Forty-sixth Street. On that date in 1955, Lieutenant Berneal Deady suffered a fatal heart attack during a fire in a Swift & Co. plant at Racine and Exchange Avenues.

Armour had escaped fire at its Chicago facilities for twenty-five years, but its luck ran out a little more than a month after the fatal Swift blaze. On March 27, 1899, fire struck a company facility a little over a mile north of the Yards District, at Thirty-first Place and Benson Street. More than 150 employees were at work in the five-story brick, half-block-long felt plant when the blaze started on the third floor, which contained wool-processing

machines. Flames advanced so rapidly that they set off a frantic scramble by the 100 men and 50 women. Falling over one another, most reached the fireproof stairways or four fire escapes. Some did not, and one who did made a fatal mistake. Forewoman Ella Hemmilwright, one of the last to reach the street, decided to return to claim some books she'd left behind. For reasons never explained, she asked a young boy to accompany her. The two retrieved the books, but the boy lost sight of Ella in the dense smoke. He made his way out, leaving the books in the company office and Ella to the mercy of the smoke and flames.

Co-workers Joe Breen and Jerry Steele were on the fourth floor when the alarm sounded. Steele realized they couldn't escape by the stairs, so he rushed to a window, climbed out and hung to the sill, with smoke and flames moving ever closer. After about five minutes, he let go as firemen held a net to catch him. Only one of his feet hit the net; the other struck the sidewalk, fracturing his leg and hip. He also suffered internal injuries that nearly proved fatal. Joe Breen, meanwhile, had decided to take his chances in the stairwell. He was able to reach the second floor, but the smoke had become too thick. He jumped to the ground, escaping with only a sprained ankle. Breen joined 6 others on the injured list, including his partner, Steele. In all, 8 were killed in the blaze. There were no injuries among the 250 firemen called out. They, along with twenty-five engines, all under the command of Chief Fire Marshal Denis Swenie, prevented the fire from spreading to the equally flammable Armour Glue Works just west of the felt plant. Swenie had stationed men on the roof of the glue plant and atop boxcars to stem the progression of the flames, but the nature of the fire itself made the final difference. The western end of the felt works' roof collapsed, and the floors followed in rapid succession, internalizing the heat and flame. After two and a half hours, the fire was brought under control. Losses were pegged at $300,000, fully covered by insurance.

Fire returned to the yards later in 1899, setting off a wild stampede by more than two thousand horses. The fire broke out in the Dexter Park Horse Exchange Pavilion, the largest horse sales and auction market in the world, about 4:00 p.m. on September 21. By the time it had run its course, only masses of charred timber and twisted metal filled a twelve-acre area from Fortieth to Forty-third Streets west of Halsted. The blaze started in the dome of the pavilion, either from an electrical malfunction or a flame in a harness shop. Wind-driven embers ignited the roof of the Transit House hotel and restaurant. Soon, the entire building became involved. Assistant Chief Joseph Pazen, who had charge of the fire until Chief Swenie's arrival,

wasn't sorry to see the thirty-five-year-old landmark go. "The building…
was a menace to the safety of the Yards," Pazen declared, "and I am glad
that a more substantial one will be built." One firefighter suffered burns
to his hands and face, but in the view of Stock Yards Company officials,
the true heroes were the company employees who rescued the horses from
stables and barns that were falling like fiery dominoes. Shortly after the fire
broke out, some fifty men ran into stables and buildings, opening doors
and cutting halters to release the panicked animals that then stampeded
in every direction. The more than two thousand horses running wild just
west of Halsted Street offered a spectacle never before seen by Stock Yards
personnel or the surrounding neighborhood. Men on horseback conducted
a roundup as best they could, Wild West style, driving the horses to pens and
stables untouched by the flames. Herding and calming a couple thousand
frightened horses clearly presented no easy task. The roundup continued
far into the night, but in the end, not one horse was lost. Stock Yards vice-
president John A. Spoor spoke reassuringly as a man whose company's
$300,000 loss amounted to only 15 percent of its total insurance coverage.
"We will commence rebuilding immediately," Spoor announced. "A new
building will be erected on the site of the old Transit House." (It would burn
down just thirteen years later.) "The business of the Stock Yards will not be
interfered with…sales will be held as usual in the morning."

Chapter 3

DEATH IN A VERY SMALL PLACE

In early 1905, Chicago firefighters found themselves up against another Stock Yards warehouse that seemed to have been intentionally designed to thwart all efforts to save it from destruction by fire. The eight-story Schwarzschild & Sulzberger (S&S) building stood like an impregnable fortress on Fortieth Street near Ashland. Its double walls, four to six feet thick, were filled with sawdust to maximize the cooling of stored beef. Frustrated men under the command of Chief Fire Marshal John Campion couldn't even see much less reach the fire. But the flames were there all the same, eating away at the hermetically sealed sawdust.

The fire was discovered about 7:00 p.m. on January 15 by a watchman who noticed smoke on the second floor. Almost immediately, the man was knocked down by a powerful explosion that blew a hole six feet wide through a fire wall. Soon, the fire was belching heavy black smoke in ever-increasing volumes. When Campion arrived on the scene, he complained bitterly about the lack of doors and windows that would allow access for his men to fight the fire. Less than an hour after the outbreak, men had to be ordered off the roof for fear the walls would bulge from the heat and collapse. The two lower floors were ready to fall at any minute. Campion ordered twenty men to chop through the north wall with axes and sledgehammers, but it took more than half an hour before they could penetrate the outer portion. The small hole they had made was just large enough to provide a vent for clouds of overwhelming smoke. Three pipemen (firemen assigned to a hose or engine company) were overcome and had to be carried away. Their

companies regrouped and mounted another assault. They tried to run a small line through the opening but were driven back twice. Campion was at his wit's end. His men attacked the fortress from every angle. Whenever they could breach the walls, they were driven back by smoke. At least seventeen more firemen were overcome. Next, they focused hoses on the hot walls at the end of the building while a dozen more lines were trained on the roof. "Keep it up until you see the fire, and then go for it," came the order.

More than thirty-six hours into the battle, firemen caught a break from a somewhat unusual source. Three senior managers of the S&S Company volunteered to lead a fire company along a narrow gangway to the top of the burning building. It represented a daring gamble, but after an hour's work, the firefighters were able to punch a hole through a wall and allow several streams of water to be trained on the fire inside. This breakthrough allowed weary firemen to score the only victory they'd been allowed thus far: preventing the blaze from spreading. After the fourth special alarm had been sounded, thirty-nine fire companies were on the scene. Jim Horan, then assistant fire marshal, noted that a larger number of units would have proved useless because of a lack of hydrants in the vicinity. What Horan didn't realize was that in many regards he'd been participating in a dress rehearsal of the fire that would claim his life.

In addition to the firefighters overcome by smoke, at least thirteen suffered burns or bodily injuries. All ten members of the packers' private firefighting force were hurt. Nearly a week after it started and $500,000 in damage later, the S&S fire was declared struck out.

Just two and a half years after fire visited its beef warehouse, an S&S pork house in the same complex at Forty-first and Ashland became the scene of a stubborn fire on May 5, 1907. Firemen were forced to battle flames 150 feet in the air after the blaze broke out in an S&S box factory that shared the top floor of the seven-story brick building with the pork-cutting department. Soon after the first firemen arrived, the roof collapsed, sending flaming debris crashing down to the sixth floor, where vats of brine were located. A 4-11 alarm was followed by five specials, which brought fifty engines. With that many engines pumping, a phenomenon unusual to the yards occurred. Instead of running short, firemen poured so much water on the plant that it caused nearly as much damage as the flames that were prevented from spreading to the lower floors of the pork house. S&S buildings eight stories tall, on either side of the burning structure, gave firemen a vantage point for their hose lines. Firefighter James Grace of Truck Company 8 ventured out on a ladder from one of these buildings and, equipped with a rope,

attempted to pull down a cornice that was blocking the attack. While in midair, he became overcome by smoke. Fellow company member Joseph Taylor climbed out on the ladder and rescued Grace just as he was about to fall. From the top of one of the taller buildings next door, a daredevil squad improvised a new line of attack. They noticed that the roof they occupied was connected to the top of the other eight-story structure by a narrow runway 50 feet above the burning pork house in between. Dragging a line after them, they maneuvered out to the center of the walkway and trained the hose on the flames immediately below, as if it were all in a day's work defending Chicago's Union Stock Yards.

People acquainted with Big Jim Horan referred to him as "Sunny Jim" because of his friendly, outgoing manner. Both nicknames fit, but the second occasionally came regarded with a tinge of sarcasm. The man could display a darker side, capable of "getting a grouch on," as those around him would put it. Long before he became chief fire marshal, Horan was recognized as one of the strongest disciplinarians in the department.

Horan had traveled a long way from the baseball fields on the near South Side where he played alongside future mayor Fred A. Busse and Charles A. Comiskey, future owner of the Chicago White Sox. Big Jim was born May 29, 1859, in Chicago of Irish immigrant parents. His father, Patrick, a laborer, came from County Tipperary and his homemaker mother, Ellen, from Limerick City, forming what the Irish of the day boastfully called "the best blood of Ireland." The family settled in the 1700 block of South Butterfield (later Federal) Street, now part of the First District police headquarters' parking lot. The young man grew up to the sound of train whistles; Butterfield lay one block immediately east of the Rock Island right-of-way. Horan's birth occurred one year after formation of the city's professional, or "paid," fire department. He was twelve years old at the time of the Great Fire, a seminal event in his and countless other lives. Although the Horan family lived south of the fire zone, they could easily see the inferno. Horan's great-grandson, John Rice, who has studied and written about the chief's life, has developed a theory: not only did his ancestor's experience in 1871 motivate him to become a fireman, but it also "gave him tunnel vision"—a single-mindedness that he brought to fires and a determination that no fire he fought would get the better of him, if he could help it, the way the Great Fire got the better of the 1871 department. Another Horan descendant who has studied the chief's life, great-great-grandson Don Thompson, agrees: "Chief wanted to go at it head-on."

Horan worked for a time at the Stock Yards and as a telegraph operator before he joined the department in 1881. His first position, "drinking-water

boy," sounds laughable if not altogether demeaning today—a Gunga Din job ill befitting a strapping twenty-two-year-old man, all bone and muscle. He was assigned to Station 1 at Franklin and Quincy Streets at the west end of downtown. His responsibility was to haul the company's drinking water back to the firehouse from an artesian well a block away. Horan didn't find the chore unpleasant, except when a fireman would get mad about something and kick over the can.

Early in his career, he set his sights on the top job. Before the year was out, Big Jim graduated to pipeman. He stayed in that slot for more than four years and then made lieutenant. He was promoted to captain two and a half years later on Christmas Eve 1888. On July 1, 1893, he became chief of the First Battalion, the most prestigious command in the department. From its headquarters at Dearborn and Lake Streets, the First was responsible for fighting fires in the most important section of the city, the downtown business district. His long suit was considered to be a virtual insider's knowledge of the plans and construction of the buildings within his jurisdiction.

After rising from water boy to battalion chief in twelve years, Horan's progression seemed to stall against a backdrop of politics, personalities, rivalries and ambitions. His career path intertwined with those of two men who would join in fighting the 1910 Stock Yards fire—Charles Seyferlich and William Burroughs. Competition to succeed living legend Denis Swenie, who was retiring as chief fire marshal, had reached a boil before First Assistant William Musham, the seemingly logical contender after twenty-one years in the number-two spot, received the appointment from Mayor Carter Harrison II. Horan had been considered a serious challenger. Musham was well aware that Horan had made a number of influential friends during his eight-year command of the downtown district, so he did what superiors have often done to ambitious subordinates—he transferred him. Horan discovered that he'd been "sent to the prairies," in the *Tribune*'s words, to a station on West Chicago Avenue, in an area "where most of the houses are two-story cottages and a really dangerous fire occurs about once in three years." Musham moved Second Battalion chief Seyferlich, nine years older and at least fifty pounds heavier than Big Jim, to Horan's old spot downtown. Musham, long known for a lack of tact, said only that the move was for "the good of the service." Did that mean Horan had done something wrong? "Seyferlich is just as good a fireman as Horan," Musham succinctly replied.

Musham performed an about-face a year and a half later, bringing Horan back downtown and returning Seyferlich to the Second Battalion. Again,

Musham claimed to be acting only for the good of the service, but of course no one believed him. One rumor had political pressure being brought to bear on Mayor Harrison. Another speculated that someone in high places was unhappy with the way a recent downtown fire had been fought. Several engines had been ordered to return to quarters, only to be hurried back to the scene in response to a special alarm.

Whatever the reason or reasons, Horan's career was back on rocket trajectory. Months later, he was elevated to third assistant, and he rose to second assistant little more than a year after that. Just five more months and he was next in command, with Seyferlich stepping up to second and Burroughs to third assistant marshal.

Newly minted as chief fire marshal in July 1906, Horan didn't just hit the ground running, he shot out of the starting blocks like a man making up for lost time. He didn't need insurance executives to tell him what the department required. In 1906 and 1907, he oversaw construction of nine new and twenty-five rebuilt firehouses, the purchase of twenty-four steam engines, one new and three rebuilt hook-and-ladder units, fifty hose wagons, seven service trucks, five supply wagons, five buggies, nearly five hundred horses and ninety thousand feet of hose. A lover of horses, the new chief purchased a system to eliminate the time-saving but uncomfortable practice of keeping the animals continually in harness. Under the new scheme, harnesses were suspended from the ceiling and quickly lowered to answer a call.

Less than one week before his death, Chief Horan sent a letter to the Stock Yards Company soliciting its interest "in installing an up-to-date high pressure system in Packingtown." A fire of any magnitude there, the chief stated, brings twenty to thirty-five companies, "leaving the entire district on the south side from 22nd Street to 63rd Street practically bare of companies. Kindly advise me if your company would care to go into the matter. Yours respectfully, James Horan, Fire Marshal." The chief didn't live to see a response.

The Stock Yards had been enjoying a comparatively long respite from major fires, the last coming in May 1907 at the second S&S packinghouse blaze. Since then, a devastating grain elevator fire, a water intake crib fire that claimed sixty lives and an equally horrific fire at an L. Fish furniture store had captured the headlines. But every fireman on the South Side, as well as their leaders, from Big Jim Horan down, realized it was only a matter of time until the most combustible square mile's number came up again.

On the last full day of his life, Horan left his office at city hall about 4:30 p.m. and had driver William Moore take him home. About 9:00 p.m., Horan

called Moore at Engine 103's house and asked to be picked up. Moore said Horan wanted to be driven to Engine 104 at Fourteenth and Michigan so he could see Third Assistant Marshal Thomas O'Connor. Told that O'Connor wasn't in, Horan took time to congratulate Captain Michael Corrigan on his promotion to battalion chief. Neither man realized that the encounter marked the passing of a torch, although Corrigan, who would become one of the department's most renowned commissioners, wouldn't be named to the top uniformed position until seventeen years later. ("Big Tom" O'Connor would also hold the top spot before the reign of Corrigan.) Moore said he dropped off the boss at home around 10:30 and returned to his quarters several blocks away. If Horan had attended a Christmas party and had a few drinks, as rumor sometimes held, his driver makes no mention of it, nor does the timeline he relates allow much room for such a social encounter on a weeknight four days before Christmas. Shortly after four o'clock the next morning, Moore was awakened from his disturbing dreams by the alarm from Box 2162 and soon was on his way with partner Joe Mackey to pick up the chief for the run to the Stock Yards.

Horan's mind was racing faster than the automobile carrying him to the extra-alarm fire in the Stock Yards. He sat in the front seat to the left of his driver, Lieutenant Joe Mackey. The steering wheel was on the right side of the vehicle. Horan preferred sitting in the front, where he could more easily bark orders to Mackey and serve as a second pair of eyes for his driver. Backup driver Bill Moore had the luxury of the whole rear seat to himself.

The Buick was not enclosed against the frigid night except for a leather convertible top. The headlights were fueled by acetylene gas delivered by tubing from carbide generators above the running board on the left side. The cowl lights at the base of the windshield and the tail light burned kerosene. Fortunately, no snow or rain filled the air that night because the concept of a windshield wiper, although already patented, was still a device for the future. The automobile, originally painted black, had been repainted red two years earlier to give it the appropriate appearance of an official fire department vehicle. A gong announced the car's response to an alarm; a horn, operated by squeezing a rubber bulb, could be sounded during less urgent trips.

The chief had been told by his drivers that the alarm came from Building 6 of the Nelson Morris meatpacking complex. Unknown to Horan, the fire was actually next door in Building 7. If the chief had formulated a plan for attacking the fire, it might have to be changed on arrival. The nagging fear that there might be problems getting enough water to fight the blaze must have crossed his mind. He knew the water supply in the yards was a disaster

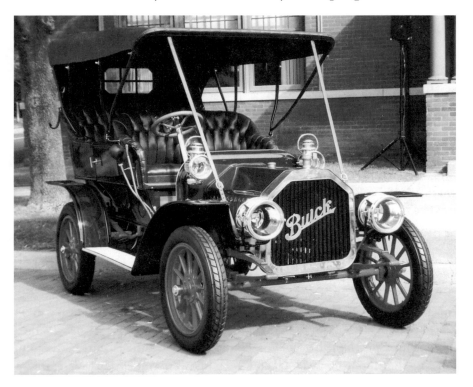

This 1908 Buick is similar to the 1906 model in which Chief Horan rode to the fatal Stock Yards fire. Horan's automobile was the first motorized vehicle in the Chicago Fire Department. *Courtesy of James S. Bloomstrand.*

waiting to happen. Just the other day he had warned that the city needed a high-pressure water system, particularly in the Stock Yards. Sending firemen to fight flames without adequate water was like sending infantrymen into battle without bullets.

The Buick lumbered down poorly lit Ashland Avenue, which was covered with patches of ice and snow that made navigation treacherous. At least with the car Horan didn't have the worry of a horse slipping on the ice, falling and breaking a leg. Then again he realized the car had a tendency to break down, so all he could do was hope to reach the fire without delay. There was little need for the gong or horn that night since traffic was practically nil and pesky traffic signals remained for the future. About all Horan and the others saw was a streetcar running on its "owl" schedule and an occasional horse-drawn wagon headed north toward the wholesale meat and vegetable markets.

Mackey was making good time on this run straight down Ashland. The lieutenant and Moore were good drivers. Both had experience with the Buick, which wasn't easy to drive. It featured three pedals to the left of the steering column: the brake pedal, a slow speed pedal and a reverse pedal. The layout could pose a serious problem for a novice.

Horan could picture the general layout of the Nelson Morris complex. He knew it was big and potentially dangerous. At times like this, the anticipation got the adrenaline flowing and the mind working like that of a general preparing to encounter the enemy. Neither he nor any fireman knew exactly what would be found upon arrival—a flaming inferno or a "smoker" that made it impossible to locate the actual flames. How many lines would he find pouring water on the fire? Had Assistant Fire Marshal William Burroughs, already at the scene, requested special calls to summon more firemen and equipment? With luck, the fire would be under control or even struck out. Time would soon tell.

Sometimes an assistant fire marshal or battalion chief might panic and call for more alarms than necessary. Horan didn't mind getting out of a warm bed on a frigid night if necessary, but if some underling had made a boneheaded decision, he would face the chief's wrath. Horan had fought long and hard to become chief, and he didn't want somebody fouling things up. Although he would never admit it, going to fires at night, especially in winter, was getting harder. He was fifty-one years old with twenty-nine years in the department. Fires had taken their toll, but nobody ever heard a word of complaint from him.

Finally, there was Forty-first Street, and Mackey began his left turn into the Stock Yards. Less than ten minutes had passed since the three left Horan's home.

Loomis Street in the Stock Yards, between Forty-third and Forty-fourth Streets, could have easily been called Fort Nelson Morris. Covering the entire west side of the street, three six-story, solid brick buildings stood side by side, separated only by fire walls. Each building was nearly windowless, the floor space interrupted by only a few partitions. While the walls boasted sturdy brick construction, the interiors featured flimsy wood, whose flammability level rose because of grease-soaked floors. The warehouses lacked sprinkler systems. Firemen had confronted such buildings before in the yards and had come to fear and loathe them. They were designed to seal in the refrigeration that preserved the meat waiting to be shipped by refrigerator cars lined up outside. Unintentionally, the warehouses served one of the purposes of an actual fort—keeping would-be intruders at bay, even if the interlopers were firemen bent on saving the buildings.

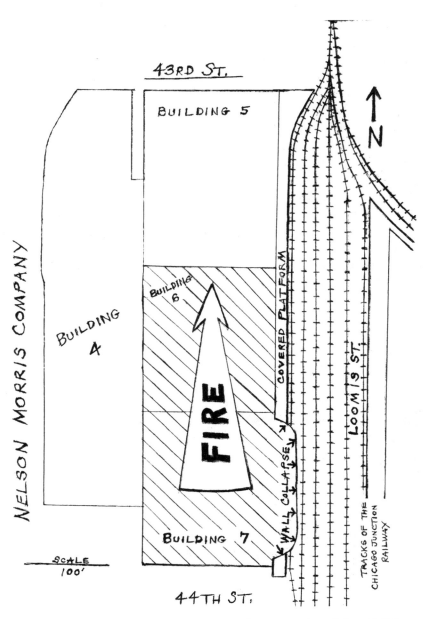

A map of the immediate vicinity of the fire shows how flames spread north from Building 7 to destroy Building 6. Fire walls prevented further spreading. For firemen, Loomis Street was the only opening to attack the flames. The railroad tracks running down the street hampered firefighting efforts. *Alex A. Burkholder.*

Beef Warehouse 7 occupied the northwest corner of Forty-fourth and Loomis. Built in 1888, it measured 184 feet long by 155 feet wide and contained 28,520 square feet. Warehouse 6 stood in the middle of the block, flanked by Slaughterhouse 5 to the north, extending to Forty-third Street. Each contained approximately the same amount of square footage as Number 7. Another warehouse, Number 4, at four stories, abutted parts of Numbers 6 and 7 to the west. This design left only the heavily fortified east and south walls and a small section of the west wall of Number 7 exposed to the outside and any approach by firemen. Moreover, the south wall featured no doors or windows whatsoever. North of Warehouse 4, directly behind parts of 5 and 6, the company operated a fertilizer works, which in turn abutted a five-story tin shop that extended to Forty-third Street. To the eye, the six units appeared as one monolithic structure encompassing almost an entire city block. On the east side of Loomis, across from Nelson Morris, Armour & Co. maintained a meat warehouse of its own that also featured a covered platform that faced its counterpart across the street.

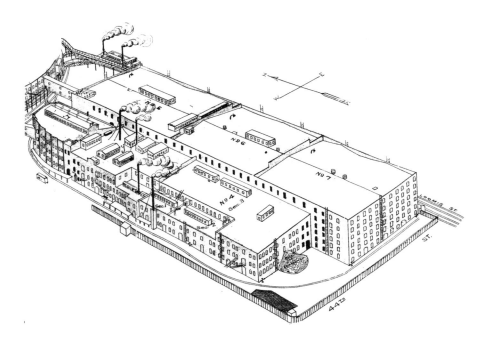

The authors were unable to locate a photo of Building 7 taken prior to the disastrous fire. However, an artist's sketch of the Nelson Morris complex depicts the building twenty years before the tragedy. All of the windows are bricked-over or closed off by iron shutters. Visible are four fire ladders permanently attached to Building 7 that apparently were not used by firemen the night of the deadly fire. *Courtesy of Charles Rascher.*

A History of Flame and Folly in the Jungle

Loomis Street looked more like a rail yard than a thoroughfare. Taking up most of the street were six sets of tracks owned by the Chicago Junction Railroad. In the early morning of December 22, 1910, like most mornings, the tracks were filled with refrigerator cars ready to be loaded with shipments from Nelson Morris and Armour. The interior of Warehouse 7 at 4:00 a.m. was a cold, lonely place, containing row upon row of beef barrels and casks of cured hams. The night foreman and three night watchmen had the place largely to themselves. Night or day looked the same. Only a single row of small, iron, shuttered windows ran across the second floor of the building facing Loomis. This side also held a service entrance and a line of wooden freight house doors that were kept locked and barred from the inside. Running along the warehouses stood a fifteen-foot-wide wooden loading platform. Overhead, a twenty-five-foot-wide wooden canopy served to shelter the workers who filled the waiting rail cars. Interspersed around the circumference of the entire complex were thirteen ground-to-roof ladders that were built into the sides of the buildings. Warehouse 7 held four of the ladders; Warehouse 6 had two.

The Nelson Morris Company didn't rely solely on the Chicago Fire Department to protect its plants. Early on, Morris and its neighbors organized an employee fire brigade to cut frequent fire losses and obtain lower insurance rates. The carriers themselves created Fire Insurance Patrol Number 4 and located it strategically at 1156 West Forty-third Street, just about dead center in the Yards District and two blocks east of the Nelson Morris warehouses. Both the packers and insurance companies used their influence with the city to have three fire stations placed inside the yards. In 1905, one of the three was moved to a new location at 4710 South Elizabeth Street, just outside the yards. During this period, Chief Horan also exerted a bit of influence. Well-liked and respected by the packers, the chief convinced some of them, including Nelson Morris, to install their own high-pressure systems. Regrettably, some companies shut down the systems on winter nights, ostensibly to keep the water from freezing in the pipes.

Stock Yards watchmen, who numbered about two hundred, received training in firefighting but hardly qualified as trained firemen. Total equipment available to them throughout the yards included seven pumpers; nine hose carts, which carried 3,600 feet each; 11,000 feet of hose located in major buildings; interior and exterior standpipes; handheld extinguishers; buckets; and axes. To summon additional help, the watchmen had access to eighty private American District Telegraph (ADT) alarm boxes that transmitted signals to the ADT office at 4213 South Centre (Racine) Avenue,

as well as to the two firehouses inside the yards and the city's Englewood Fire Alarm Office several miles to the southeast.

The warehouses on Loomis were serviced by both city and private water systems. At Nelson Morris, company standpipes provided the first line of defense. Three private artesian wells, two reservoirs and six city hydrants were available to the immediate area. One hydrant was located on a private road that ran behind Warehouse 4 to the west; three were found on Forty-fourth Street, south of Warehouse 7, and the remaining two along Forty-third Street to the north. If more were needed to fight a major fire, distance became a serious problem. Significantly, no fire hydrants were located on Loomis. The reservoirs, on the other hand, could hold copious quantities of water—139,000 and 500,000 gallons—but they presented one significant handicap: when the temperature fell below twenty degrees or so, they either froze or were drained to prevent freezing. Likewise, the private water mains that fed the yards were shut down on winter nights to avoid freezing. When a fire broke out, the system had to be activated by an employee who operated a valve.

Foreman Charles Podesta, along with watchmen Paul Leska, Andrew Dzurman and Patrick Reaph, had drawn the task of safeguarding Warehouse 7 and its containers of beef and ham the night of December 21–22. The typical yards night watchman put in a twelve- to thirteen-hour shift walking up to twenty miles, some of the distance up and down flights of stairs. Drinking before work and sleeping on duty posed rampant problems. Leska was making his rounds about 4:00 a.m., perhaps wishing he were home in bed at Fifty-fourth and Winchester, when he noticed hazy smoke filling the first floor. It seemed to be coming from the basement. Leska followed the trail down the stairs to the hide storage room, the apparent source of the smoke. When he opened the door, he was driven back by a rush of smoke and flames. His first instinct was to get out—fast. He stumbled and fell several times as he groped his way out of the basement and back up the stairs. Before exiting, he committed the first of two fateful omissions—he left the storage room door open, providing the fire with both a fresh supply of oxygen and a pathway to other parts of the building.

"The flames had spread from the hide storeroom and the first floor had filled with smoke by the time I rushed up the stairs," Leska said later. He mentioned that he could see fire in the ceiling had spread to the floor above. "The planks in the second floor were burning and the rafters. And a hole about four feet square had been burned. I was nearly overcome by the smoke and heat. I fell a number of times but managed to reach the [service] door." Leska went into adjacent Warehouse 6 and pulled an ADT alarm box. The

ADT watch service two blocks east relayed the alarm at 4:09 a.m. to the two fire stations within the yards, both equipped with an ADT register. To clarify the location for responding companies, the ADT office converted the signal to the number of the nearest Chicago alarm box, Box 2162, near Forty-third and Loomis, outside Warehouse 5, two buildings from the fire scene. But the alarm received by Companies 53 and 59 came from the ADT box in Warehouse 6, alerting them that the fire was in that building and not in Building 7. It's possible that the initial responders lost time by going first to a building that wasn't on fire.

One version of events tells of an unknown person pulling Box 2162 at the same time Leska pulled the ADT alarm. Fire historian Ken Little, who served as a senior fire alarm operator, takes issue with this account, saying the ADT alarm was all that was needed to alert the two firehouses. There was no "mystery" sentinel, he posits, for several reasons. One—the fire had been discovered only moments earlier, apparently soon after it started, so its visibility would seem unlikely from nearly a block away. Two—assuming that someone would be on the street of a private industrial district at 4:00 a.m. on a bitter December morning also seems a stretch. Three—even if someone pulled Box 2162, the possibility of this happening at the exact moment Leska was pulling the ADT alarm presents quite a coincidence. Four—no one ever came forward to claim such an important role. And five—the report of the coroner's jury makes no mention of anyone pulling Box 2162.

Watchman Leska, to his credit, wasn't finished, despite his miscue. He returned to burning Warehouse 7 to look for either of the two fire hose reels without success. Five minutes later, firemen from Insurance Patrol 4 arrived from their quarters two blocks away, and soon after them came foreman Charles Podesta.

"Charlie and I went to Section [Warehouse] 4 to get the hose," Leska said. "We got it, took it back to Section 7 and left it for the firemen." Leska shouted warnings to fellow watchmen Dzurman and Reaph, whom he presumed were inside the burning building. Hearing no response, he fled. Dzurman and Reaph also escaped safely and later joined city firemen in fighting the blaze.

The fire spread quickly through the open hide room door, setting off the rest of the basement. Flames crept up the stairway to the first floor, as if retracing the steps of the man who had released them. At the top of the stairs, fire met wooden floors soaked with grease and produced heavy black smoke that filled the building and escaped through cracks in the shuttered windows and freight house doors. Leska, in his haste, had also

failed to close the service entrance to Warehouse 7 when he left to seek help and send the alarm. By the time the first steamer, Engine 53, arrived from Fortieth Street and Packers Avenue, six blocks away, heavy smoke was pouring through the door.

"The basement was filled with flames in the south end when the first firemen arrived," Leska stated. "I don't know how the fire started. It spread awful fast." Flames were also visible in the northeast section of the warehouse, and the rest of the building was filling with dense smoke. A moment later, Engine 59 appeared on the scene from its quarters inside the yards' main gate, 826 West Exchange Avenue, about nine blocks away.

Engine 53's crew connected to the nearest of the three hydrants on Forty-fourth Street, which were supposed to be fed by the larger of the two private reservoirs. Hose had to be dragged down Loomis through the narrow passage between two rows of freight cars and along the loading platform to the fire. The men ran their line to attack the fire through the service door that Leska had left open and now was venting heavy smoke. But when the hydrant was turned on, no water came out. Engine 59's crew, which had taken up positions on the platform, encountered an identical experience. Firefighters were hit with the stark realization that the water system had been shut down.

No less an authority than John A. Spoor, president of the Stock Yard Company, later conceded that the Morris Company's private water supply had been turned off for the night, as was the custom in cold weather. Spoor decried the "deplorable lack of water," agreeing with fire authorities that the time expended to get the system up and running gave the fire the upper hand. "When the first fire company reached the scene of the blaze," Spoor declared, "[the fire] could have been extinguished in fifteen minutes if there had been enough water. There was no city water in enough quantities available, and in the time it took to get the Morris water supply turned on, the fire got the best of the department." As he spoke, Spoor carried in his pocket Horan's December 16 letter seeking his support for a high-pressure water system.

Hoofbeats coming from all directions signaled the arrival of more help. From the south, at Forty-seventh and Elizabeth, came Engine 52, the company located inside the yards until 1905. From the southeast, the buggy carrying the first chief officer on the scene, Eleventh Battalion chief Martin Lacey, arrived with Truck 18, the unit with which he shared his headquarters at Forty-seventh Place and Halsted. Lacey assumed command of the fire about 4:15 a.m., six minutes after the alarm and ten minutes before Second Assistant Fire Marshal William Burroughs checked in and took over.

Burroughs was driven to the scene from his quarters to the northeast, at Fortieth and Dearborn. By now, Truck 33, Engine 39 and Engine 49 were converging from the west, northwest and southwest, respectively, to complete the second wave of responders.

Chief Martin Lacey of the Eleventh Battalion testifying at the coroner's inquest into the deaths of Horan and the others. *Courtesy of Edward Lacey.*

When the alarm came in at the various houses, the same feeling of apprehension undoubtedly gripped everyone. Their only knowledge was that they were headed for the Stock Yards, a dangerous place—maybe even a death trap. Just like Chief Horan making his way down Ashland, no one knew what they would find at the end of the run, or any other, for that matter. Finding no water was the last thing they needed.

Lacey and Burroughs found themselves in charge of a rapidly intensifying fire with no water to fight it. Their only logical access to the flames inside appeared to be through the freight house doors. Burroughs held off on smashing them open because he didn't want to feed oxygen to the fire without having water to suppress it. Someone finally located a Nelson Morris employee who could solve the problem. The man went to a company head house and opened a valve that activated the standpipes. The men of Engine 53, still poised near the service entrance, saw water begin to trickle from their hose. Even then, the flow became interrupted by air escaping from the rising water mains. When full pressure filled the hose, the men tried to enter Warehouse 7 through the service entrance, only to be greeted by fire and black smoke that drove them back. The delay in getting the water turned on was estimated at ten minutes. On the loading platform, meanwhile, Engine 59's pipemen waited anxiously for water to fill their hose. Obeying orders from Chief Lacey, the men of Truck 18 were furiously hacking away at a freight house door. Lacey wanted an opening large enough to attack the fire but small enough to limit the amount of air it would admit.

Few firemen knew the Stock Yards as well as Lacey and Burroughs, a pair of quarter-century veterans whose careers presented a nearly mirror image. Both in their late forties, they joined the department in 1885, less than six months apart, and worked their way up. "Their experience and tactical knowledge of combating fires in cold storage buildings was unsurpassed," according to fire historian and retired Chicago firefighter M.G. "Sully" Kolomay. Lacey was a young lieutenant in 1893 when he was dispatched to the Cold Storage Building fire at the World's Columbian Exposition. Burroughs was at the Iroquois Theatre Fire in 1903. "They knew too well of the dangers encountered when a large, windowless building was involved with fire," Kolomay noted. Adding to the potential dangers of Warehouse 7 was the suspected presence of ammonia and saltpeter, which were used in curing meat and highly explosive under fire conditions. Lacey and Burroughs had good reason to be cautious. Lacey knew the yards from an added perspective; he lived at 4506 South Emerald Avenue, one block east of its Halsted Street boundary.

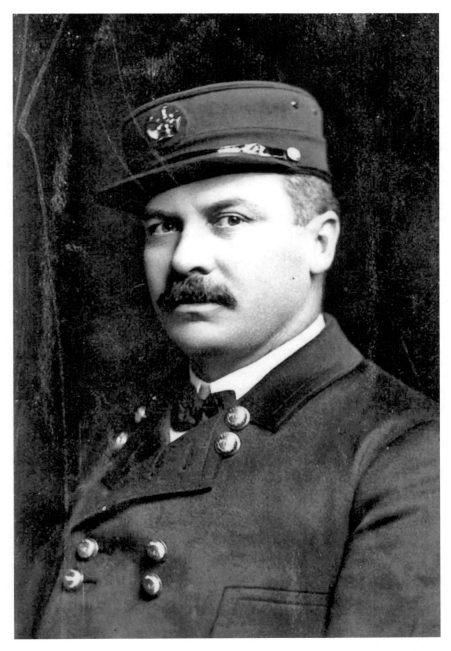

Second Assistant Fire Marshal William Burroughs, who issued a warning to Horan, his superior, to "stand down" a short time before Burroughs, Horan and twenty-two others were killed. *Courtesy of the Fire Museum of Greater Chicago.*

After much hard work, the men of Truck 18 succeeded in punching a hole in the freight door so that their comrades from Engine 59 could focus a stream of water on what appeared to be no more than a red glow inside. They were joined by Engine 39's pipemen, who got a second line on the fire after 18's men smashed through another portion of door. As more hose wagons arrived, firemen ran out of hydrants in the immediate vicinity. Water had to be relayed from a block or more away. When a third line was trained on the fire, water pressure in the small, antiquated mains dropped precipitously. Veteran firefighters displayed little surprise, as this represented one more fixable problem that those in authority hadn't gotten around to fixing for more than twenty years. Few city water mains had been installed to supplement the yards' reservoirs and artesian wells after municipal annexation in 1889. On the platform, one nozzle had to be turned off to retain pressure in the two other lines.

Logistics were proving as great, if not greater, a problem as water pressure. Freshly arriving companies had to lay more than six hundred feet of hose to draw water. Pipemen had to run hose between rail cars to reach the platform, where their colleagues were forced to operate from extremely tight quarters. With the canopy looming above, a long line of cars behind them and a wall of smoke and flame in front of them, all they could do was crouch low to avoid as much smoke as possible and try to advance through the openings in the door. Surely they had to understand their peril. The twenty-five-foot-wide canopy above the loading dock prevented ladders from being raised, making it impossible for firemen to force open the iron shutters covering the second-floor windows and release the pressure that was mounting inside.

Burroughs stood on the dock directing the operation while Lacey patrolled the perimeter of the building, returning periodically with updates. Each report grew worse. The fire continued to advance. Flames were now mixing with smoke shooting out from around the shuttered windows. The pressure was forcing smoke through the mortar joints of the massive brick walls. Worse, the fire was traveling above the first floor and threatening to climb all the way to the roof. At 4:42 a.m., thirty-three minutes into the battle, Burroughs ordered his driver to pull a 4-11 alarm. The fireman went to Box 2162 at Forty-third and Loomis to tap out the request using a telegraph key inside the box. The alarm went out to every fire station in the city. At Engine 103's house, Joe Mackey and Bill Moore prepared to pick up the chief and join the battle.

The department considered all fires in the Stock Yards critical at any hour of day or night. Whenever an alarm went out, companies in the vicinity of

the yards that didn't get called initially figured their turn would come soon. Their practice was to "hit the floor"—in other words, dress and hitch the horses to the rig so they could be out the door as soon as an extra alarm came in. Chief Burroughs's 4-11 (a combined 2-11 and 3-11) brought about a dozen more pieces of equipment and two battalion chiefs, the standard response for an extra.

After Horan, Mackey and Moore turned off Ashland and entered the Stock Yards at Forty-first Street, the chief made a mistake, according to Moore. Instead of having him turn south on Loomis, Horan sent driver Mackey one block too far east, to Packers, then south between Forty-third and Forty-fourth Streets. The chief's error seems difficult to understand since he knew or should have known that the alarm came from an ADT and/or city box near Forty-third and Loomis.

"I looked west," Moore related, "and told the chief that we were too far east, as I could see the fire west of us. He ordered Mackey to turn around and go north [on Packers] to 43rd Street and west to Loomis Street, which he did. The chief and Mackey ran south one half block to the fire. I hated to see the chief leave, as in my dreams I had a premonition that something was going to happen."

Like many a leader, Horan considered himself a perfectionist—a detail guy. Making a mistake like getting the coordinates of a major fire wrong, in the presence of two subordinates, no less, had to contribute to his growing ill humor. "We arrived at the fire about 5:05 a.m.," Moore continued. "Everything was dark with smoke and there was very little blaze or fire. I stayed with the machine about two minutes to put a robe on the cooling radiator to keep the water from freezing."

Big Jim actually came upon the fire scene at approximately 4:56 a.m. "Sunny Jim" was nowhere in sight. If Horan was aggravated about being roused from bed and taking a wrong turn, his ire increased tenfold as he sized up the battle. About fifteen engine companies were on the scene, but in his judgment, everything was going wrong. What had Lacey and Burroughs been doing? "Why isn't there more [water] pressure?" he wondered aloud as he and Mackey left the car in Moore's care. He had no way of knowing this early that there had been no water at all in the beginning.

"As we reached the south platform," Mackey recounted later, "the chief said to me, 'It's a wonder they wouldn't have those [rail] cars removed.'" Who did he mean by "they?" Lacey and Burroughs? Railroad people? All of the above? A directional mix-up, low pressure, rail cars in the way—now

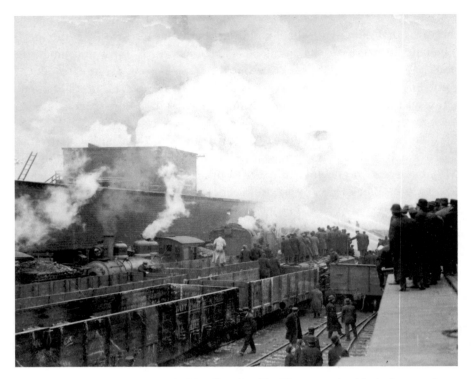

Loomis Street is shown congested with railroad traffic. The congestion blocked escape for some of those killed and injured when the east wall of Building 7 collapsed. *Chicago History Museum, #DN-0056340.*

an increasingly upset chief saw that only two freight house doors had been broken through and that after three-quarters of an hour the hoses had not been advanced to the seat of the fire.

What unfolded over the next ten minutes would spell life or death for dozens of firefighters as conflict between Horan and his top deputies at the fire burst into full view. Their words, actions, emotions, conflicts and nuances remain open to varying interpretations, including those of survivors who gave slightly differing accounts. In the face of crisis, the mind and memory can play tricks.

When Horan and Mackey arrived, they headed for the platform. "Where's Burroughs?" the chief demanded. Burroughs, already on the platform directing the fight, approached Horan and bowed, according to Mackey. The chief merely nodded in reply. What to make of the bow? A subtle insult? A sly way of suggesting it was about time he showed up? Or was it just a meaningless gesture?

A History of Flame and Folly in the Jungle

The two men discussed conditions until Horan decided to send Burroughs and Mackey to the top of the canopy for an overview while he tried to pinpoint the main body of the fire. Thinking better of the idea, the chief decided a walk-around by the pair would glean more intelligence. Just before Horan's arrival, Lacey had led several men into the basement of Warehouse 7 but found the smoke so thick they had to retreat. When Lacey emerged, he joined Horan and Burroughs on the platform. Lacey said the chief told him he wanted to go inside the burning building. "No, you can't," said Lacey. "I just came from there." The battalion chief warned his boss of the possibility that the structure had been weakened by the fire. Some accounts have Horan becoming livid, even accusing Lacey of cowardice. "Demeaning and unprofessional" is how Lacey's grandnephew, retired Schaumburg fire chief Edward Lacey, characterizes Horan's treatment of the two twenty-five-year veterans. Horan ordered Lacey to "get out of [his] sight" and sent him to the north end of the loading dock, where the chief wanted more doors battered down so additional lines could be put on the fire. Lacey later denied that Horan subjected him to harsh language but did disclose the chief's parting words: "I'll see you in a minute, Lacey." Depending on Horan's tone of voice, the remark could have been taken several ways. "I left Horan and Burroughs together," Lacey recounted. "They walked one way, I the other."

Bad blood may have preceded the confrontation between two men who traced their family roots to County Tipperary. Earlier in his career, the Cincinnati-born Lacey may have enjoyed a political advantage over Horan. According to Edward Lacey, the family maintained a friendship with Mayor Carter Harrison II, who may have helped Great-Uncle Martin win promotion after his career had stalled. Martin Lacey had been a captain for more than fourteen years before his elevation to battalion chief in April 1908. Harrison had been out of office for a year, supplanted by Mayor Busse, but still wielded considerable influence in civic affairs. Lacey's rise from lieutenant to captain had taken less than five years, most of the time while Harrison's father held the mayor's post. Whatever the Harrison-Lacey connection, if any, Horan received no favors from Harrison the younger, who bypassed him when he appointed William Musham chief fire marshal. For all but a ten-minute span early in the battle, Burroughs, not Lacey, had been in charge, so one is left to wonder why Horan vented most of his displeasure on the battalion chief and whether or not part of the answer lay in some previous differences.

When Burroughs and Mackey returned from inspecting Warehouse 7 from all sides, the lieutenant and three pipemen mounted the canopy with a

hose. Horan braved a cloud of smoke and disappeared into the building by himself to try once and for all to locate the main body of the fire. The chief's tunnel vision had clicked in; there was no stopping him. He was like Ahab preparing to dart the harpoon. He emerged and ordered Engine 59 to follow him into the building with their line. Mackey overheard Burroughs tell Horan, "You'd better stand down, Chief." Backing down was anathema to Horan. Burroughs might as well have told him to climb a tree. Horan ignored him and led Engine 59's crew into the warehouse with their charged line. They were forced to retreat to the platform moments later. At that instant, Captain H.J. Fuchs of Engine Company 29 appeared on the platform to report for assignment. Horan told him where to have his men run a line. Fuchs stepped away, and in his place came Lieutenant James Fitzgerald of Engine Company 23, also checking in. Fitzgerald's men were standing beyond the line of rail cars where "it looked dangerous from the top," according to Mackey. Horan personally led them by ladder over the cars and onto the platform. Mackey and the three pipemen had their line trained on the building from the top of the canopy when he decided they needed more help up there. He could see Horan, Burroughs and about eighteen firemen fighting the fire from below. About another dozen on the platform apparently escaped his view. Mackey said, "I told one of the pipemen to go down and tell Chief Horan to send me up a number of men."

Horan's other driver, Bill Moore, had spent the previous several minutes tending to the Buick's radiator. "When I started for the fire," Moore related, "I met [fire fan] Red Gallagher…telling me how he beat us in, coming from Van Buren and Hoyne Avenue in a taxi cab." Moore concluded the brief conversation, not realizing the delay had saved his life. His late arrival gave him a broad perspective of the danger confronting those who faced the fire up close. Standing between the two rows of rail cars, ready to join Horan and the others, Moore could see the precarious position they occupied, squeezed between the wall and the cars with escape possible only by running north or south along the platform. "At that time," Moore said, "the smoke that was pouring out of the small windows had become very dense, and there was no other opening above the windows." Pressure from the heat inside the warehouse was approaching the bursting point. Moore recalls:

I heard an awful grinding sound, and I knew the walls were loosening and quicker than it takes to tell it, a crash occurred. I was blown north by some terrific force, and when I had recuperated from the shock of my injuries, I looked back south and all I could see was dust and smoke with very little

fire. The canopy was pushed over the top of the freight cars, and I knew from the looks of things that every man who was underneath the canopy was killed or fatally injured.

Horan and the others never saw what hit them; the canopy had blocked their view. There was no warning, no escape, only a dull roar as the wall swayed back and forth like a drunk ready to take a tumble. Six stories of solid brick pushed out about ten feet and then dropped, straight down, with the swiftness and precision of a guillotine, spelling the end for twenty-one firemen, two watchmen and a teenage rail worker. The collapse left the entire front of Warehouse 7 exposed. The floors sagged and swayed but held, defying gusts of wind and flames that swept across them. Hundreds of casks of pickled meat rolled across the uneven floors to where a wall used to stand and then plunged onto the ruins below that had become the temporary graves of the firemen. The falling casks smashed against the rubble and disgorged their contents of salted ham and pork sides that now represented the temporary headstones.

Captain Fuchs, who had just left Horan and Fitzgerald on the platform, dodged a shower of bricks and timbers to escape untouched. Fuchs had experienced an equally narrow escape the previous Thanksgiving while fighting a fire at a Swift & Co. plant. "Providence must have given me a charmed life," he said. "Men are killed around me, yet I escape."

Lieutenant Charles Berkery, the only surviving member of Engine Company 59, said he was behind the men when the canopy fell. "Chief Horan was foremost," Berkery noted, as he was keeping everyone close to him as they tried to break down the doors. "None of us thought of the danger of the shed falling, and we believed we were safe on the platform. Suddenly, I heard a crash, and the shed came crushing down on the men. I was standing quite a distance behind the other men and the force of the shed's fall blew me from the platform and between two freight cars." Berkery, who could hear men groaning, was able to drag himself out and tell other firemen that "the boys had been imprisoned."

The pipeman Lieutenant Mackey had dispatched to bring more help hadn't started down from the canopy when the lieutenant heard "a dull roar from inside the building." Mackey recalls:

The shed shook like a piece of paper. The walls of the building seemed to be pushed toward us. Then suddenly, the wall separated into bricks. I shouted to the men below and at the same time ran back toward the other

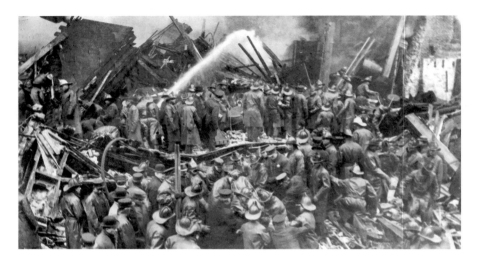

Firemen worked frantically to locate their missing comrades buried in the huge piles of rubble. *Courtesy of Sully Kolomay.*

end of the canopy. I heard the chief call, "Look out, men!" I looked toward him. He was lifted into the air, whirled around and then disappeared. I think he must have been killed instantly.

Moore was only thirty feet from Horan when the wall collapsed. He said he saw Mackey jump or get thrown into an empty coal car as the front of the warehouse caved in. "The wall fell at the southeast end of the shed," Mackey continued. "My being at the southern end was the only thing that saved my life." That and the canopy itself, which fell over the car, protecting Mackey from the cascading rubble. "My legs were caught under some bricks," he related, "[but] I managed to drag myself out. By the time I got free, the wreckage of the shed was in flames." Other firemen came to Mackey's aid and had him transported to a hospital. He spent three months recovering from his injuries.

After getting chastised by Horan, Chief Lacey said he hadn't taken more than a dozen steps along the platform when the collapse occurred. Lacey had a good view of the tragedy. Horan was up front, directing the pipemen's efforts against the flames with Burroughs and Fitzgerald standing back a short distance. "Suddenly, I heard a terrific explosion," Lacey recalled, "and the east wall crashed down on top of the canopy without the slightest warning. The chief and the others went down before my eyes. I saw them disappear under the bricks. I heard the men scream. The next moment, everything was

still." Lacey said Horan and Burroughs got buried on the spot he had just left. If the chief hadn't told him to get out of his sight, he no doubt would have suffered the same fate. Lacey and his driver did catch the fringe of the falling bricks. Flying wood and bricks felled both men. Lacey estimated that he lay unconscious for four or five minutes. When he recovered, he dragged another fireman who'd been struck by a brick to a safe place and then rushed toward the pile of debris where he'd seen Horan and the others go down. "I couldn't see any of the men who were buried; there was too much wreckage on top of them," Lacey noted. "To make matters worse, the broken timbers of the canopy caught fire and flames broke out over that awful pile. Within a few seconds, there was a crowd of firemen around the pile…to rescue the men, but the bricks were so hot it would be like picking up hot coals."

The fates that intervened to spare Bill Moore, Martin Lacey and H.J. Fuchs now smiled on First Assistant Fire Marshal Charles Seyferlich, last of the four senior officers to take command of the fire. Seyferlich arrived in the

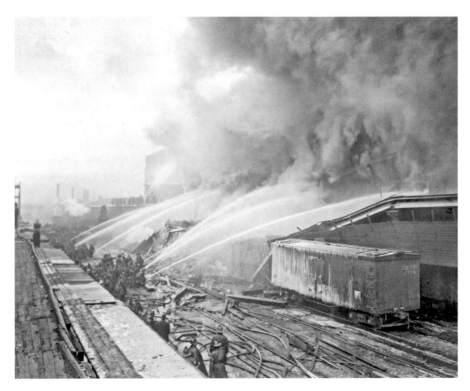

Despite the best efforts of the fire department, the flames spread into Building 6 and destroyed the structure. *Chicago History Museum, #DN-0056315.*

only mechanized vehicle besides Horan's 1906 Buick, a 1907 Apperson, the luxury make that Horan had wanted to buy before the salesman snubbed him. A fireman shouted, "The chief's beat you here this time!" Maybe the three-hundred-pounder smiled before he left the car to join Horan on the platform. Along the way, he passed a hose wagon whose wheel had become stuck in a railroad "frog," a device on intersecting tracks that permits wheels to cross. The driver was whipping the horse unmercifully, but the rig wouldn't budge. A horse lover like Horan, Seyferlich was appalled by the sight. He ordered the driver off the cart, took the reins himself and got the horse to back up, freeing the wheel. Seyferlich bawled out the driver for his stupidity and maltreatment of the animal, patted the horse on its sore flanks and then continued toward the platform. He heard the wall crumble but in the darkness didn't realize what had happened until he encountered Moore, still groggy after being thrown by the force of the collapse. Horan's driver was on his way to Box 2162 to send for more men and equipment to replenish the ranks and help search for buried victims. (No department apparatus was damaged during the fire.)

"When I regained my senses," Moore explained, "I looked back to where the chief [Horan] had stood and saw a mass of twisted timbers and piles of brick. They were caught under the avalanche of the collapse, as were all of the firemen who ran south. The men who ran north escaped." With one exception, the force of the collapse knocked every refrigerator car adjacent to the platform off the tracks onto their sides and sprinkled them with bricks and mortar. The car standing closest to Horan and Burroughs got crushed like a tin can.

Moore had retreated only about fifty feet when he crossed paths with Seyferlich, who shouted, "What happened?" When Moore explained, all the chief could muster was, "Oh, my God." He stood stunned by the twin realizations that Horan, Burroughs and who knew how many others were lost and that he too had come within moments of joining them. Freeing the hose cart from a rut and the horse from a beating had saved his life. Seyferlich composed himself quickly and told Moore to call for five more engines and three hook and ladder trucks. Then the now acting chief fire marshal headed toward the demolished warehouse wall as quickly as a man of his girth could move.

When Moore reached Box 2162, he followed Seyferlich's instructions, but he also did something that confused the people at the Englewood Fire Alarm Office. He signed off using code 1-2-2, Seyferlich's signature. Knowing the fire belonged to Horan, Englewood thought some mistake had occurred; the special should have been signed 1-2-1. The alarm office signaled Moore 4-3

to pick up a telephone and explain what was going on. But the downtown office already had sent the special call through using Horan's signature, not realizing that at 5:12 a.m., the time of the call, Horan, Burroughs and nineteen of their men lay beneath tons of rubble.

The fire alarm offices and the rest of Chicago learned of the tragedy soon enough. The manager of the Chicago Telephone Company reported that by 9:00 a.m., forty-five trunk lines leading to a city hall switchboard were swamped with calls, most intended for the fire marshal's office. By 11:00 a.m., the official estimated that calls were coming in at the astonishing rate of 200,000 an hour.

Burroughs had waited thirty-three minutes after the box alarm before he called for the 4-11. Seyferlich's first call for a special came just four minutes after the wall went down. He quickly followed up with two more calls, making three specials within a span of eight minutes, 5:12 to 5:20 a.m. A total of fourteen engines, three hook and ladders and four battalion chiefs responded. The new chief acted with good reason—conditions were growing worse by the minute. The collapse of the wall had opened up Warehouse 7 to a rush of fresh oxygen that fanned the flaming, grease-soaked wooden interior.

If Seyferlich had a moment to reflect, he could have considered how events might have turned out differently had he been at the scene five or ten minutes before disaster struck. The chief maintained a healthy respect for the potential of falling walls. In his obituary three and a half years later, the *Tribune* wrote:

> *He was never still when at a fire. He walked around the burning building shouting to his men, ordering, directing—swearing at them sometimes… and, above all, protecting them from the danger of falling walls. "Get back there you loons"—you could hear his voice carry above the roar of the flames, the pumping of the engines and the swish of water against the buildings. "Get back there. Don't you see that wall tremble?"*

Had Seyferlich been on the platform, would such a voice have been heard? If so, would Horan have heeded the older man—or ignored him as he did Lacey and Burroughs? Regardless of any "what ifs," the acting chief stepped in to take charge of a rampaging fire and hoped against all odds that rescuers might find life among the ruins.

Early rescue attempts netted four lucky survivors from the rubble, but the searing heat of the coals foreclosed any further efforts for nearly six hours. When the men went to pick up the bricks, they burned through their heavy

gloves and blistered their hands. "The firemen who rushed up to the brick pile...were powerless to aid the victims," acknowledged Third Assistant Marshal Thomas "Big Tom" O'Connor. "The flames that broke through the pile of bricks were so furious and the smoke so dense the pile could not be seen at times." Nor could some of the injured be seen because the dust and grime that covered them rendered them almost indistinguishable from the ruins. One such victim was Captain James McGrath of Engine Company 48, who suffered a fractured leg. In the early morning darkness, he became almost invisible to searchers for an extended period as he lay on the edge of the debris. Six pipemen—Edward Oehjer, Anthony Hyland, John Miller, John Kassenfock, Thomas Carney and Anthony Agilard—were hospitalized with serious injuries after they were struck by flying bricks. Many more on the fringe suffered cuts and bruises but were able to return to duty. Not so fortunate was Captain Alexander Lannon of Engine Company 50. He was one of the first to be pulled alive from the wreckage, but he failed to survive. Lannon died the next day in St. Bernard Hospital. He was the last of the twenty-four fatalities and the only one not killed outright. In the meantime, hours remained before the search of the main pile of debris could begin in earnest.

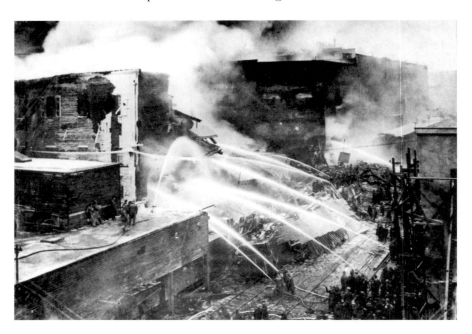

There were no hydrants on Loomis between West Forty-third and West Forty-fourth Streets. This forced firemen to use the few available hydrants along those two east–west streets to lead out hose over considerable distances. *Courtesy of the Chicago Fire Department.*

A History of Flame and Folly in the Jungle

Spirits rose, to the extent possible under the circumstances, when firemen were able to extinguish the blaze in the upper three stories of Warehouse 7. This small triumph, coming an hour and a half after the first special, raised the possibility that some of the building might be saved. However, hope was spiked by those old yards bogeymen: lack of water, low pressure and an inexhaustible menu of lard, fat and grease-soaked wood in the basement and first and second floors. Smoke seeping from the steel shuttered windows of Warehouse 6 offered the first evidence that the flames were heading north. When Seyferlich saw what was happening, he requested his fourth special call, at 6:50 a.m., and in its wake sent for a fifth special at 6:57 a.m. On the double came another ten engines, three hook and ladders and a battalion chief. Hope, no matter how faint, of rescuing men buried under the rubble superseded thoughts of fire suppression. Five times cadres of firemen plunged into the flaming rubble to search for victims—five times they were driven back.

The fire in Warehouse 6, stocked primarily with lard, was becoming markedly worse. Like its neighbor to the south, it featured no windows other than those covered by steel shutters. Smoke from smoldering grease filled the building, routing firemen who attempted to enter. Seyferlich ordered everyone to stay out. A gusty wind came up and threatened to carry the flames farther north, to Warehouse 5, and perhaps beyond. At 7:47 a.m., the acting chief called for another special, bringing nine more engines. The total of special calls had delivered thirty-three engines, six trucks and five chiefs, bringing the pieces of heavy apparatus engaged in the battle to fifty-two. Still, Seyferlich called for more reinforcements. At the 8:00 a.m. roll call throughout the city, two hundred firemen coming on shift were ordered to report to the fire any way they could get there—by streetcar, elevated train or taxi—to relieve the exhausted men on duty and help dig for victims. "This fire is beyond my control and is spreading," Seyferlich admitted. "Our water supply is inadequate for a fire this size and with the low pressure we have awful odds to overcome. The buildings here are merely firetraps and ready fuel for the flames."

With regard to the long-delayed attempt to search the rubble for fallen men, conditions were improving. The fresh troops who had ridden public transportation in full uniform arrived with a burst of vigor and enthusiasm. They delivered streams of water that finally began to cool the steaming rubble and permit an all-out search to begin—six hours after the wall collapsed. Before them stood a mound of bricks laced with broken timbers and twisted pipe, topped off by ruptured barrels of pickled meat and

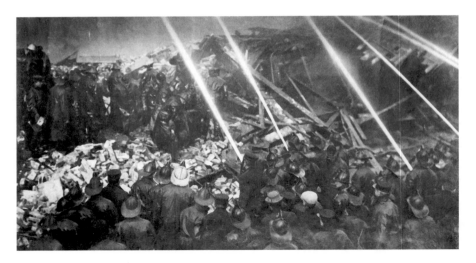

The flames, still raging nearby, had to be beaten back while the hunt for victims continued. The rescuers faced the threat of death or injury from further structural collapse. *Courtesy of Sully Kolomay.*

cured hams. A wrecking train belonging to the Chicago & Eastern Indiana Railroad was already at work clearing away wreckage on the tracks. The wrecker shoved the ruins of freight and refrigerator cars to one side in hopes of finding any firemen underneath who might have been protected from the crushing weight of the bricks and mortar. Rail workers attached chains running from a derrick to the heaviest parts of the wreckage. As the hulks were lifted, firemen dug in to remove loose bricks and other debris. Fellow railroad men tunneled under the tracks to create pathways for firefighters to run lines without obstructing the movements of the wrecking train. A separate intervention by rail resulted in failure. Two engines were brought in to remove the refrigerator cars that had been knocked on their sides and partially buried. The cars refused to budge, but some fifty firefighters scampered over them anyway and attacked the pile like men possessed. Some heaved bricks back toward the tracks, while others formed a variation of a bucket brigade and passed them hand to hand. Still others put their shoulders to the largest protruding beams and pushed them out of the way. Within minutes, the searchers discovered the helmet of Chief Burroughs, along with that of an unidentified fireman. The chief's helmet had been blown a considerable distance from where he fell.

Bodies of the firemen stationed at the north end of the platform, farthest from the main impact, were discovered early in the operation. The first body was that of Captain Patrick Collins, age forty-seven, of

A History of Flame and Folly in the Jungle

Engine Company 59, one of the first two units to arrive. Collins had been directing the approach through the third, or northernmost, freight door opening, with Horan and Burroughs in charge of the two doors to the south. Near Collins's body were found those of Pipeman George Murawski, thirty-seven, of Engine 49, who left a wife and four-month-old baby; Truckman Charles Moore, twenty-nine, married and the father of a two-year-old; and his partner on Hook and Ladder 18, Nicholas Crane, age thirty-four, married with no children. The fifth body uncovered was that of Chief Burroughs. Firemen instinctively stopped work, removed their helmets and bowed their heads as the fallen chief's body was borne by stretcher down the flooded railroad tracks, over the network of hoses and under rolling clouds of smoke. Then the digging resumed.

That Collins, Burroughs and Horan had been out front came as no surprise to anyone familiar with the Chicago Fire Department. Of the twenty-one victims, ten were officers, men who led—not simply ordered—their troops

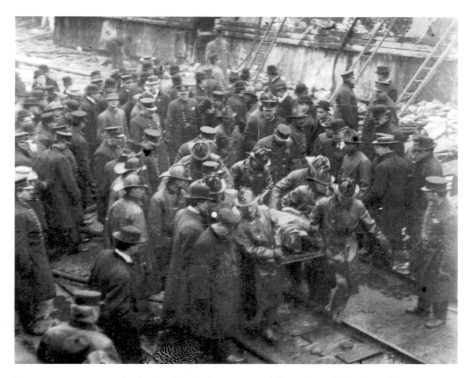

Firemen carry away the body of a victim recovered from the rubble. It took approximately seventeen hours to remove all the bodies of the dead firemen. *Chicago History Museum, #DN-0056306.*

into battle. Another example of egalitarianism could be found in the way losses were apportioned. Excluding Horan and Burroughs, the remaining nineteen department victims represented ten separate companies. Seven of the ten lost an officer; four lost only an officer. Hook and Ladder 11 suffered the heaviest toll. All but one member of the seven-man crew, the driver who remained with the horses, lost their lives. Truck 11's commanding officer, Lieutenant Herman Brandenburg, forty-one, was supposed to be off. He'd traded days so he could be free on Christmas. Fireman Bill Brown was spending a scheduled day off. The next bodies uncovered were those of thirty-four-year-old William Weber, driver of Engine 59, and an unidentified victim. Weber, his wife, Margaret, and their three children had just moved into a new home at Seventy-second and Morgan and were preparing to celebrate Christmas there.

After these latest bodies were removed, Seyferlich warned the rescue parties to stop digging because of the danger of more falling walls, but many of the men pretended that they didn't hear the command. Crews operating the wrecking train did heed the warning and moved to a different location. The chief's intuition proved accurate. The remaining floors and south wall of Warehouse 7 gave way, but fortunately for the men of Engine Company 103, the floors went first. At the sound of the falling floors, the firemen, under the command of Captain Anthony McDonald, dropped the hose they were training on an opening in the wall and dashed for cover under a string of boxcars immediately behind them. They'd been standing within twenty feet of the collapsed wall, which dumped ten feet of masonry on the hose they were holding. No one needed to be convinced that a pause in the digging would be wise. It was shortly before noon. When the search resumed, rescuers discovered the body of forty-six-year-old Lieutenant William Sturm of Engine Company 61. Found near Sturm, who was married with one child, was a body later identified as that of sixteen-year-old Steven Leen, a yard clerk for the railroad who had interrupted his task of posting notices on cars to watch the firefighters on the platform.

All day long the scenes were reenacted. The work was becoming more difficult as the rescue parties probed ever deeper. The body of Andrew Dzurman, twenty-nine, one of the Nelson Morris watchmen/firemen, was found next, and close to him was thirty-one-year-old pipeman George Enthof of Engine Company 23, sole supporter of ailing parents. The eleventh victim was Thomas Costello, thirty-four, pipeman of Engine Company 29. Costello was married and the father of one. Red Cross workers addressed the grim detail of carrying away the bodies on stretchers and placing them

in ambulances for the trip to the funeral home that was serving as a morgue. The attendants had to navigate boards placed over the rubble, which had been made slippery by thousands of pounds of fallen meat. By this point, the recovery teams were discerning a pattern. Although badly broken and disfigured, the victims had not been burned. Many were discovered with their arms across their faces in a futile attempt to protect against a force that could not be repelled.

Every man who could be spared from fighting the fire was put to work searching the ruins. About fifteen minutes after Costello's body was dug out, searchers made a discovery that turned Seyferlich's normally booming voice hoarse. As the chief summoned the stretcher-bearers back across the hill of boards and spilled meat, someone asked, "Who is it?" "It's Nick Doyle," came the reply.

A hush fell over the assemblage. Truckman Nicholas Doyle of Hook and Ladder 11, which had been wiped out except for one survivor, was only twenty-five—the youngest victim. He'd been a fireman for little more than three years. Doubly tragic, Nick Doyle was the son of Captain Dennis Doyle of Engine Company 39, who almost certainly lay somewhere else in the rubble. The captain's body had yet to be discovered, but it was known that he was standing near Chief Horan when the wall fell. Onlookers realized that the wall had claimed two generations. The body of thirty-four-year-old Albert Moriarity, Nick Doyle's sidekick on Hook and Ladder 11 and the married father of one, was discovered next. Moriarity had been looking forward to a family reunion at his parents' home. All were excited about the return of Al's brother, George, a rising star in the Detroit Tigers organization who had been playing winter ball in Cuba. George was planning to give Al several boxes of Cuban cigars.

Lips bleeding, his face caked with grime, worn out and soaking wet, Seyferlich again found himself forced to turn away from the fallen and focus his attention on the fire in Warehouse 6. He knew that flames seethed within and that the floors, holding thousands of pounds of meat, had collapsed. A second-floor door presented the only opening, and for hours firemen had used it as their sole entry point for a continuous stream of water. The rest of Building 6's exterior, however, remained tightly sealed. Seyferlich felt satisfied to keep the flames contained so they wouldn't spread to adjoining Building 5, the slaughterhouse. But the fire demonstrated a will of its own and advanced in the opposite direction, back toward the crumpled remains of Warehouse 7. Tongues of flame shot through crevices that surrounded a bricked-up door or large window that once stood flush against the fire

wall shared with the building. When streams of water failed to douse the escaping blaze, firemen got a sense of the buildup inside. Heightening their concerns, smoke began curling around every shuttered window and rising from the center of the building, indicating that the fire had eaten its way to the roof and was threatening to blast through. Seyferlich decided to make a risky move. He ordered about twenty firemen to the roof of Number 6 with instructions to chop holes in four spots so hoses could be trained down on the flames. "We must take our chances," the chief determined. Suffocating smoke, whipped by a south wind, greatly complicated the task of the firemen. Seyferlich felt himself in a quandary. "My men can't stand it on top of that building much longer if the wind doesn't shift," he observed. "Yet that building is now the danger spot. If the walls should fall or if we opened up the doors in order to get at the fire, the flames would burst out with such terrific force that I fear they could not be controlled. Then everything would go." Police formed lines to push back crowds of spectators, but work went on undaunted for firemen searching the ruins and those pouring water on Warehouse 6 from the ground and roof.

Lieutenant Herman Brandenburg, the commander of Truck 11 who was supposed to have the day off, became the fourteenth victim taken from the rubble. After him came a body so mangled that it could not be identified immediately. The deceased turned out to be one of Brandenburg's men, Truckman Edward Schonsett, the second-youngest fireman to perish. He turned twenty-seven that day. On Christmas Eve, Schonsett and his wife would have celebrated their third wedding anniversary. They had one child.

Of the thousands of spectators who gathered, Mayor Fred Busse, Horan's boyhood friend, came from farthest away. The mayor received word of the tragedy as he returned from visiting a friend in Fort Leavenworth, Kansas. A *Daily News* reporter who boarded the train at Western Avenue broke the news. The mayor wept silently as he gazed out the window. He had just finished reading a newspaper story about a leather factory fire in Philadelphia that had killed thirteen firemen and one police officer when the five-story building collapsed. Busse said he found himself hoping that nothing of the sort would ever happen in Chicago. Following a quick stop at home to don warmer clothes, Busse was whisked across town in his car to the recovery scene, where he joined at least seven city officials and an informal delegation of packinghouse representatives. The packers' group included Nelson Morris president Edward Morris and his wife and two sons, J. Ogden Armour and Charles and Edward Swift. "It was an awful catastrophe," the mayor commented. "I am simply heartbroken over it all. Jim Horan and I

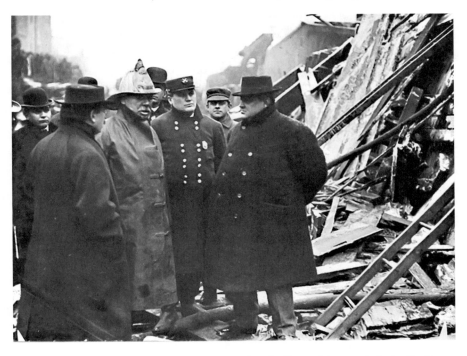

Mayor Fred Busse (right) receives a report regarding the fire and the search for bodies from First Deputy Fire Marshal Charles Seyferlich (pictured in the white helmet). Seyferlich's brother, Arthur, chief of the Second Battalion, stands between the two men. *Courtesy of the Fire Museum of Greater Chicago.*

had known one another since he was a boy five years old, and no man did I admire more than him. He was a firefighter through and through and a man that was a man."

The dignitaries were mingling with firemen closest to the blaze at the point when the remaining floors and south wall of Warehouse 7 collapsed. The lard repository in the basement of Building 6 issued a series of muffled explosions. Chief Seyferlich urged the civilians to move back. The mayor did so, haltingly, as he imparted some better-late-than-never wisdom: "Enough lives have been lost," he asserted. "I want no more risks taken to save a few dollars worth of property. All the men must be kept far enough away to be out of danger of falling walls."

After watching the fire for two hours, Busse left to console Margaret Horan and her children before attending to business at his office. He vowed to return to the fire scene and "stay there until they [took] Jim's body out." When he came back, the mayor stood in the cold and slush for the rest of the day, left to preside at a special city council meeting he'd called and

then returned once more. Edward Morris Sr. also maintained a lengthy vigil, standing as close to the spot where Horan fell as flames would allow. "It's awful, fearful, horrible," he said with obvious anguish. "We can replace buildings, but loved ones once removed cannot be replaced. I want to extend my deepest sympathies to all the families of the men who were killed. Chief Horan and Assistant Chief Burroughs were friends of mine. I considered Chief Horan one of the bravest and best firemen who ever lived."

Until all the bodies had been removed, families of firemen were held in the grip of agonizing tension. Some maintained vigils; others awaited word at home. Rumors abounded. "It can't be!" or "It's not possible!" are typical reactions to tragic news of a loved one. Mary Lacey reacted that way when she received word that her husband remained alive and barely unscathed. She refused to believe the *good* news. Following his hairbreadth escape, Chief Lacey dispatched an emissary to call on his wife and assure her of his safety. Mrs. Lacey was having none of it. She felt certain the fireman was trying to deceive her to soften the blow. The man eventually gave up in frustration and returned to the fire, leaving Mrs. Lacey sobbing. Inexplicably, someone called the Laceys' daughter, Nell, and told her that her father had been killed. The younger woman refused to believe this news. She rushed to the scene and wandered among the firemen until she found her father. She threw her arms around him and burst into tears, then returned home to tell her mother some news she *would* believe.

Similar joy eluded the family of forty-six-year-old Edward Danis, lieutenant of Engine Company 61. He became the sixteenth and last victim reached before Seyferlich decided to pull back the searchers. With the early darkness of a late December day coming on, smoke from the burning debris increased and was whipped into the faces of the digging crews by the strong south wind. Seyferlich and the men considered the heavier smoke just one more aggravation, even as flames from the rubble rose higher. Men dressed in black-rubber uniform coats cast shadows as they moved against the backdrop of the glowing fire. Here and there, lanterns flickered through the smoke like fireflies. The winter solstice had just passed, and one of the longest nights of the year was upon them. Dawn must have seemed an eternity away. But more than the Stygian landscape forced Seyferlich's hand. Warehouse 6 could no longer hold the pressure that had long been building inside. Flames from the fire-ravaged interior finally burst through the roof as if by explosion, leaping fifty to one hundred feet in the air. Firemen stationed at the north end of the roof narrowly escaped being struck by flying wreckage and clambered down ladders built into the walls. The chief re-deployed companies that

were still pouring water on smoldering Warehouse 7. Even with the extra punch, firemen were able to get only one line to play on the roof, and its impact proved negligible. Six additional streams reached only halfway up. For now, the walls remained standing, but for how long? Digging crews were still at work almost directly under the southeast corner of Building 6 when Seyferlich ordered them to a place of safety.

Half an hour went by. The chief reconsidered his strategy. All around him he saw men made weary by fighting to save buildings whose contents lay across the rubble that still concealed the bodies of Chief Horan and five other firemen. Again and again, Seyferlich watched exhausted firefighters take a few steps back and grab a moment's rest by leaning against a freight car on the east side of Loomis. Most of the men had been at their task for twelve or fourteen hours or longer. The chief himself, his face blackened and voice nearly gone, ignored suggestions that he take a break. He would shake his head and point to the flames shooting out of Number 6 and menacing Number 5 next door. The firemen had to envy their brothers in blue who'd been on duty all day. They were being relieved for the night by fellow officers. At this juncture, Seyferlich moved the search party a little farther south, away from the looming hazard of the Building 6 walls. This probe located the body of Chief Horan.

An already dismal scene gathered more gloom. Snow on the ground had long since turned to slush, blackened by smoke from the fire, the residue of burned timbers and cinders spewing from the fleet of assembled fire engines. Huge chunks of ice, formed from the continuous streams of water, took their places on the ground, along with the bricks, beams and other remnants of Warehouse 7's east wall. Hovering over everything were the flames leaping from Building 6, as if mocking the tiny specks of light from the lanterns and the men who held them.

Horan's body appeared less disfigured than any of the preceding sixteen. He was found in a sitting position, facing the fire, pinned down by two heavy timbers. His unmarked face was buried in folded arms that rested on a knee. The men who found the chief's body placed it on a stretcher, covered it with a black rubber poncho and carried it two blocks to a waiting ambulance. Accompanying the body was the chief's brother, Daniel, an undertaker, who took it to his funeral parlor at 307 East Sixty-first Street. Most other victims were taken to the morgue established at McInerney undertakers, close to the fire scene at 650 West Forty-third Street. McInerney's was a long-standing Canaryville institution and perhaps the only funeral establishment honored with a poem. (The opening stanza reads: "Pull down the shade and call

McInerney; I'm nearing the end of my life's pleasant journey.") Like Mayor Busse, Daniel Horan had stood most of the day in the cold waiting for the recovery. He wept when he arrived at the scene. The mayor interrupted his vigil for a bite to eat and missed the discovery of the chief's body.

Chief Seyferlich's primary concern as December 22 moved into its final hours centered on the potential spread of fire from Warehouse 6 to Number 5. Companies continued to drench the north end of Number 6 and south end of Number 5, which stood separated only by a fire wall. In the meantime, a second threat materialized when the flames from Building 6 jumped Loomis and attacked the roof of the Armour plant across the street. Luckily, a stream from one engine and the stomping feet of a platoon of workers proved sufficient to end the danger.

Nearing midnight, the recovery crews extricated the body of Lieutenant Fitzgerald, thirty-three, a task that required nearly half an hour because of the body's precarious position in a doorway. Rescuers speculated that Fitzgerald might have survived to see his wedding day if he'd taken a few steps backward to a safe spot where timbers had lodged overhead and deflected the falling bricks. The bodies of men from the two hardest-hit companies were found next. Close to one another lay truckmen Michael McInerney (no relation to the funeral home family), thirty-two, who left a wife and three children, and thirty-four-year-old Peter Powers of Hook and Ladder 11, a married father of two. Pipeman Frank Walters, forty-six, of Engine 59, whose father fought the Great Chicago Fire, was also found nearby. The younger Walters was married with no children. The body of Nelson Morris watchman/fireman Patrick Reaph, twenty-three, was discovered later.

About 1:00 a.m. on Friday, December 23, Chief Seyferlich's sixty-year-old body demanded a respite after twenty hours of anguishing work in the cold and without food. Exhausted, he reluctantly left the scene for a few hours of rest and, no doubt, a hot meal. Perhaps he slept in his Apperson as he was driven across town to his home at 714 North LaSalle Street, about eight miles northeast of the fire scene. While he was away, with Fourth Assistant Marshal Patrick Donohue in charge, tragedy nearly struck again. The east wall of Warehouse 6, which thus far had resisted the intense pressure from within, finally gave way. Members of Engine Companies 24 and 104 were standing close by. The latter unit was headed by Captain Michael Corrigan, whom Horan had visited hours before the fire. Unlike Horan, whose view was blocked when Number 7's east wall fell, Donohue spotted this one buckling and yelled, "Look out, men! The walls!" His warning provided just enough time for the endangered firemen to scramble out of the way as

one more avalanche of ruins fell perilously close by. One man was hit by a flying plank but not incapacitated. A short while later, another section of the same wall fell, causing non-life-threatening injuries to three firefighters. Whether Seyferlich would have allowed the men to get that close to the walls is debatable. There is no record of him saying anything later to Donohue about these brushes with death.

Seyferlich returned to take command sometime after 5:00 a.m. The breather had been short, but his men greeted him with the good news that they had finally turned the corner in their battle against Warehouse 6. For hours, it had seemed that they were making no progress at all. But the collapse of the east wall allowed them to get dozens of streams on the raging blaze, limiting its attack on the fire wall that separated Building 6 from 5. The chief declared the fire struck out at 6:37 a.m., more than twenty-six hours after the first alarm. Seyferlich wasn't the only one who enjoyed a much-needed break in the waning hours of the fight. Men who had been working as long as the acting chief were divided into small squads and allowed to take turns going home for five hours at a time before reporting back. To give the overworked men an added break, Mayor Busse brought in 150 city laborers as replacements on the search teams. The fire may have been struck out, but more work lay ahead.

Only one body remained to be recovered, that of Captain Dennis Doyle. He was reunited in death with his son, Nick, at Frank W. King undertakers, 3604 South State Street, early Friday afternoon. Recovery of all twenty-three bodies had taken approximately seventeen hours. (The remaining victim, Captain Lannon, died in the hospital.) Thirty-four firemen had been injured. Warehouse 5 had been saved, but 6 and 7 continued to smolder for several more days. Firemen kept a dozen lines trained on the wreckage while the search went on for potential civilian victims. No more bodies were located, but members of Engine Company 14 uncovered the eagle and plate shield of Chief Horan's helmet. Seyferlich ordered it taken to the marshal's office for safekeeping. Meanwhile, the financial loss to Nelson Morris & Co. was put at $500,000, nearly all of it covered by insurance.

A CITY IN MOURNING

No matter the hour, Margaret Horan never slept while her husband was fighting a fire. Her practice was to call his headquarters frequently, asking for news of him. The men left behind on duty came to expect the calls. About 7:30 a.m. on December 22, three hours or so after the chief had left for the Nelson Morris fire, Mrs. Horan didn't have to initiate the call; it came for her, revealing that her husband was missing and possibly dead. Her agonizing wait for confirmation was worsened by the best of intentions. Mrs. Horan's sister and brother-in-law, Mr. and Mrs. Walter Aylward, arrived at the Horan residence. The Aylwards knew the truth, but they didn't have the heart to tell Margaret, despite her pleas for an honest answer. The unpleasant task fell to another couple, Battalion Chief Edward McGurn and his wife. A lifelong friend of Big Jim's, McGurn freely admitted to a reporter present that he'd rather "be out in the biggest sort of fire" than comfort a grieving widow. A teary-eyed McGurn made an early exit, leaving most of the comforting to his wife and Jim's eighteen-year-old daughter, Marguerite, who embraced her stepmother as they wept together. The younger children, three-year-old William and two-year-old Ella, seemed to understand that something bad had happened to Daddy. They cried, too, as they clutched their mother's skirt. Horan's twenty-one-year-old son, James, had left for work before the news arrived. Margaret Horan had been ill for several months and was now confined to bed and placed in the care of a doctor.

Even more wrenching scenes were unfolding at McInerney's. Family members and friends crowded into the establishment on West Forty-third Street for a glimpse of their loved ones. In most cases, the bodies were in such bad condition that police wouldn't allow anyone to view them. Several people would not be deterred. Margaret Weber, widow of Engine 59's driver, was the first to arrive. She was accompanied by her three children, ages six, eight and ten. "Let me see William," she begged. A mortuary official gently but firmly told her that wouldn't be possible but confirmed that her husband had been positively identified. Mrs. Weber became hysterical and had to be led out of the building with her face in her hands.

The heartbreak of losing an only son drove Mrs. Mary Leen to struggle with two police officers who prevented her from entering the room where the body of sixteen-year-old Steven lay. "Why weren't the police there to keep people away from the burning building?" she demanded to know. "My boy had worked all night about the railroad yards, and I suppose he was all tired out. He was my only boy, my only boy." Officers finally escorted Mrs. Leen to the exit, but she returned later and entered through a side door. This time she was taken to the McInerney home above the funeral establishment and given something to help compose herself. Mrs. Belle Burroughs, widow of the assistant chief, was so overcome that she was unable to go to the funeral parlor. Burroughs's cousin, Captain Charles Becker of Engine Company 52, identified the body and took charge of the arrangements.

A pall descended upon the city like a blanket of soot over the Stock Yards, not enough to smother the spirit of Christmas but sufficient to intrude. Memories of the Iroquois Theatre fire only seven years before remained fresh. On the surface, it looked just like any other Christmas in the city. As usual, procrastinators turned out in force on the day before, encouraged by newspaper ads declaring, "It is not too late!" and "Open tonight as late as necessary!" State Street merchants enjoyed brisk business, while some companies closed at noon. With the holiday falling on Sunday, a number of businesses, as well as non-emergency government operations, would remain closed until Tuesday. But beneath the tinsel and glitter, the merriment and the reward of an extra day off for some, there lurked the specter of death and the knowledge that profound grief would supplant the joy of the season in many homes.

It seemed as though the funerals would never end. For four consecutive days they went on, beginning on Christmas Eve, each service a fresh reminder of the worst night experienced by any fire department. The deceased firemen were called heroes; the papers continually referred to

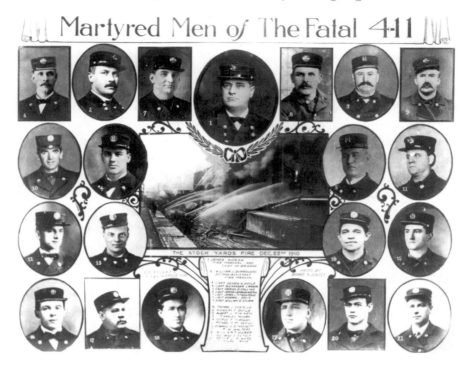

A Chicago newspaper published this tribute to the members of the fire department killed on December 22, 1910. *Courtesy of the Chicago Fire Department.*

them as such while lauding their self-sacrifice and devotion to duty. Some eulogies employed the term martyrs, faithful public servants who laid down their lives for a greater good.

The first of the victims laid to rest was the fireman whose body was discovered first—Captain Patrick Collins of Engine Company 50. On Saturday morning, December 24, an honor guard of more than one hundred firefighters accompanied the body from the Collins residence at 5605 South Drexel Avenue to St. Thomas the Apostle Church at Fifty-fifth and Kimbark. The funeral Mass was offered by Father Maurice Dorney, the outspoken pastor of St. Gabriel's parish in Canaryville. Father Dorney, a longtime friend of the Collins and Horan families, was a vocal critic of inadequate water supplies in the neighborhood. "I knew Jimmy Horan and Captain Collins when we were kids on the street," the priest told the mourners. "Captain Collins followed his commanding officer and died… [he] was a martyr to the duties he knew and filled." Collins was buried at Mount Olivet Cemetery southwest of the city.

That afternoon, a procession led by fifty mounted police and more than two hundred firemen accompanied the body of Assistant Fire Marshal William Burroughs from the family home at 4019 South Michigan Avenue to Medinah Temple, immediately north of downtown, where he was accorded full Masonic rites. More than eight hundred mourners attended the service, with another four hundred left standing outside. Mayor Busse, nearly every member of the city council and dozens of other city officials witnessed the ritualistic ceremonies. Burroughs's widow, Belle, and their only child, eleven-year-old Helen, occupied seats near the casket, where Mrs. Burroughs appeared on the verge of collapse. Following the ceremonies, it was announced that friends would be allowed to view the body. Everyone in the temple, plus those waiting outside, passed by the casket before it was closed and placed in the hearse for the journey to Graceland Cemetery on the North Side.

One additional victim, sixteen-year-old railroad worker Steven Leen, was buried on December 24. The families of nine others—eight firemen and one Nelson Morris employee—elected to bury their dead on Christmas Day. The deceased included: Lieutenants Edward Danis and Herman Brandenburg; Pipemen Frank Walters and George Enthof; Truckmen Albert Moriarity, Nicholas Crane and Charles Moore; Driver William Weber; and Nelson Morris watchman Patrick Reaph. The majority were laid to rest the day after Christmas. In addition to Chief Horan and the Doyles, father and son, these men were: Lieutenants James Fitzgerald and William Sturm; Pipemen George Murawski and Thomas Costello; Truckmen Michael McInerney, Peter Powers and Edward Schonsett; and watchman Andrew Dzurman. Last to be buried, on December 27, was the last man to die, the fatally injured Captain Alexander Lannon.

Separate funeral services were conducted for Captain Dennis Doyle and his son, Nicholas. Mass for the younger Doyle was said at 9:00 a.m. at St. Bridget's Church, 2924 South Archer Avenue. Afterward, a procession bore the body to neighboring Our Lady of Good Counsel Church, 3528 South Hermitage Avenue, where the caskets were placed side by side at a 10:00 a.m. Mass for Captain Doyle. Father and son then followed Pat Collins to Mount Olivet, where the Doyles received a joint burial.

Chicago must have felt that a little bit of itself died with Big Jim Horan. That's one way to explain the heartfelt homage accorded the man by thousands who turned out on a cold day, scarcely before the Christmas presents had been put away. In many regards, Horan personified the city, or at least the way the city would have liked to think of itself—big; strong;

fearless; proud yet unpretentious; dedicated to family, friends and church; comfortable with civic leaders as well as everyday folk; a lover of sports, especially baseball; a neighborhood guy who never forgot where he came from; and a son of immigrants in a town populated with immigrants. He was born and raised in Chicago and proud of it.

Chicago may have staged more lavish outpourings on behalf of a departed dignitary. For one, the huge official tribute to President McKinley, following his assassination, eclipsed the salute to Chief Horan. That turnout honored a fallen leader, it's true, but few Chicagoans knew the president personally. Many who lined the streets for Big Jim did know him personally, and even those who didn't considered him someone they felt they knew. Hours before the funeral procession was to start, thousands gathered in the streets around the Horan residence at 722 South Ashland Boulevard with nothing but their clothing to keep them warm. They stood silently and respectfully as the chief's body was brought from the house to a waiting hose cart. A squadron of mounted police led the procession that would travel some three miles, mainly east, to Holy Name Cathedral, seat of the Archdiocese of Chicago. The mounted officers were followed by the police brass, more policemen on foot and a solemn marching band. Some 2,500 members of the Knights of Columbus came out to honor one of their own. Dark formal uniforms topped by cocked hats sprouting white ruffles adorned the first 500 KCs, those of the elite Fourth Degree. Honorary pallbearers, one chosen from each of the city's 117 engine companies and 34 truck companies, surrounded the simple hose cart bearing the casket. Black draperies covered the vehicle, with Horan's white helmet resting on top. Horan's 1906 Buick, a symbol of his foresight and reminder of his death, followed the hose wagon. The auto that took him to his last fire carried the man who drove him there and almost paid with his own life—Lieutenant Joe Mackey. As if leading the past into the future, the Buick preceded more than one hundred horse-drawn carriages, one containing Margaret Horan and her family.

The procession made its way along Ashland over to Jackson, east to State and then to the cathedral at State and Superior Streets, where another enormous crowd had been waiting for hours. Marchers were still falling into line back on Ashland when the cathedral doors swung open. Police had kept the doors closed until the cortege arrived. They admitted as many as the limestone church would hold before shutting the entrance again, leaving the majority of the throng outside. Archbishop James Quigley, surrounded by more than fifty priests, offered the requiem High Mass. The eulogy was preached by Father Peter O'Callaghan of St. Mary's Church, who praised

Horan as an exemplar of Catholic manhood, true to friends, associates and, above all, his wife and family—"brave yet tender, daring but not rash." He died defending the city in which he was born, said the priest.

Following the service, Joe Mackey, still recovering from his injuries, took the chief for one final ride. The lieutenant drove a horse-drawn rig bearing the casket on its long trip to Horan's final resting place, Calvary Cemetery in Evanston. The procession that followed stretched for more than three miles.

Many who couldn't attend the funerals sent condolences by wire. Horan was known and liked by nearly every fire chief in the nation. Hundreds of telegrams offering sympathy for the victims poured in. Some were directed to Margaret Horan or the families of other firemen; others expressed more general grief to the city or fire department. Messages arrived from nearly every large city in the United States and Canada, and the fire master of London expressed his sympathy. Once more Chicago had been defined by fire.

Coroner Peter Hoffman, whose higher education consisted of a stint at a Chicago business college, began mapping plans for the inquest before the sixteenth body had been recovered. Hoffman and a deputy arrived at the scene about mid-morning, shortly after Chief Seyferlich had transmitted his final call for a special alarm. A one-time Republican Cook County board member from Des Plaines, the coroner selected a jury within fifteen minutes of his arrival. According to the *Daily News*, the jurors were "taken from the spectators less than 100 feet from the pile of bricks in which the bodies of the victims were buried." This account makes the jury selection process seem random, almost haphazard, with Hoffman looking around and saying, "OK…you, you and you." The drill sounded reminiscent of the way the old fire wardens used to choose civilian "volunteer" firefighters in the 1830s.

A look at the backgrounds of the chosen six suggests a colossal coincidence—or maybe a premeditated plan. This was no cross section of ordinary gawkers at a fire. Five of the six were prominent Chicago businessmen who were personally acquainted with Chief Horan and one another, while four belonged to an unofficial club of "fire fans," for whom attending fires offered a type of sport. The ranks of the club included millionaires who would leave home at any hour of night any time of the year to attend a major fire—"the bigger and hotter the better"—for the fun of it. A *Tribune* feature in August 1909 described a typical "fan" being driven by his chauffeur at top speed to the scene of a fire where he "takes up a good position, lights a cigar and proceeds to watch the flames and firemen do battle." The dash to a blaze seemed to mirror that of a senior

fire officer—like Horan or Seyferlich being driven to Nelson Morris—except the fire chiefs obviously weren't making the urgent trip for fun. Bragging rights became part of the fans' game—who got to a fire before whom, who did (or did not) turn out in bad weather, who attended the most fires, etc. Sometimes the chauffeur-driven enthusiasts would beat the firemen to the scene because they received practically the same notification. No matter what time of night or early morning (they rarely interrupted the business day), a fan could expect a call at home from a friend in the fire alarm office alerting him to "a good fire." With that, the man would dress as quickly as any fireman, call and expect the chauffeur to do the same and transform himself from a staid, middle-aged businessman into a "superfan." Horan was sympathetic, perhaps even amused. "The sound of the gongs turns 'em back to boyhood," the chief believed. "There's something about the flames and the clatter of the apparatus and all the excitement that appeals to the adventurous spirit that's in the heart of every true kid. A big fire is an exciting affair, and the more excitement the more fun there is for the fan." The chief had no problem with fire alarm personnel retaining the home telephone numbers of the fans and giving them a call whenever something big was up. Whether or not any fans left something in the Christmas stockings of their fire alarm friends can only be guessed at.

In Horan's estimation and by general consensus, Albert W. Goodrich reigned as the champion fire fan. The millionaire socialite owned the Goodrich Transportation Company, the largest steamship line on the Great Lakes. From 1927 to 1931, Goodrich would serve as Chicago's civilian fire commissioner. For the present, however, he would have to remain content to serve as foreman of the coroner's jury investigating the death of his good friend Jim Horan.

In addition to Goodrich, Hoffman tapped another fire buff, silk stocking Republican alderman Francis Winthrop Taylor of the Gold Coast's Twenty-first Ward. Only thirty-two years old and strikingly handsome, Taylor could boast "some social distinction," according to the *Tribune*. He received his education at St. Paul's School in Concord, New Hampshire, "and afterward traveled abroad for some time." Taylor held a partnership in a downtown real estate firm.

Another jury member who could claim a notable day job was Frank Farnsworth Holmes, fifty-two, head of a fire insurance agency that bore his name. Holmes also served as secretary and treasurer of the National Association of Fire Insurance Agents. Locally, he was a member of the Chicago Board of Underwriters, which meant he would be weighing the testimony of his colleagues.

Fire fan George P. Gilman, vice-president of the Lindsay Light Co., was added to the panel, as was fellow fan J. Emmett Carney, an executive with the coffee concern of Puhl, Webb & Co. Odd man out among the heavyweights was John Keemans of 4201 South Lowe Avenue. The Canaryville resident presumably had wandered over to watch the action. Three of his five colleagues rated listings in the 1911 edition of *The Book of Chicagoans*, a who's who–type publication. Keemans's name didn't even appear in the 1910 Chicago directory. That Hoffman knew at least some of the jury members beforehand appeared likely. As a public official long active in Republican politics, he would have been acquainted with such prominent figures and conveniently encountered them pursuing their hobby.

Some members of the jury were known to rub elbows with Mayor Busse, Chief Horan and other city leaders. In June 1908, Goodrich and Carney joined Busse, Horan and three dozen more Chicagoans on a day trip to Manitowoc, Wisconsin, to witness the launching of the new fireboat *Joseph Medill*. The *Medill*'s twin, the *Graeme Stewart*, stood alongside but was a bit further behind in construction. The new boat was launched in a heavy rainstorm, after which the party scurried indoors for a luncheon that saw Horan praise the construction of the new additions as advancements in firefighting. Busse said he knew the *Medill* would succeed because it would be under Horan's command. Following the luncheon, Goodrich took everyone for a ride on the Manitowoc River aboard the tugboat *Arctic*.

About sixty fans dressed in firemen's uniforms, complete with hats and badges, turned out in February 1910 to honor Horan in song, story and jest at a banquet in the LaSalle Hotel. The merrymakers included Taylor, Carney and Gilman—one half of the panel that would investigate the death of the guest of honor and twenty-three others later in the year. To mark the occasion, all attendees were presented with chief's bugles. An alarm bell, courtesy of the fire alarm office, was placed at the head table so that all calls sounded that evening could be monitored by the guests. Mayor Busse's remarks were interrupted by a 2-11 at Clark and Division. When the tributes to the chief had ended, the *Tribune* reported, "the party adjourned to an adjoining room to await amid quantities of fire extinguishing fluids for the sound of an alarm" to answer and conclude their evening of revelry in proper fashion.

The fun and laughter must have seemed a distant memory to Carney and Gilman early on the morning of December 22 when they arrived at Horan's city hall office with copies of the extra editions tucked under their arms. The papers already were announcing the chief's death, though his body

wouldn't be recovered for another twelve hours. Could it be true, the fire fans wondered. A choked-up stenographer nodded, and Carney and Gilman headed for the yards. They weren't there long before they found themselves members of Hoffman's jury. The coroner divided his day between the fire scene and the morgue. In late afternoon, Hoffman and the panel viewed the first fifteen bodies, after which the coroner released the jurors subject to call.

Almost immediately, Hoffman began shedding light on the tragedy. He ruled out an explosion in Warehouse 7, as well as the presence of ammonia fumes: "Indications are that the earlier report that there was a heavy explosion was a mistake. The debris left by the collapsing walls seems to show that they fell almost vertically and were not thrown out with the force that an explosion would have caused." A physician on the coroner's staff said he would have detected the odor had any ammonia filled the building at the time he inspected it. The doctor came away convinced that most of the victims were crushed to death: "A few were protected by timbers sufficiently to be saved for a few minutes, only to die of suffocation beneath the ruins." Hoffman vowed a full investigation. He promised to focus on reports of low water pressure, the condition of the walls, the weight capacity of the floors and how each was utilized, wiring conditions, fire department reports and documentation from Nelson Morris. The coroner said it was too early to speculate about the cause, but he did state the obvious—"that the firemen were obliged to carry water a considerable distance to the blaze."

The inquest began on January 10, 1911. Two overarching questions dominated the four-day proceedings: one, did faulty electrical wiring cause the fire, and two, to what extent were firemen hampered by insufficient water and low pressure? Whether by predetermined strategy or not, Nelson Morris witnesses strove mightily to discredit the bad wiring theory and deny that the company's water system hampered responding firemen. Any water shortage, they suggested, may have been caused by an accidental valve malfunction.

Frank Boyer, the Nelson Morris night electrician, was the leadoff witness. Boyer testified that he was in the company powerhouse when he heard the alarm at 4:05 a.m. The alarm was transmitted to all company pumping stations, Boyer explained, so that they would apply high pressure to the company water supplies. Asked about electric light wiring in the burned buildings, he said cutoff systems alternated the lights so they might burn in one building and be turned off in others. Boyer stated that the only lights turned on in the burning sections of Warehouse 7 were tiny red lights on the fire alarm boxes. His testimony suggested that bad wiring couldn't have started the fire if no current was flowing to keep the lights on. That theory

raised a host of questions. If there were no lights, how could Paul Leska and the other watchmen have made their rounds? In the dark? With lanterns? Leska never mentioned that the building was dark. How could he have made his way to the basement to discover the fire and then make his escape? Boyer was recalled to the stand later and corrected his testimony to say that entire strings of lights were left on at all times to guide the watchmen. This about-face seemed to annoy members of the jury.

Next up came George Eyle, the Nelson Morris chief electrician, who revealed that some of the wiring was fifteen years old but had never caused a fire. Eyle acknowledged receipt of a May 12 directive from the city's Electrical Inspection Bureau that would become a key point of contention. The communiqué required changes in the wiring. Eyle claimed the changes had been completed in Buildings 6 and 7 shortly prior to the fire. That statement may have been true, partly true or untrue, depending on who was judging the accuracy. If there were changes, they didn't occur quickly or easily. Jurors became frustrated trying to learn exactly what was supposed to be wrong, what Nelson Morris did about it and when they did it. The panel expressed further annoyance when the company couldn't produce a diagram of the wiring layout. "Pretty sloppy," groused foreman Goodrich.

An inspector for the Chicago Board of Underwriters testified that he too found bad electrical connections in the basement of Warehouse 7 and reported his findings to the board on October 4, nearly five months after the city's directive to the company. Nothing got done, according to the underwriters, so a second notice was sent. Work still did not begin. A third notice, announcing a 25 percent increase in Nelson Morris's insurance rates, captured the company's attention. City electrical inspector Hortsmann testified that Eyle told him on December 14 that nothing had been done at that time to remedy the defects, but that work would begin immediately to get the insurers to reverse the rate increase. Hortsmann's account seemed to challenge records produced by the company showing that $377 worth of electrical repairs were done in Building 7 between November 26 and December 15. Nelson Morris complained that the city's criticisms were difficult to address because they were vague. Despite protests to the contrary, it was becoming clear that some members of the jury believed defective insulation coupled with faulty wiring had started the fire. Through their questioning of witnesses, jurors seemed to advance the theory that arcing electricity ignited surrounding materials and caused the flames to spread throughout Warehouse 7. In another attempt to discredit the bad wiring theory, Nelson Morris general superintendent

William Ferris offered a new possibility. Ferris mentioned that overheated steam pipes in an office at the north end of Building 7 may have been the cause. That idea was shaken by Chief Lacey, who observed that the office was located above the spot in the basement where the fire was discovered. Lacey said he and other firemen determined that the fire had not burned a hole down from the office to the basement.

Lacey took the stand after the inquest heard from some of the first firemen who reached the scene. The men agreed that in the beginning there was no water in Building 7's standpipes, but that when it finally did come on, both the quantity and pressure were adequate. Chief Seyferlich's main objection was that some of the hydrants were located so far away from the fire that water had to be pumped over long distances, resulting in a loss of pressure. Under questioning by Coroner Hoffman, Captain Edward Haegle mentioned that it was "customary" in the yards to keep the standpipes drained in winter. That observation drew a rise from Seyferlich, who demanded to know where that was the custom.

"At the Anglo-American plant, I know," Haegle replied. "I am not sure about the others."

"Do you know why it is done at the Anglo-American?" the chief asked.

"To keep the water from freezing in the pipes."

"Why is the water apt to freeze in the pipes at the Anglo-American?"

"Because they run over the roofs of some buildings."

"Did the pipes run over the roofs of any buildings in the Morris plant?"

"No."

Lacey testified that two Nelson Morris standpipes were empty when firemen arrived. "I understood that the pipes were being repaired," he said in response to a question. Separately, company and underwriters' witnesses asserted that all six standpipes in the complex were kept filled at all times and that any lack of water must have been due to a defective valve.

The chief said he tested every hydrant in the yards a few months before the fire and recorded the highest pressure at eighteen pounds per square inch, compared with a downtown average of thirty-two and a high of fifty. Lacey recounted that five minutes had elapsed after the first responders tried unsuccessfully to draw water from standpipes in Buildings 6 and 7 before they reached Number 5. At this point, Lacey's testimony not only began to frustrate Hoffman and the jury but also puzzled anyone with a casual understanding of the events.

Hoffman said, "Do you think that in those five minutes the fire spread materially?"

"I cannot say," the chief replied.

"Do you think that if, five minutes before, you had been able to get water from the first standpipes you connected with you might have kept the flames in check?"

"I cannot say."

"Do you think you had enough water to fight the fire?"

"I can't say."

Why Lacey effectively "took the Fifth" in response to such easy questions has never been explained satisfactorily. Even Stock Yards president Spoor volunteered the obvious answers at the time of the fire. The coroner's softballs were no more challenging than the question of whether rail cars standing against Warehouse 7 hampered firemen. ("The cars did bother us, there is no getting away from that.") After more than one hundred years, Horan's great-grandson, John Rice, bristles. "Lacey lied his ass off on the witness stand," Rice maintains.

The chief was more forthcoming about what caused the wall to collapse on Horan and the others. "There wasn't exactly an explosion," Lacey answered. "That is, there was no gas or anything like that. What explosion there was was caused by heat."

The investigation proved the chief correct. It was determined that superheated gases (a back draft) pushed out the entire wall. The sound of an explosion was attributed to air being sucked into the fire. Contrary to initial speculation, highly explosive ammonia wasn't used to refrigerate the plant. Instead, the company employed brine for coolant. Large quantities of saltpeter, also highly explosive, were stored on the premises but played no part in bursting the walls.

On the third day of the inquest, with most key testimony taken, a previously untold story of heroism emerged. Witnesses said that when the first companies arrived on the scene, Steven Leen, the young railroad worker, was standing nearby with a small lantern. A fireman pulling a hose asked Steven for the lantern. The young man handed it to the firefighter and then watched him climb a ladder mounted against a freight car. The fireman was having a difficult time, so Leen offered to help. Up the ladder he went until he reached the fireman's side. At that moment, the two became enveloped in smoke as flames leaped over their heads. That was the last anyone saw of the young worker until his body was recovered. But what became of the fireman? Coroner Hoffman found himself captivated by the account. For some reason, he believed the fireman survived, so he directed an assistant to check with the fire companies to find the man Leen had assisted. "If this

young man's death was the result of a volunteer attempt to fight with the firemen in the midst of that blazing building, the world should know the heroic facts," Hoffman asserted. The mystery fireman was never identified.

The coroner's jury concluded its inquest at noon on Friday, January 13, after Daniel Horan, undertaker and brother of Chief Horan, declared that he had no further evidence to present and after the city building department presented a report showing that the burned buildings were constructed in accordance with the requirements on the books in 1888. More partitions might have prevented the structures from collapsing when they did, stated the report, but Nelson Morris was under no obligation to add them. In a companion letter, Building Commissioner Murdoch Campbell disclosed that the buildings had never been inspected before the fire because no complaints had been received.

The jury returned the following day with a verdict short on blame but long on recommendations. Hoffman called it "largely a compromise." After consulting top architects and builders, the coroner said, "We could not find that we could put blame on any person." Nor did the jury determine the cause, despite the fact that some members seemed to lean strongly toward faulty wiring. The report did nothing to clarify the dispute over the wiring corrections Nelson Morris was supposed to have made. The remainder of the panel's account of the fire's onset contained no surprises: The fire started near the northeast corner of Warehouse 7, between the basement and second floor. The door (left open by Leska) allowed fresh air to reach the seat of the fire and increase the rate of combustion. This, in turn, created a slow explosion that put sufficient pressure on the east wall of Building 7 to cause its collapse. "Section 7 was of substantial construction and...no unusual conditions existed."

The jury also took a pass on the question of why firemen found no water in the standpipes of Buildings 6 and 7. In fact, the report makes no specific mention of a lack of water or water pressure, only recommendations for an ample water supply, a sufficient number of hydrants, a high-pressure water system and automatic sprinkler systems for larger storage and manufacturing buildings. The one specific criticism of water supply at the time of the fire concerned the excessive distance between hydrants that forced firemen to run hose 1,200 feet in some instances.

Only one name—James Horan—is mentioned. It appears in the first sentence, identifying him as a victim with no acknowledgement that others perished, and in the last sentence, endorsing his final recommendations to the city council. There is no discussion of how decisions or actions by

individuals influenced the course of events. No mention of Leska being the one who left doors open, Horan's displeasure with Burroughs's and Lacey's firefighting strategies, Horan's decision to push ahead in the face of danger, Burroughs urging Horan to "stand down," Seyferlich's call for multiple special alarms or the city and underwriters' pressure on Nelson Morris to make electrical corrections. Nothing. Totally absent was any trace of a human element. Beyond "deeply deplor[ing] the terrible loss of life," the jury failed to even mention that twenty-three other men lost their lives, much less offer condolences to the bereaved families. "There were those following the developments," the *Daily News* observed, "who predicted that…the document was likely to yield a sensation or so. Those forecasters were doomed to disappointment." Perhaps the only surprise was the fact that it took twenty-four hours to deliver such a bland document. Maybe the whitewash needed to dry. An uncompromising report would have made for more informative reading.

Flames were still rising from the Nelson Morris warehouses when Bernard Sunny, president of the Chicago Telephone Company, convened a meeting of similar ranking businessmen at the Chicago Club. Their goal was to launch a relief fund for the dependents of the deceased firefighters. Of the twenty-one men, nineteen left widows, and two had dependent parents. The rest of the survivors were children, nearly all minors.

The Citizens Relief Committee chose as its chairman seventy-two-year-old socialite and philanthropist Hiram Higinbotham, former president of Marshall Field and Company. In an eloquent appeal to the public for contributions, Higinbotham stated, "Civic sympathy for the bereaved families is seeking to rob death of its sting and the grave of its victory." Whoever coined the term "noblesse oblige" clearly had someone like Hiram Niles Higinbotham in mind. During his years in business and in retirement, he earned a reputation for investing considerable amounts of his own time and treasure in charitable and educational causes. When he became involved in a project—to help kindergarten children, the incurably ill or numerous other endeavors—he reported for work with his sleeves rolled up. He served as president of the World's Columbian Exposition in 1893. Following the tragic Cold Storage Warehouse Fire at the fair, Higinbotham helped raise more than $100,000 for the families of firefighters killed in the blaze. Here stood the right person, it was universally believed, to help the families of the Stock Yards firemen. Before long, many of the widows would express their doubts.

Higinbotham, Sunny and their colleagues initially chipped in $20,000 but quickly withdrew their offer when they determined that it was too small.

On the second go-around, they raised $50,000 by December 23, en route to their final goal of $250,000. Nelson Morris & Co. promised a substantial contribution but declined to state the amount publicly. The company did announce a $5,000 donation to the surviving firemen who fought the blaze. Committee members were heartened by the fact that the first contributions rolled in before the fund drive received a formal announcement. Once that happened, more donations piled up, including those from banks, retailers, packers, railroads, insurance companies, churches and synagogues, theaters (through benefit performances), the Chicago Board of Trade, Chicago Athletic Association, dozens of additional enterprises and, of course, the public at large. To solicit the various lines of trade and industry, seventy-five subcommittees were formed. The fundraisers set up shop in space donated by committee treasurer John J. Mitchell, president of the Illinois Trust and Savings Bank. The group felt confident of reaching its quarter-million-dollar mark within ten days. Higinbotham urged a number of smaller, separate funds that had been started to consolidate their receipts with those of the larger effort.

Realizing that many of the families faced immediate needs, the committee promised to deliver money to erase pressing debts, even outstanding mortgages. Mayor Busse tapped his contingency fund to provide $200 to each family to help cover funeral expenses. On the day of Christmas Eve, seven aldermen visited each of the homes in mourning and left a check for $250 in city funds along with their condolences.

Distribution of the big fund should follow the plan successfully implemented after the Cold Storage Fire, Higinbotham and his colleagues agreed. The chairman explained that in 1893, his group paid out $35,000 to fifteen families for immediate needs and invested $64,000 on their behalf. "At first, the beneficiaries clamored for the lump sum," Higinbotham noted, "but we persuaded them that the investment plan was best and now all are happy about it." The relief committee proposed that this time $2,000 be invested in bonds for each widow and that she receive a regular income over her lifetime. The same sum would be invested on behalf of each fatherless child, with the principal to be paid when the beneficiary reached age twenty-one. Separately, the firemen's pension fund provided, effective February 15, 1911, that each widow receive $35 a month as long as she remained unmarried, each child $8 a month until age sixteen and each dependent father or mother $25 a month. Additionally, the surviving families each received a lump sum payment of $1,500 from the firemen's insurance fund. Higinbotham said he expected that his committee's fund

would be easier to manage than its 1893 counterpart because all the firemen resided in Chicago, unlike eight of the earlier firefighters, who were privately employed and came from various parts of the country. The chairman was about to learn that things can change in seventeen years.

The Higinbotham committee suffered its first setback when it failed to reach its goal of $250,000. After the initial burst of enthusiasm and contributions, the total came to $211,000. A bigger bump in the road to a happy ending came in the form of the feisty widows themselves. Whatever powers of persuasion Higinbotham used with the women of 1893 failed to convince the Stock Yards widows that the committee wise men should invest the proceeds for them. They wanted the payout up front—period. Their insistence startled the downtown powers that be and undercut their sense of paternalism. Housewives were challenging the heads of the phone company and one of the leading banks and the former chief of the city's premier department store, not to mention Robert Todd Lincoln, Cyrus McCormick, John G. Shedd and sundry other luminaries who considered themselves peerless in such matters.

By early April, the battle lines were drawn. The widows formed the Stockyards Fire Protective Association and assembled a team of three to lobby the principal contributors to exert their influence on the relief committee. Members of the pressure group included Mrs. Mary Moriarity, widow of the Hook and Ladder 11 fireman and sister-in-law of the ballplayer; Captain John Crotty, also of Truck 11; and Captain Frank Grady of Engine Company 16. Crotty said each widow should get $7,500 in cash right away. Meanwhile, Higinbotham returned from Hot Springs, Virginia, and promptly arranged a meeting of the relief committee, at which he restated his opposition to any change in the distribution plans. Good intentions notwithstanding, the septuagenarian philanthropist found himself in a tough spot—as an adversary of the widows and orphans he was trying to help. He must have cringed when he read a *Tribune* headline that proclaimed, "Higinbotham Opposes Widows." His own words made matters worse. "These women are not sufficiently good judges of business conditions to administer this fund for themselves," he declared. "In fact, I do not know twenty women in Chicago who could take a fund of $211,000, divide it up among themselves, and keep it intact against the inroads of 'get rich quick' schemers and others for a period of five years." Then, as if to soften the sexism, he added, "I might even say I do not know of twenty men who could do it."

A week later, members of the relief committee invited Mrs. Moriarity to appear before them and present her group's objections. She did so and raised a particularly sore point—preferential treatment for the families of

Chiefs Horan and Burroughs. For example, she mentioned that while other survivors were kept waiting, James Horan Jr. had already received $1,000. The committee defended its tilt toward the Horan and Burroughs families by arguing that a significant portion of the fund had been contributed by the friends of Jim Horan. Furthermore, the committee said the distribution plan took into consideration the salaries of the victims and their families' previous income. In other words, they said, the families of higher-ranking, higher-paid firemen were entitled to higher payouts.

Both sides dug in. Continued discussions went nowhere, so the widows' group filed suit in July, asking the superior court of Cook County to appoint a receiver to distribute the $211,000. The widows were represented by three attorneys who worked pro bono. Throughout the remainder of the summer and well into the fall, the women waited. Finally, just before Thanksgiving, the relief committee decided to settle. Most of the widows would receive $3,000 for themselves and $2,000 for each of their children. Margaret Horan was awarded $17,000 for herself and a combined total of $16,000 for the four children. Belle Burroughs was to receive $11,500 and $2,000 for her daughter. The widows of captains were awarded more than $5,200 each, the widows of lieutenants in excess of $4,300 each. Two firemen left dependent mothers, each of whom received $2,000 from the fund. Alice Powers, one of the group's leaders, got the news late Thanksgiving Eve. Mrs. Powers was another Hook and Ladder 11 widow. Like Al Moriarity, Pete Powers belonged to the doomed company that returned to the firehouse with one member left from a crew of seven. Mrs. Powers said she could hardly believe the news. "There have been so many difficulties and delays," said the mother of two daughters, ages seven and three. The three-year-old was recovering from her third bout of pneumonia. "It hasn't only been the worry of the fight," Mrs. Powers continued. "It's been more than that—the questions every day of the lawyers, the endless repetitions of the things we all wanted to forget." She said all the women believed Higinbotham was trying to do what he thought best, "but we don't think he gave us credit for as much sense as he should have. I for one hold only the kindest feelings toward him and the deepest gratitude for the persons who contributed to the fund."

"I am so glad," said Mary Costello, widow of Thomas Costello of Engine 29, "so glad." For nearly two years after the fire, life treated Mrs. Costello reasonably well, as it did most of the widows, according to a "where are they now" feature in the August 26, 1912 *Tribune*. The concern expressed by relief fund chairman Higinbotham, that the survivors would fall prey to unscrupulous characters, never materialized. Reporters found the majority

of the women doing an admirable job of managing their families and finances. Following the advice of relatives, Mary Costello had invested her proceeds from the fund in first mortgages. She and her child still called the Bridgeport community home but had moved from Thirty-first and Union to Thirty-fifth and Emerald.

Alice Powers became the only member of the group to remarry. She wed a traveling salesman and moved to Jackson, Mississippi. She was one of only two women who didn't remain in Chicago.

The widows of the two chiefs—Horan and Burroughs—were left with no financial worries. Margaret Horan and Belle Burroughs benefitted greatly from the advice of influential friends their husbands had made over the years.

Minnie Schonsett and her only child moved in with Mrs. Schonsett's mother at Thirty-sixth and Princeton in Bridgeport. She reported that her investments had left her with no misgivings about the future.

Martha Murawski paid off the mortgage on her home at Forty-eighth and Wood in Back of the Yards and declared, "I think I have been lucky." She said she used her funds to buy four lots, which had increased in value. "I don't want to be dependent on anybody," she asserted.

A reporter who called at the Canaryville home of Agnes Crane found a man and woman looking after the place. Mrs. Crane was visiting her old home in Ireland, the man stated, and "having the time of her young life."

Another Bridgeport widow, Mary Moriarity, laughed when asked about her business ventures. She assured the questioner that she was well satisfied with loans she'd made.

Elizabeth Moore and Mary Danis didn't have a lot to say about their situations, other than to indicate through friends that they were profiting from their investments.

Bertha Sturm was another who profited from investments under the guidance of friends. She and her child were spending the summer at Brown Lake, Wisconsin, while making their permanent home at Sixty-fifth and Peoria in Englewood.

Margaret Weber paid off the mortgage on the home at Seventy-second and Morgan that she and her husband, William, had purchased just before the fire and reported that she was "making both ends meet."

Helen Brandenburg also did well in real estate, while Jennie Walters passed a civil service exam and landed a job at city hall.

Charlotte Lannon's investments were doing well, but doctors' bills were taking up much of her income. Mrs. Lannon said each of her four children had been ill at one time or another.

The mother of George Enthof of Engine Company 23 had become the only beneficiary of the fund to die. Mrs. Caroline Enthof was survived by her husband, Henry, a semi-invalid, who said he was holding onto the money and "just waiting for the end."

Lieutenant James Fitzgerald of Engine Company 23, who died two days short of his wedding day, also left a widowed mother. Mrs. Johanna Fitzgerald said James paid all the bills and "took care of everything." Now, with an adult son and daughter who were semi-invalids and barely able to work, Mrs. Fitzgerald said she was just hoping her money would hold out.

By far, the heaviest blows fell on the Doyle and McInerney families. Mrs. Elizabeth Doyle, an invalid, had not left her home on West Thirty-third Street since her husband, Captain Dennis Doyle of Engine Company 39, and son Nicholas Doyle of Truck 11 were killed. Friends were looking after her business affairs. Mary McInerney never recovered from the shock of losing her husband, Michael, of Truck 11. She was placed in a private asylum near Milwaukee, while her three children remained in Chicago. As in the case of Mrs. Doyle, friends were managing her affairs.

Chapter 5
HORAN AND CUSTER

Can Chief Horan be blamed for causing his own death and those of twenty-three other men that frigid early morning in December 1910? After all, it was his decision to fight the fire from that cramped railway platform despite a warning from Assistant Chief William Burroughs. What contributed to a judgment that turned out very badly? Something went terribly wrong in that very small place, but what?

There were rumors that Horan might have been drinking hours before the fire and that the alcohol had fogged his mind. This seems highly unlikely, since there is no indication that he was a heavy drinker or even drank at all. John Rice, Horan's great-grandson, believes the chief may have taken "the pledge" as a young man to swear off alcohol. Many young men, particularly those of Irish ancestry, took the pledge at that time. How many kept it is another matter. Even if Horan had had a few the night before, it being the Christmas season, his body would have had some six hours of sleep to metabolize them before he was called to respond to the fire. Further, Horan was a big, imposing man who would have required a great deal of alcohol to incapacitate him. The rumors may have been the work of enemies of the chief, determined to soil his reputation even in death.

Could Horan have been just plain incompetent? Again, that seems highly unlikely. Horan had been a member of the Chicago Fire Department for twenty-nine years and had extensive firefighting experience, gained in both the lower and upper ranks. He had fought major fires throughout the city, including many in the Stock Yards, and was well aware of the dangers that

the mile-square area posed for firemen. Certainly no small testimony to his ability was the admiration in which he was held by the Chicago Fire Insurance Underwriters who campaigned for his promotion to chief. For Horan, firefighting was a way of life. The chief was anything but incompetent.

During our research into Horan's fatal decision, parallels with George Armstrong Custer came to mind. Like Horan, who led his paramilitary force into battle against one type of enemy, Custer led his Seventh Cavalry into combat against his Sioux and Cheyenne enemies, resulting in his death and those of more than 250 others. What became known as Custer's Last Stand happened on June 25, 1876, along the Little Big Horn River in Montana and received national attention. Could what happened that day provide a clue to what happened in Chicago thirty-four years later? To answer that question, we began comparing the lives of the two men.

We recognized that an abundance of books has been written about Custer and his last stand. Periodically, new books appear, examining and re-examining what happened in Montana well over a century ago. In addition, newly minted students of "Custerology" churn out a flow of research and articles concerning the one-sided battle. On the other hand, little is available concerning Horan's role at the 1910 fire. Almost all our knowledge comes from newspaper accounts more than one hundred years old, some documents of the time and personal accounts passed down over the years to descendants of the fire's protagonists. Despite these limitations, it's possible to discover similarities in the lives, abilities, characters and motivations of George Armstrong Custer and James Joseph Horan.

Their lives overlapped by seventeen years. Custer was born in Ohio in December 1839, while Horan was born in Chicago in 1859. Custer would die at thirty-six, Horan at fifty-one. As a teenager, Big Jim must have read details of the Battle of the Little Big Horn. Custer was hailed as a martyred hero. Did the stories of his bravery in the face of overwhelming odds leave a lasting impression on the younger man? We can only speculate.

Both men held dubious distinctions stemming from their deaths and those of others. Custer's Last Stand recorded the greatest loss of lives for the U.S. Army in any single engagement of the Indian wars. Horan was in command of the largest number of firemen killed at one fire in Chicago, the United States and possibly the world at that time. The Nelson Morris disaster marked the greatest toll for any professional fire department, until 343 firefighters were killed in New York City on 9/11/2001.

Both men knew early in life the careers they would pursue. For Custer, a fascination with the military may have dated back to when he was four years old

and proudly wore a soldier's uniform made by his mother. We can't make the same educated guess as to when Horan's fascination with firefighting began, but we know it must have come during his youth, possibly at age twelve when a large section of Chicago burned to the ground during the Great Fire of 1871.

Custer attended the United States Military Academy at West Point. Horan joined the Chicago Fire Department as soon as he reached the required age. Both men decided to build careers in their chosen professions that went far beyond consideration of pay, job security and safety. It was not a matter for either of taking a job because nothing else was available. Custer and Horan enjoyed their work immensely and took pride in doing it. Each had a vision of achieving leadership in their futures, and they were not disappointed.

Promotions came quickly for both men. With the help of the Civil War and his leadership skills, Custer soared to the rank of brevet brigadier general by the summer of 1863 at the ripe young age of twenty-three. Although he held the title of brigadier general, the brevet meant that Custer was paid at his actual rank of first lieutenant. The so-called Boy General of the Union army would hold the rank of brevet major general when the Civil War ended.

Although he didn't rise through the ranks as rapidly as Custer, Horan advanced quickly for someone in the fire service. He was promoted to lieutenant after five years and worked on two downtown engine companies. In two more years, he was promoted to captain of a downtown hook and ladder company. Five years after that, he advanced to chief of the Third Battalion and soon after was moved to the First Battalion. That move was considered a sign of the respect of his superiors for Horan's abilities. An unwritten rule decreed that only the best served in the First Battalion.

Both Custer and Horan developed strong ties with influential people. Custer's connections were in Washington, which he visited a number of times. The visits were not wasted. One was described by author Jeffry Wert in his book, *Custer: The Controversial Life of George Armstrong Custer*: "While in the capital, he attended a dinner party at Chief Justice Salmon Chase's and met with Secretary of War Edwin Stanton, who greeted the officer with, 'Custer, stand up. I want to see you all once more. It does me good to look at you again.'"

Horan's ties in Chicago were especially strong with the insurance underwriters. During his duty downtown, the chief developed a rapport with some of the leading bankers, businessmen and government officials. After his death, the *Tribune* reported, "No man in public position in Chicago ever was more widely known or more generally held in affection."

As would be expected, both men had their enemies. About Custer's, Wert writes, "While his men were devoted to him and his superiors praised him,

fellow officers resented—perhaps envied—his fame, his showmanship, his loudly proclaimed 'luck.'" Some historians say one of those enemies was Captain Frederick Benteen, who was accused of dragging his feet instead of taking his battalion to aid Custer after his call for help shortly before the last stand. President Grant was another Custer enemy. Reacting to the last stand, when many revered Custer as a dead hero, Grant said, "I regard Custer's massacre as a sacrifice of troops, brought on by Custer himself that was wholly unnecessary—wholly unnecessary."

Horan too could claim an enemy in high places. In 1901, Chief William Musham moved him from the elite First Battalion to the Fifth Battalion, west of downtown. The transfer was seen as a demotion but turned out to be only a minor setback. In March 1905, Horan became first assistant chief of the entire department. The next year, he was expected to become chief with the retirement of John "Fighting Jack" Campion, Musham's successor. But Horan was passed over in favor of John McDonough. The surprise, politically motivated appointment by Mayor Edward Dunne was not greeted well, especially by the underwriters and the downtown movers and shakers who had come to like and respect Horan. However, McDonough's tenure was brief, so brief that he failed to win formal approval by the city council, and a chagrined Mayor Dunne named Horan chief. Among the rank and file in the department, Horan was disliked by some who supported a two-platoon system. But Horan, who opposed two platoons because of their expense, tempered the hostility by providing more time off and better working conditions.

Custer also suffered a major career setback that was not remedied as easily. With the end of the Civil War, the twenty-five-year-old Custer represented one of 135 major generals in the U.S. Army—far too many for peacetime. Custer was compelled to continue his military career as a lieutenant colonel. He would no longer be leading cavalry charges against Confederate forces but instead against Native Americans. He would never again hold the rank of general.

Even their severest critics never questioned the bravery of either Custer or Horan. Wert wrote of Custer's displays of bravery while leading his Michigan Brigade during the Civil War, "Custer removed any questions about his bravery, his leadership qualities and his skill in combat. On the road at Hunterstown, in the fields at Gettysburg and on the knoll at Falling Waters, he led them, not from a distance behind a battle line, but at the very forefront of combat." In other words, Custer was renowned for leading his troops, not pushing them.

A History of Flame and Folly in the Jungle

Horan was held in the utmost regard for precisely the same quality. As a matter of fact, he might well have survived the carnage of 1910 if he had safely positioned himself away from the railroad platform. It's interesting to note that some reactions to the deaths of Custer and Horan were identical—basically, that both died doing what they were dedicated to and, if they had to die, probably would have favored the way life was taken from them. Regarding Custer, author Vine Deloria Jr. put it this way in his book, *Custer Died for Your Sins*: "He had the rare privilege of dying for what he believed in, and dying as a military leader might wish and expect to die—in battle surrounded by his men."

Concerning Horan, the *Tribune* editorialized, "Had he made a choice of death he would have chosen to die as he did, at the head of his men fighting unselfishly for the interests of others." The president of Chicago's Board of Local Improvements told the newspaper, "He [Horan] died doing the work he loved the best and to which death proved him faithful."

Both men would have regretted the large number of subordinates who were killed with them. But both, nonetheless, are remembered as bigger than life. Such giants are expected to be impervious to their enemies. If an average but unfortunate person were walking down a Chicago street and a wall collapsed on him, it wouldn't be said that "he died the way he would have favored." However, walls were not expected to fall on Horan, and Indians were not expected to massacre Custer.

Is it possible that either or both Custer and Horan were suicidal? Could either or both have wanted to die, even if it meant taking their subordinates with them? No evidence supports that conclusion. Both men had young wives and, in Horan's case, a family and were looking to the future, even though both had faced the possibility of death on numerous occasions. In the military, in the fire service and in law enforcement, medals and honors are often awarded posthumously for acts that are considered heroic. Observers sometimes shake their heads and question the rationality of those heroic deeds, considering that the heroes more than likely realized that death could result. For the heroes, it was a matter of duty despite the consequences. There remains no better example of public servants facing death bravely than the tragedy of 9/11, when hundreds of firefighters, paramedics, police officers and civilians died heroically.

Taking a closer look at the parallels between the final battles of George Armstrong Custer and James Joseph Horan, one common thread jumps off the page: both men underestimated their adversaries based on faulty information they'd been given.

What led to Custer's Last Stand? Many theories have been advanced to place blame for what happened that day in 1876 in Montana. They range from accusations that Custer wanted a well-publicized victory to get his general's stars back or, more grandiosely, to power a bid for the presidency. When considering possible motives, it's important to remember that Custer was a brilliant cavalry commander who would have understood that a military debacle would dash any hopes for the future. Some critics say he launched the battle so he could hog the glory of a victory yet wound up sending a message for help that was largely ignored.

Custer reportedly was concerned that the Indian warriors would, as they had so often in the past, not stay and fight but ride off, leaving the cavalry behind to pursue an elusive foe. But this time things would be different. The Indians had united with far superior numbers. They also had to consider their slow-moving women and children, who not only would hobble any retreat but also might be captured or killed. They had to be protected. No, this time the Indians, with momentum on their side, would stand and fight.

One certainty about Custer's Last Stand is that the Indians far outnumbered the cavalry. In his book, *Custerology: The Enduring Legacy of the Indian Wars and George Armstrong Custer*, author Michael Elliott writes that Custer did not have an accurate estimate of the number of Indians awaiting his cavalry. He continues, "All the documents that precede his last battle suggest that he had been led to expect a village no larger than half the size of what he found." According to Wert:

> *The Custer command was crushed by an overwhelming force of Indians who, in addition to superior numbers, had the advantage of terrain and possibly weaponry...we know that Custer did not make inexplicably foolish decisions: he made reasonable military decisions on the basis of incorrect information, certainly a less striking explanation for failure in battle than overweening ambition or insanity.*

Thus, the evidence shows that Custer underestimated his adversaries after being given erroneous information about their numbers. Horan had much the same experience on December 22, 1910.

We know that the chief was on the scene of the fire only for about ten minutes before the wall came crashing down, hardly enough time under hectic circumstances for him to size up the situation, make decisions and take action. We know that Horan complained to one of his drivers, Lieutenant Joe Mackey, about the fact that the railroad cars had not been removed from

the tracks beside the covered platform. The complaint came as Horan and Mackey approached the scene on foot after the chief's car had been parked on Forty-third Street, near Loomis, about a block north of the burning building. Time had been wasted when the chief's car made a wrong turn onto the north–south street a block east of the fire. The auto had to double back and wound up getting parked on Forty-third. The chief's car should have been driven to Forty-fourth and Loomis, which would have allowed him to reach the scene more quickly. This snafu probably stemmed from the original confusion over the exact location of the fire.

Although the fire started in Building 7 at Forty-fourth and Loomis, the night watchman had fled that building and turned in the alarm from a snap box in Building 6, located mid-block between Forty-third and Forty-fourth Streets. This meant that the first companies responding to the blaze based their positioning and lead-outs on the wrong structure. Those first companies would not have had the benefit of seeing visible flames because the structures were practically windowless. It's not known how much time had elapsed before firemen realized the blaze was centered in Building 7, but precious minutes had been lost.

Fire historian Sully Kolomay writes that Horan was unaware of which building was on fire when his auto and drivers arrived at his home: "Big Jim got dressed and, after asking which building was burning, told them to wait a minute and put on some heavier clothing." We don't know which building was mentioned, but because there was little communication between the drivers and the fire alarm office, the chauffeurs may have passed along the misinformation that Building 6 was burning. This possible mix-up might have provided another reason for Horan's growing dissatisfaction upon arriving at the scene.

The poor communication raises the further question of whether the chief was aware that the fire had been burning intensely for almost an hour before his arrival. Walls that had been under mounting pressure for that long obviously were more likely to cave than if the fire hadn't had that much time to build. Horan only became aware of the fire when the alarm office contacted him at approximately 4:42 a.m. to report the extra alarm and to advise him that his car and drivers were on their way. The Horan residence was connected to the alarm office by a direct phone line. When Lieutenant Mackey arrived at the chief's residence to rouse him and drive him to the scene, the fire had been burning for at least forty minutes. If Horan was unaware of the fire's head start, it might explain why he didn't appear overly concerned about the building's structural integrity immediately upon arrival.

Some of Horan's time on the scene was used up in a heated discussion with Eleventh Battalion Chief Martin Lacey over the firefighting effort before the extra alarm. Lacey reportedly was berated by Horan, who didn't have to face the delays that the battalion chief and Assistant Fire Chief Burroughs encountered upon their arrival. It's possible that Horan was misled by the sorry state of affairs that greeted him. Seen through the chief's eyes, the effort being put forth by the firemen was feeble at minimum. No one has ever been able to explain why Burroughs and Lacey, facing a raging fire with water supply problems, waited more than a half hour to call for an extra alarm.

Horan encountered another critical problem when he arrived on the scene: Building 7 hadn't been ventilated. In other words, firemen from the hook and ladder companies hadn't climbed to the top of the building and chopped holes in the roof to release smoke and hot gases. Was Horan aware of this fact? Had his subordinates failed to tell him? Perhaps Burroughs and Lacey had tried without success, or maybe they decided not to upset him even more. There is no indication that the chief ordered the building ventilated, except for chopping open railroad platform doors to get more water on the fire. That order probably did more harm than good because it fed additional oxygen to the flames.

Information that the building was not properly ventilated comes from fire historian Ken Little, who said he gained that insight from the chief's son, James Horan Jr., in 1958. The younger Horan, sixty-nine at the time, had stopped by the fire alarm office in city hall, where Little was working, and the two struck up a conversation. James Jr., twenty-one at the time of the fire, told Little that he learned about the lack of ventilation when he visited the scene the morning of the tragedy. According to Little, the chief's son seemed to indicate that the absence of ventilation represented a factor in causing the deaths of his father and the others. James Horan Jr. died in 1978.

The reason why the hook and ladder men didn't immediately begin ventilating the building probably stemmed from the lack of water faced by the first arriving fire companies. Little said that ventilating would not have begun until it was certain that water could be played on the flames. Ventilating without water would have let the fire spread without suppression and endangered the lives of the truckmen. Once the water finally got turned on, it may have been decided that the fury of the fire within a virtually windowless building made conditions too dangerous for the men to climb six stories to the roof and begin opening it. The climb would have been perilous—a straight vertical ascent requiring the use of four wooden ladders permanently attached to the walls of a superheated structure. Truck

A History of Flame and Folly in the Jungle

Company 33, the first hook and ladder due at the fire, did not come equipped with an aerial ladder and, in fact, would not get one until 1954, although the unit became motorized in 1919. Truck Company 18, which was second due at the fire, also probably lacked an aerial ladder. At that time, the ladders carried by both trucks would not have reached the building's roof.

We know that the chief entered the first floor of Building 7 but was quickly driven out by heavy smoke and flames. Aggressive firefighter Horan most likely realized that to back off and let Building 7 burn probably would result in the loss of the block-long series of six-story structures, Buildings 5, 6 and 7, and maybe allow the flames to spread beyond. Letting something like this happen on his watch was anathema to Horan, so ignoring the warning from Assistant Chief Burroughs, the boss went on the attack, apparently believing there still was time to control the fire in Building 7. What he didn't realize was that the momentum was on the side of the flames, and it would be only moments before the fire itself would ventilate the building—by sending the weakened east wall crashing down on him and his men.

By that point, hot gases had turned the building into a pressure cooker, and opening the first-floor doors allowed more air to be fed to the raging flames trapped on the upper floors. The laws of physics dictated that the fire had to go somewhere, and the east wall had been so weakened that it gave way with enough force that it was wrongly described as an explosion. The collapse of the wall did what the hapless firemen and their ineffectual axes could not: it opened up the building so water could be poured on the heart of the fire. Although it would take additional hours to control the fire, which did spread to Building 6, the entire block was not lost. The price paid was the lives of twenty-four men.

Was Burroughs smarter than Horan? More perceptive? Chief Horan did order Lieutenant Mackey to climb atop the platform canopy to check conditions above the first floor, but the command came too late. Since Horan was an experienced fire commander, we can only assume that he was unaware of two things: that the fire had been raging for at least an hour and ten minutes, far longer than he thought, and that the building had not been properly ventilated.

As in the case of George Armstrong Custer, Chief James Horan had been given faulty information (or none at all), which led him to underestimate his enemy. His decision to attack the flames was basically correct, but not in a situation where the entire interior of a large, almost windowless six-story structure had become a raging inferno, was not properly vented and had been burning for more than an hour. This is the only logical explanation for what caused the tragic events of December 22, 1910.

Chapter 6
PROPHETS WITHOUT HONOR

C hicago had every intention of erecting a lasting memorial to Chief Horan and the men who died with him. It really did. City hall reverberated with vows that these brave men shall not be forgotten, shall not have died in vain, that their names and chronicles of their deeds shall be spread upon the pages of the city's glorious history and be forever honored by generations to come. Nothing resembling the Gettysburg Address came forth, but the spoken tributes continued for days. As for something more substantive, a pair of sayings seemed to apply. "What the grave covers is speedily forgotten," according to one. The other says the road paved with good intentions leads to only one place. Whether any among the well intentioned ever descended there—for whatever reason—remained in the hands of the Almighty. Here on earth, the best intentions did lead to a first-rate memorial—artistic differences aside—but not for nearly another century.

Initially, a statue of Big Jim was proposed. Everyone agreed that the big guy would make a perfect subject, his broad shoulders draped in full firefighting attire, helmet firmly in place, maybe shouting into a trumpet. Any sculptor's imagination would have been fueled by the varied opportunities to convey heroism and leadership through bronze or granite. The eminent Illinois-born Lorado Taft would have made an ideal choice. A Chicago resident at the time, Taft had recently completed a statue of George Washington in Seattle and the haunting memorial *Eternal Silence*, arguably the artistic highlight among many exquisite works at Chicago's historic Graceland Cemetery.

That the idea of a Horan statue took root immediately after the tragedy is indicated by a death mask that was cast as the first step in the process. However, casting the mask proved to be the only step. For reasons never fully explained, plans for a statue soon were dropped. Lack of leadership, funds or simply waning enthusiasm all may have played a part. Instead, a bronze memorial plaque was designed and cast to commemorate the deaths of Horan and his men, as well as those of all future Chicago firefighters who would die in the line of duty. The unassuming memorial read: "In memory of Fire Marshal James Horan and his brave men—here followed by twenty names—who lost their lives in the stockyards fire, Dec. 22, 1910." Originally, the plaque was mounted in an alcove near the Randolph Street entrance to city hall, next to the office of the fire commissioner. In 1986, it was brought into the anteroom of the office, amid more genteel surroundings but where far fewer members of the public would see it.

A statue recognizing fallen firefighters, albeit obliquely, did exist in 1910 and before. At the Columbian Exposition of 1893, the Italian government presented the City of Chicago with a larger-than-life zinc, hand-painted statue of Christopher Columbus holding a blue orb in his left hand and a white dove of peace on the wrist of the right. In the wake of the Exposition's Cold Storage Warehouse Fire that claimed the lives of twelve firefighters, the Columbus statue was presented to Chief Joseph Kenyon of the Twelfth Battalion, who had fought the fire. The statue was placed outside the firehouse at 6345 South Wentworth Avenue, home of Engine Company 51, which was Kenyon's headquarters. Years later, after the firehouse was shuttered, the statue underwent refurbishing at the fire department shops and made its way to the lobby of city hall. From there it was moved to the lobby of the 911 center on West Madison Street. In October 2001, the statue became the property of the Fire Museum of Greater Chicago. Today, the *Great Navigator* stands at the rear of the former engine floor in the one-time firehouse and current museum at 5218 South Western Avenue, overseeing two vintage rigs and a trove of smaller memorabilia. Columbus and, indirectly, the firemen of 1893 had found a new niche, but the men of 1910 had found nothing comparable.

Members of the city's volunteer fire department were given an impressive memorial in 1864 at Rosehill Cemetery on the North Side. Plans for the marble monument began soon after four of the men lost their lives in October 1857 during a fire in a dry goods store on Lake Street. A column rises from a drum wrapped in a hose. At the top stands the figure of a volunteer holding a speaking trumpet in his left hand.

In late 1925, with the east–west leg of Wacker Drive nearing completion, a civic movement gathered steam to place a combined fire station/firefighters' memorial in a large oval on the street between Wabash and State. The two- or three-story "artistic structure" would house three companies and their apparatus along with a memorial to fallen firemen featuring a room filled with department trophies and tablets dedicated to fire heroes. At least three renderings of the building were completed, but that's as far as the concept progressed. Local business interests objected to a new building in the middle of Wacker that would obstruct the broad, open thoroughfare. Their position prevailed.

The Chicago Bureau of Statistics and Municipal Library tried its hand at the written word not long

Christopher Columbus stares down at visitors to the Fire Museum of Greater Chicago on the city's South Side. The statue had spent many years outside a Chicago firehouse and later called city hall and the city's 911 center home before winding up at the Fire Museum. *John F. Hogan.*

after the Stock Yards fire. The "Chicago City Manual of 1910," a sort of annual report, devoted three pages of an appendix to the Stock Yards firemen. Prepared by Francis A. Eastman, city statistician, the manual misstated Horan's date of birth (May 29, not May 10, 1859), misstated the number of firemen who "perished with their Chief" (twenty, not twenty-three—twenty-two if the number is stretched to include the Nelson Morris watchmen) and misspelled the names of two firemen (Nicholas Crane, not Brane, and George F. Murawski, not Murowski). Anyway, it was the thought that counted.

Ordinary citizens came up with their own schemes for honoring the late chief while hopefully turning a dollar or two in the process. A North Side music publisher named Henry E. Davey thought the heroics of the chief and his men should be honored in song. Davey himself composed the words and music, titled "The Heroes of the Stockyard Fire." The three pages of sheet music are graced by a cover page featuring a formal head-and-shoulders photo of Big Jim in full dress uniform. The lyrics begin by lamenting the fact that heroes of military battles receive their due but not "the boys who died fighting the flame." Although shorter by multiple choruses and written more than half a century earlier, "Heroes" calls to mind a similar song—Gordon Lightfoot's haunting ballad of another memorable disaster, "The Wreck of the Edmund Fitzgerald."

The Stockyards were burning, the firemen responded
With galloping horses and clang of the bell;
And on to their duty of saving the city
They tore away fearlessly and nobly fell.

The sheet music likely didn't sell many copies and apparently no recording was made, but the song's intent at least appeared more respectful than another "tribute." A trio of imaginative entrepreneurs devised a way to keep Horan's name fresh in the minds of Chicago's male populace (and perhaps a handful of females). Businessmen Louis Silberman, Abram D. Lazarus and David Rish unveiled plans to market a Chief Horan cigar. Each time a smoker lit up, he'd be making a burnt offering to the chief's memory. In early March 1911, the three incorporated the Chief Horan Cigar Company with a capitalization of $2,500. When Margaret Horan got a whiff of the endeavor, she was not pleased. She said she had not authorized the use of her late husband's name and was instructing her attorney to block the fledgling cigar company from appropriating it. "I was approached by some stranger soon after my husband's death," Mrs. Horan disclosed, "who asked for my permission to use his name for a new cigar." She said she objected and thought she had heard the last of the idea until the backers filed for incorporation. Not surprisingly, smokers were denied the opportunity to light up a Chief Horan.

After family and the fire department, Jim Horan's greatest love was baseball. Through his boyhood pal, Charles Comiskey, he made many friends in the game. One of Comiskey's circle introduced Horan to

American League president Ban Johnson, and the two became close. When the Athletics played the Cubs in the 1910 World Series, Johnson invited White Sox super-fan Horan to Philadelphia as his personal guest. To show his gratitude, Horan produced a rabbit's foot that had been given to him by a friend. Big Jim told Johnson he wanted to present the token to A's manager Connie Mack. The story Johnson related following Horan's funeral showed Big Jim at his loquacious best. "He told me it was the most potent charm and mascot known to the world of superstition," the league president remembered. "It was the left hind foot of a rabbit which had been caught in the dark of the moon at the edge of an old, deserted cemetery. To make the charm doubly effective and protective, the man who killed the rabbit was…a hunchback."

Johnson said he and Horan went looking for Mack the morning before the opening game but found him surrounded by so many friends that Horan didn't want to butt in. At Big Jim's request, Johnson took the rabbit's foot to Mack just before the game and repeated the outlandish tale of its origin. The gift gave Mack an idea. He brought the charm to the bench, or so he said, and relayed the narrative to his players, probably as a way of loosening them up. Baseball players being a superstitious lot, they loved the story. The A's starting pitcher, Chief Bender, was particularly enthralled. Legend has it that he wore the rabbit's foot in his shoe during the game, which Philadelphia won 5–4. Bender was the winning pitcher, and the A's went on to take the series by the same margin, 5–4.

"Perhaps if Jim Horan had kept that rabbit's foot for himself," Johnson speculated, "he might not have lost his life in the Stock Yards, and the Athletics might have lost [instead]. I wonder…" According to Johnson, the friend who gave the rabbit's foot to Horan was a nephew of Nelson Morris. He didn't remember the man's name.

In 2002, the city dedicated a picturesque section of south lakefront to all fallen firefighters and paramedics. The memorial lies in a generous expanse of parkland, immediately south of McCormick Place, along the hiking/biking/jogging path overlooking Lake Michigan. The centerpiece of the site is an arrangement of house bricks set into the ground, side by side. Into each is carved the name, rank and date of death of all department members who died in the line of duty. The array of bricks is surrounded by comfortable benches. Farther back, tall prairie grasses sway in the breeze. It is a place of quiet openness that encourages reflection.

On December 22, 2004, ninety-four years to the day of the Nelson Morris fire, Chief Horan and his men finally received their singular due. Bundled

against the cold, active and retired firefighters, city officials and friends of the fire department gathered to dedicate a memorial to the "Fallen 21." Just inside the main gate of the former Stock Yards, at Exchange Avenue and Peoria Street, they took their places next to a bronze statue of three figures depicting an officer, a truckman and a pipeman fighting the 1910 blaze. The figures are huddled vertically, as if atop one another. Uppermost is the officer, raising a bugle in his left hand. The truckman figure holds an axe to chop through the warehouse doors, while the crouching pipeman directs his line toward the fire. Chicago artist Tom Scarff said he tried to capture the moment before the wall came crashing down. The granite base lists the names of all 530 Chicago firemen who had died in the line of duty to that time. Names of the 21 appear separately, in larger lettering. While grateful for the recognition, some members of the firefighting community with more conservative tastes indicated that they would have preferred something a bit more traditional.

Regardless of artistic bent, one fact remains unquestioned: almost no one on foot ever sees the statue. Trucks roar in and out of the present Stock Yards Industrial District on both sides of the memorial, along Exchange Avenue, the primary vehicular entrance to the Industrial District, but pedestrian traffic is nonexistent. On busy Halsted Street, one block east, trucks and autos pass the Exchange intersection with scarcely a pedestrian in sight. The thoroughfare is devoid of any venues, commercial or otherwise, to attract people. No signs point the way to the memorial. An unused railroad track marks the eastern boundary of the site. It's a lonely place, unlike the one envisioned by the *Tribune* in April 1924, following a fire that took the lives of nine firemen. The city has the Haymarket monument, commemorating the sacrifice of police officers, the paper noted, but nothing to honor fallen firefighters. The time had come to erect a tribute to the fireman's "splendid courage and his noble devotion," the paper editorialized, and place it where "the children of the city," its adult citizens and out-of-town visitors will be reminded of "his brave guardianship." The fireman finally received his tribute; only the viewers are lacking.

Presiding at the dedication ceremonies, Mayor Richard M. Daley said the event "reminds us of how much we owe to the courageous men and women whose job requires them to place their lives on the line on a moment's notice." Dedication of the memorial completed an effort begun in 1998, when Fire Captain (since retired) Bill Cattorini launched a fundraising drive that netted $170,000—three-quarters of it raised by Chicago firefighters. The city added tax money to pay for landscaping,

A History of Flame and Folly in the Jungle

It took almost a century, but a memorial for the victims of the Nelson Morris fire was finally realized in 2004. The sculpture is located on land once part of the Stock Yards. *John F. Hogan.*

benches and lighting. Cattorini indicated that he hadn't thought much about the 1910 tragedy until he fought a house fire in the immediate neighborhood. A battalion chief reminded him that twenty-one firefighters had died nearby, and that mention got the captain thinking about doing something to honor their memory.

Among those attending the dedication was John Rice, Horan's great-grandson, who offered one explanation why ninety-four years intervened between the tragedy and the tribute. Referring to earlier Chicago tragedies, he said, "It's like the Iroquois Theatre [fire] or the *Eastland* [capsizing in the Chicago River], where people don't want to remember something so horrible."

On February 18, 1911, fire revisited the section of the Stock Yards where Horan and his men died two months earlier. In some regards, the circumstances were nearly identical. Flames broke out on the fourth floor of a five-story brick building in the Armour complex immediately east of the doomed Nelson Morris warehouses. An erroneous news report

said the alarm was turned in from infamous Box 2162 at Forty-third and Loomis, but it actually came from Box 2164, two blocks east at Forty-third and Centre (Racine).

Soon after the fire started, the plant superintendent and an employee took a step not taken at Nelson Morris: they closed the steel fire doors to keep the flames from spreading. A freight platform covered by an awning, similar to the setting where Horan and the others were crushed, prevented firemen from attacking the flames from the lower entrances. Captain Frank Grady of Engine Company 16, soon to become an advisor to the Stock Yards widows, ordered ladders hoisted and led his men, along with others, into the burning fourth floor. There they saw only two openings through which to direct streams of water—an elevator shaft and a nearby door. As they trained their hoses through the open doorway, they were met by clouds of smoke from burning floors soaked with grease and lard. Meanwhile, the men on the ground were pouring water into the building from all sides, so much that it accumulated in a pool at least a foot deep on the fourth floor, where men from two engines were operating. Six of the men, including Grady, were overcome by smoke and toppled into the water, where they likely would have drowned if they hadn't been discovered by comrades and pulled to safety. At least thirteen others were nearly overcome. Those men were forced to retreat to the windows to get fresh air. Until their appearance, those below feared that all the firemen on four had been trapped and were preparing to mount a rescue. Chief Seyferlich, who took command of the fire on the second of four alarms, said low water pressure, as usual, prevented the fire from being extinguished earlier. Damage was set at $50,000, most of it to stock.

One month to the day later, fire hit the yards again. An electrical malfunction or sparks from a locomotive ignited hay in feeding pens about 4:00 a.m. on March 18. The rapidly spreading flames engulfed forty cattle pens between Morgan, Peoria, Forty-fourth and Forty-fifth Streets. When firemen arrived, they found it impossible to release any of the panicked livestock because the pens were locked. Some five hundred cattle perished.

John A. Spoor, the canny president of the Union Stock Yard and Transit Company, wasn't one to let a tragedy go to waste. One week before the coroner's jury reached its verdict in the Nelson Morris fire, Spoor sent a letter dated January 6, 1911, to Mayor Busse that was referred to the city council. Spoor invoked Chief Horan's call, days before his death, for an increased supply of water to the Stock Yards. He coupled his request with a prediction that the Morris fire "may at any time be followed by one more disastrous." Even absent a major fire, Spoor argued that the mains supplying the yards

and surrounding neighborhoods never had been sufficient, particularly in summer when more water was needed for the packinghouses, allied industries and livestock. No rational person could have disagreed. Then the Stock Yards executive cut to the chase.

The company was proposing to create a corporation that would build and operate an underground water main running from Lake Michigan to the yards that would employ high-pressure pumping equipment and deliver at least sixty million gallons a day. Spoor requested a thirty-year franchise. The proposal contained a few sweeteners to a similar scheme the council had rejected the previous summer. At that time, a majority of aldermen concluded that the city didn't need or want a competitor in the water supply business. The *Tribune* urged the council to hang tough. "Mr. Spoor's company proposes…to take off the city's hands exactly that part of the water business which is most profitable," an editorial maintained. A high-pressure water system, while clearly necessary, doesn't require a private utility to operate it, the paper explained. "As long as the Stock Yards district is maintained in its present condition, with its wooden pens, runways, chutes, galleries, stairways and buildings, there will always be danger of catastrophic fire there," it continued. The *Tribune* suggested that the Thirty-ninth Street intercepting sewer north of the yards offered "a perfect foundation already laid" for an adequate high-pressure system.

The Stock Yards Company's renewed overture never left the Council Finance Committee. Instead, Mayor Busse appointed a special commission to consider high pressure. The mayor's tepid move came amid a chorus of warnings that the city continued to run unnecessary risks that could cost tens of millions of dollars because of inadequate fire protection. The manager of the Chicago Underwriters Association, H.H. Glidden, deemed the creation of a mayoral commission nice but challenged the city to put its money where its mouth was. Glidden told an audience that fire caused $7.5 million in property damage in Chicago during 1910, the largest amount since the fire of 1871. In thirty European cities, he pointed out, fire loss per capita was more than five times less than in Chicago (because of far greater stone and brick construction). The national underwriters set the fire loss in the United States at $70 million for the first quarter of 1911, a $30 million increase over the comparable period a year earlier.

Before a separate gathering, the underwriters' chief inspector in Chicago, W.D. Matthews, attacked the city's new building ordinance for supposedly doing more harm than good. According to Matthews, the code invited a huge fire that could destroy millions of dollars worth of property, provided

inadequate protection to theaters and encouraged the construction of frame buildings in some parts of the city. Chicago's ballyhooed prohibition against wooden construction, which followed the Great Fire, contained a loophole large enough to admit a three-horse fire rig. The so-called fire limits set by the ordinance created a zone extending from half a mile to six miles inside the corporate boundaries in which wooden structures could be built. The area included extensive chunks of the old Lake, Lake View and Hyde Park Townships along with parts of the West Side. In 1909, $13.5 million worth of frame structures rose in this nether land on the outskirts of the city, surrounding it with virtual tinderboxes. Defenders of the arrangement had long maintained that "the little guy" should be allowed to build the least expensive house possible, the threat of fire be damned. Expansion of homeownership, after all, was a component of the American dream. As the debate continued, the Fire Prevention Bureau came into being in early 1912 under the command of Chief John McDonnell. Its original budget of $100,000 got whittled down by penny-pinching aldermen to a paltry $25,000, enough to support a force of five officers and twenty-five inspectors. By contrast, the New York prevention bureau, up and running a few months earlier, boasted a staff of six hundred.

The irony of creating a fire prevention bureau, however small, while continuing to allow frame construction was not lost on the leader of one Chicago neighborhood organization. In a letter to the editor, he questioned establishing "a bureau of fire protection at one end of City Hall when a bureau of inflammability is operating to its full capacity at the other end."

The 4500 block of South Laflin, heart of the Back of the Yards, provided a case in point. The neighborhood was experiencing an ordinary afternoon in mid-May 1911. About fifty families, mostly immigrants from Eastern Europe who were barely scraping by, shared cramped space in fourteen ramshackle frame dwellings. The men were at work in the packing plants, counting the days until payday, still a week off. During their absence, South Laflin became the domain of women, many caring for infants, trying to keep an eye on older, dirty-faced children or both.

A group of boys playing in the alley behind 4506 Laflin found a dangerous way to amuse themselves. They set fire to a mattress, and the flames quickly got away from them. The fire spread rapidly, jumping from one house to the next with the occupants literally fleeing one step ahead of the flames. Within less than an hour, fourteen wooden dwellings had been reduced to cinders, several others were burning and everything within a half-mile radius appeared threatened.

A dozen fire companies responded, but half of them could have stayed in quarters. Even though the official start of summer remained more than a

month away, the packinghouses were guzzling water as if the calendar read mid-July. Practically nothing came out of a number of hydrants. The six companies got into position to fight the flames only to watch trickles of water leave their hoses. Battalion Chief Martin Lacey, who had to contend with the same problem at the Nelson Morris fire the previous winter, reportedly responded with language that added several degrees to the already scorching heat. December, May—it didn't make much difference, Lacey must have thought. Meanwhile, pipemen were dropping from the heat. In one stroke, five fell in a heap and had to be dragged back by their comrades.

Seeing hamstrung firemen compounded the panic that seized the one hundred or so women and children being routed from their homes. Rumors spread as fast as the fire. Ten people burned to death—six children were killed in one house alone. A frantic woman approached firemen crying that her baby was burning to death. The men went into the flaming building and searched it thoroughly. About the time they'd despaired of finding anyone, another woman handed the mother her baby. The second woman had carried the infant out after the mother fled. A nurse from the nearby University of Chicago settlement house singlehandedly rescued seven infants from three burning houses. Settlement director Mary McDowell and her associates learned of the fire from a boy who rushed in and related the vivid details of his mother's death in their burning attic. As he was finishing his story, his wailing mother appeared and reported that her son had been killed.

Soon, the refugees formed a stream that flowed into the settlement, knowing from experience that they could find food, medical care, temporary shelter and, above all, the comfort of dedicated caregivers.

"When you strip one-hundred poor people," said director McDowell, a longtime Jane Addams disciple, "of the few pitiful possessions they have you have our situation…all they can call their own is water, fresh air, the clothes on their backs—and their appetites."

Many of the families needed housing for up to two weeks. Settlement workers scoured the neighborhood in search of residents who would take in the homeless. McDowell said the fire had left eighteen families totally destitute and a dozen more in various degrees of need. By nightfall, all but two families had been taken in by neighbors. Those two slept in the settlement gym. Everyone could rest just a little easier knowing that (miraculously) nobody was killed or seriously injured.

Reunited at the Laflin Street blaze, Chief Seyferlich and Battalion Chief Lacey agreed that the fire could have been contained almost immediately if it hadn't been for the customary Stock Yards complaint—a lack of water.

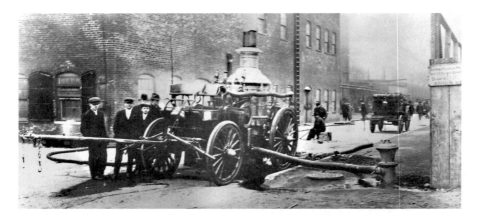

Engine Company 59, a horse-drawn steamer, is shown pumping at a fire in a meatpacking plant in November 1912. In the background is a permanent wooden fire ladder attached to a building. The ladder, which was painted red, was supposed to provide firemen with quick access to the roof. *Courtesy of Ken Little.*

Over the next five years, the yards experienced at least eleven serious fires, including four at Nelson Morris and three at Sulzberger & Sons. Insufficient water and/or pressure played a role in nearly all.

On October 19, 1911, a lack of water pressure rendered fifteen engines useless as flames engulfed Sulzberger's glue and bone house at Forty-first and Ashland. Four firemen were overcome by smoke at the $75,000 blaze.

On January 2, 1912, Swift & Co. was hit by two separate fires. The first, in a warehouse at Forty-second and Laflin, was quickly extinguished. The second started in a warehouse at Exchange Avenue near Packers Avenue and then spread to a nearby cooperage plant. Firemen from Engine Companies 50, 53 and 59 were driven down ladders from the roof of the cooperage when a wave of flames seemed to sweep over the entire building. Almost simultaneously, the south wall of the warehouse collapsed. No one was injured; Seyferlich had ordered his men to steer clear of walls and concentrate on pouring water on the roof of the warehouse. The chief once again complained of an insufficient water supply.

Three days later, on January 5, 1912, ice-coated firemen went up against sub-zero temperatures and howling winds to combat a fire at the Stock Yards' landmark Transit House hotel and restaurant. Firefighters had to build fires around frozen hydrants to get water flowing, but the task took nearly half an hour, plenty of time to turn the south wing into a furnace. Hundreds of lunch guests and hotel employees fled after a hot iron fell into a basket of clothes in the laundry room, setting off the

rapidly spreading blaze. The lone fatality was the night bellboy, who was asleep in his fifth-floor room. The Transit House fire was one of 167 during the twenty-four-hour period, the most ever recorded in one day by the fire department. In April, the Stock Yards Company announced plans to replace the Transit House with a similar facility called the Stock Yard Inn at an estimated cost of $800,000.

Fire continued to stalk Nelson Morris & Co. The third blaze to hit the company in two months broke out March 31, 1912, in a two-story brick building at Forty-fourth and Justine and threatened to spread to an adjacent glue works. The two-alarm blaze, small by yards standards, caused $10,000 damage. The cause was believed to be spontaneous combustion.

Alarm Box 2162, said to have summoned Chief Horan and his men to their deaths, called firemen to a blaze at Morris & Co.'s Warehouse No. 16 the night of October 1, 1912. Losses were held to $1,000.

Sulzberger & Sons recorded another fire April 2, 1913. The scene was a company fertilizer plant, where the blaze started in the basement and raced up the elevator shaft to the fifth floor. Water coming into contact with the fertilizer created fumes that sickened half a dozen firemen. The loss from the 4-11 fire was estimated at $35,000.

The night of October 24, 1913, brought a pair of fires that saw roughly one-third of the city's firefighting force called to action. The first fire claimed the life of Fireman George Yore of Truck Company 6. Yore and three companions were fighting a blaze in a four-story building at 22 North Desplaines Street and had made their way to the top floor. Yore found himself separated from the others by flames and smoke. Groping for an air pocket, he stepped into an open shaft and plunged three stories. He died later at St. Elizabeth's Hospital. His comrades were saved by a rescue party led by Battalion Chief Thomas Reynolds.

News of the tragedy was still making the rounds of the city's firehouses when a 4-11 plus three specials clattered in from a location known all too well by Stock Yards firemen. The calls came from Box 2160, just one block north of where the December 1910 Nelson Morris tragedy occurred. Thirty-eight engine and truck companies, assisted by five insurance patrol units, descended on a five-story Swift & Co. sausage warehouse on West Forty-second Street near Loomis. There they encountered fumes from ammonia as well as blazing fat that persisted well into the morning. Chief Seyferlich proceeded more cautiously than usual, ordering that a rope be placed at a safe distance around the burning building. In spite of the precaution, twenty-one men were felled by fumes from a series of fifteen ammonia pipe

explosions, but no one was killed or injured when the roof and walls caved in. Damage was set at $500,000.

On the night of July 24, 1914, Nelson Morris's number came up again, and the call came from Box 2162. This time it was the cooperage shop and the lard and tallow refinery, which occupied one of the oldest buildings in the yards, a five-story, block-long structure on Forty-fourth Street between Laflin and Bishop. The entire building, about one block west of the 1910 fire, was destroyed at a loss of half a million dollars. Flames fed by two million pounds of lard, fifteen thousand gallons of grease and five thousand hogs covered the Yards District with the smoke of a barbecue to end all barbecues. A 4-11 and several specials brought out twenty-five engine and five truck companies, as well as the fireboat *Joseph Medill*. As at the 1910 fire, the alarm was turned in by a watchman after the fire was supposedly triggered by faulty wiring. Unlike the 1910 fire, the walls remained standing, although the floors fell through and the roof caved in. About 150 laborers in the building got out safely.

Engine Company 53, one of the first two units to reach the 1910 disaster, saw its own quarters catch fire on November 28, 1914. The firehouse adjoined a Libby box factory at Forty-first and Packers that burned after a spark from an electric motor set off flammable materials nearby. The one-and-a-half-story frame structure was destroyed at a loss of $70,000. About one hundred employees left the premises unharmed. Flames spread to a wall and the roof of the adjoining fire station. There was no need to hitch the horses. The men dragged out the apparatus and subdued the flames.

The Stock Yards—and firefighters—received a most welcome two-year respite from serious incidents due to luck more than any proactive measures. Then, on September 8, 1916, fire revisited Nelson Morris at nearly the same spot as the July 1914 blaze and half a block from the site of the 1910 inferno. The alarm, it almost goes without saying, came from Box 2162. A new six-story storehouse at Forty-fourth and Bishop was destroyed at a loss of $100,000. The building might have been new, but firemen confronted familiar problems. The only windows were located at the top floor. Firemen had to climb winding stairways to reach the flames.

Battalion Chief Martin Lacey, the last surviving senior officer at the 1910 Stock Yards fire, found himself in action on Halsted Street, outside the yards, twice during a three-month span in 1916. On August 10, Lacey took charge of a fire that followed an explosion aboard a streetcar as it passed the Stock Yards' combined police and fire stations at Forty-seventh Place. The blast wrecked the front end of the car and injured thirty of the forty passengers,

After Engine Company 53's Stock Yards firehouse was damaged by fire, a new house was built nearby in 1918. The new firehouse was abandoned in 1964 with the decline of the yards. In 2012, after use by some private interests over the years, the house sits vacant, almost completely surrounded by debris. *John F. Hogan.*

nine seriously. A short circuit was believed to have caused the explosion in the motors that powered the front wheels. The explosion smashed windows and touched off a rapidly spreading fire in the woodwork. The motorman said he was unable to stop the car, prompting a number of passengers to leap out and tumble to the pavement as the vehicle was traveling about ten miles an hour. Farther down the street, police officers were able to grab the trolley and pull it from the overhead wires. Lacey told the firemen, "Take care of the injured first." Members of Truck Company 18, which lost two men at the Stock Yards fire, helped police carry the injured into the station house, where neighborhood doctors were being summoned. The streetcar was allowed to burn for twenty minutes before it was extinguished.

At 5:40 a.m. on November 8, someone pulled Alarm Box 243 at Thirty-ninth and Halsted. Lacey and his chauffeur, John "Betz" Lozeau, responded along with other units. They were rushing down Halsted at a high rate of speed as their car approached the intersection at Root Street. A heavy wagon belonging to Armour & Co. crossed in front of them. Lozeau swerved to avoid a collision, but the car overturned. Lozeau lost an eye. Lacey suffered

a fractured skull and died a short time later in Englewood Hospital. He was fifty-five. The alarm proved false.

Martin Lacey was buried at Calvary Cemetery, the final resting place of Big Jim Horan, the man who had likely saved his life six years earlier when he angrily told the battalion chief to get out of his sight at the Nelson Morris fire. Lacey's family arranged to have his fire helmet affixed to his headstone. Sometime during the 1920s, according to grandnephew Edward Lacey, the helmet was stolen and never recovered.

THE FLAMES THAT ALMOST SWALLOWED CHICAGO

The seemingly endless succession of fires to bedevil Nelson Morris & Co. edged ever closer to the site at Forty-fourth and Loomis where Chief Horan and the others fell. On March 2, 1919, fire struck a section of the block-long complex left undamaged by the 1910 inferno. The 4-11 alarm was accompanied by special calls that brought sixty engines to combat the blaze in Section 4 of the property, immediately west of the two warehouses that had burned earlier. Ammonia fumes that spread to adjacent Section 5 claimed the life of company watchman Frederick Lang, age sixty. His body was discovered by Stock Yards firemen on the floor of the hide cellar in a building saved in 1910 by the Herculean efforts of Chief Seyferlich and his men. At least twenty firemen, Chief O'Connor among them, were overcome by the fumes. The fire was nearly under control, after a nine-hour battle, when O'Connor was felled by smoke and gas. He was treated at the scene and taken home. Four members of Engine Company 59, which lost three members in almost the same spot more than eight years earlier, were overcome by a mixture of smoke and ammonia fumes on the third floor of Section 4. They were rescued by comrades, revived and returned to action.

The fire, discovered by a yards watchman, started early in the afternoon on the third floor, which held pork and hide cellars, beef coolers and a cooperage shop. By one o'clock the following morning, the seven-story building was a heap of smoking ruins. Half a million dollars in property was destroyed. Company president Edward Morris Jr., who reached the plant

soon after the fire started, saw that sandwiches and hot coffee were provided to the firemen.

Twice in May 1920, firemen were called to the infamous stretch along Loomis Street, between Forty-third and Forty-fourth Streets, hard by the Chicago Junction Railway tracks. By this time, the area was served by a high-pressure water system, but it failed during the fire of May 9. The first responders, members of ill-fated Engine Company 59, must have felt they were reliving the past. They were followed in by units responding to a 3-11 alarm plus two specials. As was frequently the case at yards fires, officers in charge feared that the blaze would spread to wide expanses of the district. The mid-afternoon fire originated in a one-story frame building occupied by the Stock Yard Company and containing a hay barn and animal pens. More than seventy-five horses, mules and hogs were incinerated. As at the 1910 fire, companies were forced to work in cramped quarters imposed by a loading platform. No lives were lost, but two members of Engine Company 84 were knocked unconscious when they stepped into a pool of water covering a live electrical cable. Damage was estimated at a quarter of a million dollars, the cause undetermined.

Exactly two weeks later, on May 23, Engine Company 59 returned to the area to fight a fire in the Armour complex across from the Nelson Morris warehouses that burned in 1910. Firemen were able to save the Armour property during the earlier fire, but in this instance, a combined one-story/three-story building housing a fertilizer plant incurred approximately $125,000 damage. The 10:30 p.m. fire, of unknown origin, brought out essentially the same manpower and equipment as the blaze two weeks earlier.

The scene shifted less than a mile west on October 13, 1920, when a spectacular million-dollar fire struck a block-long building at Forty-third and Robey Streets (Damen Avenue) and nearly killed members of Engine Company 65. The fire was believed to have started in a warehouse belonging to the Chicago Junction Railway. Flames spread to four other tenant companies occupying the four-story building, consumed 260 boxcars loaded with merchandise that were standing on the adjacent tracks and spewed flaming embers that touched off a fire in a second warehouse next door. Some five hundred employees in the Chicago Junction building fled safely, but the men of Engine 65 experienced a much closer call. They became trapped in the burning railroad warehouse. Other firemen had to chop their way into the building to perform a rescue. The trapped men were treated for smoke inhalation and revived at the scene. The three-alarm fire (plus three specials) sent up huge pillars of smoke that could be seen for miles.

Illinois & Michigan Canal

This map, drawn by historian Ken Little, demonstrates the heavy presence of firefighting equipment in and around the Stock Yards in 1925. That heavy presence, which already existed in 1910, had been augmented by a new engine company (123), two squads (3 and 9) and the creation of the Twenty-sixth Battalion.

Department leaders came and went during the 1920s, but three constants remained—Stock Yards fires, grain elevator fires and, most regrettably, firemen dying and suffering serious injuries under collapsing walls.

The never-ending procession of fires stalked the yards six times in the mid-twenties, hitting Armour & Co. on half of those occasions. The regularity with which packing company facilities continued to go up in flames was

underscored by a newspaper photo caption that described one blaze as "one of the most spectacular in months"—not years or decades, but months. More than sixty years after the Stock Yards opened and fifteen or more years after the Nelson Morris disaster, big fires remained de rigueur. Not only were they breaking out continually, but often they threatened to sweep the entire expanse. Only the determination of the members of the Chicago Fire Department prevented such a catastrophe, but the firemen could have been likened to the boy holding his finger in the dike (not to mix metaphors). The deluge of flame would come, but not for another decade.

The winter of 1925 brought two major fires to the yards. Late on the night of January 4, flames wrecked the Chicago Packing Company plant at Forty-fifth Street and Gross Avenue (McDowell Avenue), causing an estimated $400,000 damage. Nearly all the firefighting apparatus on the South and Southwest Sides responded to the 4-11 alarm. When the first companies arrived, they found the three-story brick building totally involved. Firemen had their hands full trying to keep the flames from spreading as a brisk wind kept sparks darting across the night sky and landing on nearby structures. To combat any advance, firemen lugged hose to the roofs of the threatened buildings while their comrades at ground level trained dozens of streams on the burning plant from two sides. Several firemen were overcome by smoke but quickly revived. Hundreds of nearby residents fled their homes in the face of a blanket of smoke that hung for hours. Compounding their misery—and that of the firemen—was an almost unbearable stench from the burning carcasses of cattle, sheep and lambs slaughtered earlier in the day. Company officers said the packing plant had just been remodeled from top to bottom.

Two months later, more than forty engine companies returned to a site close to the 1910 fire, an Armour beef-cutting plant at Forty-third and Loomis. History nearly repeated as Chief Seyferlich and a group of his men narrowly escaped the fate of Chief Horan and the others when a wall collapsed on the exact spot where the 1910 victims fell. Elsewhere at the scene, Captain Charles McClaughey of Truck Company 33 suffered a broken arm when he fell one floor to the ground. Division Marshal James Costin and Fireman Frank Sweeney of Engine Company 65 were burned in lard explosions.

The origin of the fire, which started at 3:30 in the afternoon, was unknown. It resisted the best efforts of firemen for more than three hours, sending showers of sparks into a high wind and threatening surrounding structures. Always fearful of an inferno that would sweep much of the yards, officers

called for a 4-11 alarm and five specials that brought companies rushing from all directions. Damage was placed at $300,000.

Armour got hit again in September 1925. Flames destroyed an unoccupied four-story building at Exchange and Racine Avenues, sending firemen running for their lives to avoid falling walls. At 8:00 p.m. on September 6, with the fire nearly under control, the west wall collapsed. Flying debris just missed thirty-five firefighters. Twenty others were overcome by smoke, and another suffered a shoulder injury when he was hit by a falling steel door. The collapse of the wall gave the flames a fresh start. Sawdust between the building's walls continued to smolder long after the flames were extinguished, making it necessary for firemen to remain at the scene. Because the building was unoccupied, company officials said the dollar amount of damage was negligible.

The G.H. Hammond Company wasn't so fortunate. Only three weeks earlier, on August 15, fire caused half a million dollars damage to the company's plant at Forty-fifth Street and Racine Avenue.

The Stock Yards avoided major fires for most of the next two years. Then, on the evening of June 25, 1927, another Armour facility went up in a spectacular blaze. Call it a carryover of the jinx that afflicted the Nelson Morris Company, which Armour acquired in 1923. An Armour fertilizer plant at Forty-fifth Street and Packers Avenue, one block east and another south of the 1910 fire, was destroyed by flames that shot high into the air and threatened adjacent buildings, triggering four alarms plus several specials. An Armour garage and stable stood directly in the path of the fire. Heroic work by three company employees saved forty horses, fifty trucks and a small number of cars. The fire, of undetermined cause, attracted thousands of spectators who had to be held back by police lines. Just as the police, along with much of the firefighting apparatus, began to depart, the roof of another firm's building behind the Armour garage broke into flames. Firemen were called back, but only the roof incurred damage. Estimated losses at the fertilizer plant were set at $100,000.

Later that summer, fire destroyed a one-story frame building belonging to the Reliable Packing Company at Forty-seventh and Bishop Streets. Responding firemen, more accustomed to dodging falling debris or embers, found themselves jumping out of the way of stampeding pigs.

Within less than a year in 1929–30, three fires hit the yards.

On November 2, 1929, a machinist's helper was killed and a fireman overcome by smoke when a four-alarm blaze struck a six-story building owned by Armour at 1450 West Forty-third Street, just around the corner from the site of the 1910 fire. Much of the fire equipment located on the South Side battled the flames for three hours. Damage was estimated at $250,000.

On April 15, 1930, nearly all those companies returned to fight a $150,000 fire that partly destroyed a Swift fertilizer plant at Forty-second and Justine Streets. Division Marshal John Costello was seriously injured when he peered out a window on the third floor and was struck on the head by a blast from a hose that sent him reeling twenty-five feet across the floor. The 5-11 fire broke out during the lunch period, enabling thousands of packinghouse workers to watch the firemen battle the flames. (In 1927, the fire department began phasing in 5-11 response cards. In addition to providing responses to five full alarms, the new cards designated change-of-quarters companies, those moving up to houses vacated by companies at the fire. It would take more than a dozen years for the 3-11 cards to be phased out.)

Another 5-11, on September 20, 1930, swept half a square mile of feeding pens, but quick work by firemen operating fifty pieces of apparatus kept flames from spreading to the packing plants. It was Saturday afternoon, when the pens stood largely empty, and only fifteen hogs perished. The fire spread rapidly over an area bounded by Halsted, Racine, Fortieth Street and the Chicago Junction Railroad tracks, offering an ominous precursor to the inferno four years later that wouldn't stop at the pens.

Some things never change—some do. Chicago remained subject to long periods of drought and prevailing southwest winds and home to an enterprise that had done little to shed its distinction as the most combustible square mile on earth. On the other hand, the long-awaited pumping station at Fiftieth and Western was providing increased water and pressure to the Stock Yards and surrounding communities.

On Saturday, May 19, 1934:

The White Sox outslugged the Philadelphia Athletics 14–10 for their third win in a row. Mayor Edward Kelly and school board president James McCahey sat in the Comiskey Park stands to cheer on the Sox.

Clark Gable, Myrna Loy and William Powell were starring in *Manhattan Melodrama* at the Roosevelt Theatre. (That July, John Dillinger would be gunned down by FBI agents after seeing the movie at the Biograph.)

The Anson Weeks Orchestra ("Dancin' with Anson") was playing the Aragon Ballroom.

The Bulgarian army overthrew the government of King Boris.

Marshall Field's was offering "cool white sandals with good-looking stitching" for teens at $5.50 a pair.

The Century of Progress was preparing to throw open the gates for its second year on the lakefront.

A History of Flame and Folly in the Jungle

When Chicagoans awoke on Saturday morning, May 19, 1934, they braced for "an unseasonably warm and uncomfortable day" predicted by the U.S. Weather Bureau. Few were surprised as the city remained in the grasp of an extended drought. Temperatures would climb into the low nineties, with no rain in sight to cool things off. Precipitation was running 34 percent below normal since the first of the year. The last rainfall to reach one-tenth of an inch had occurred five weeks earlier. It had been six days since the last barely measurable amount, one one-hundredth of an inch. Strangely, the humidity hadn't risen with the mercury. During the preceding week, the humidity averaged an unusually low 25 percent. Winds on the afternoon of May 19 would average fifteen miles an hour, gusting to twenty-two miles per hour, out of the southwest. It wouldn't take much (in fact, it took very little) to ignite what everyone—from Mayor Kelly and Chief Fire Marshal Corrigan to veteran firefighters and insurance underwriters—agreed was the city's worst conflagration in terms of size and destructive force since the Great Fire of 1871.

West Forty-third Street through the Stock Yards took a slight southerly bend before rising above Morgan Street along a frame viaduct. The elevated thoroughfare overlooked a warren of wooden cattle pens and animal runs that extended at least two blocks to the north, east and west. Sometime around 4:15 p.m., an occupant of a car passing overhead apparently flicked a burning cigarette out a window. The cigarette landed in a pile of loose hay in one of the pens. Or maybe somebody down below was careless with smoking materials or an open flame. The exact cause of the fire was never determined. In any event, the ensuing flames spread rapidly in all directions but primarily to the northeast, propelled by the wind. They fed eagerly on the wooden pens, raised cattle runways, viaducts and hay storage sheds. Eyewitnesses said the fire raced along the wooden framework of the pens as fast as someone could run.

Some accounts credit a watchman employed by the Stock Yard Company with discovering the fire and pulling ADT Alarm Box 852 in the watchman's shanty on the viaduct at Forty-third and Morgan. That version is partially correct. The watchman, James Fuller, told authorities that Isaac Means, the sixty-three-year-old supervisor of the feed dock below the viaduct, spotted the fire and shouted to him to turn in the alarm. Means then attempted to fight the flames with pails of water. His charred body was discovered the following day, representing the fire's only human fatality.

The alarm turned in by Fuller was received at 4:21 p.m. The first companies to arrive, Engines 53 and 59, were also first on the scene at the

1910 fire. In another reminder of the Nelson Morris tragedy, Joe Mackey, then Chief Horan's driver and now an assistant fire marshal, helped direct this latest battle. Fourth Division Fire Marshal John Costello was the first commanding officer and the first fireman to arrive, responding from his headquarters at Engine 59's house inside the yards, on Exchange Avenue just west of Halsted. To the lasting appreciation of fire historians, Costello left a vivid, well-written account of the fire that sometimes approaches the poetic. On arrival, Costello wrote, "we found about 300 square feet of the pens ablaze, with the fire eating into the 43rd Street viaduct and into the elevated chutes and cattle runs and spreading with considerable speed in every direction." Engines 53 and 59 connected to a hydrant tied to a private water main running below a narrow lane, grandly misnamed Texas Avenue, between sections of pens.

Responders to Stock Yards fires, especially the inside men of Companies 53 and 59, understood from long experience the danger of invading this maze of cramped alleyways, surrounded by flaming wood and hay. Think Johnny Cash jumping into a "burning ring of fire." The companies were able to get two leads of hose on the blaze for less than five minutes before they found themselves in peril of getting trapped in a circle of flame. By the time they were forced to retreat, the fire in the pens, sheds and runways was burning out of control.

Just five minutes after the first alarm, Costello called for a 4-11 from the nearest city fire alarm box, summoning an additional twenty-five pieces of apparatus. "At this time," Costello continued, "the fire seemed to be leaping over gaps of 50 to 100 feet and new fires starting up all around us." When Costello upped the ante to 5-11, nine minutes later, he had to send a messenger to Engine 59's quarters, nearly half a mile to the northeast, because the fire had already destroyed the first box used. Special alarms continued to sound every few minutes until the total reached fourteen.

The fire was spreading in all directions, but its main thrust continued toward the northeast, urged on by freak wind currents created by the mixture of ambient wind and superheated temperatures. Chief Corrigan later estimated that these blasts, carrying gases and showers of sparks, reached sixty miles an hour. "This was practically a gale of living fire which writhed and swirled and twisted in every direction…almost instantly destroying everything that happened to be in its path," the division chief related. Published reports citing a lack of sufficient water pressure, so common at earlier large fires, proved inaccurate. The seven-year-old pumping station at Fiftieth and Western, about two miles southwest of the fire area, demonstrated its worth.

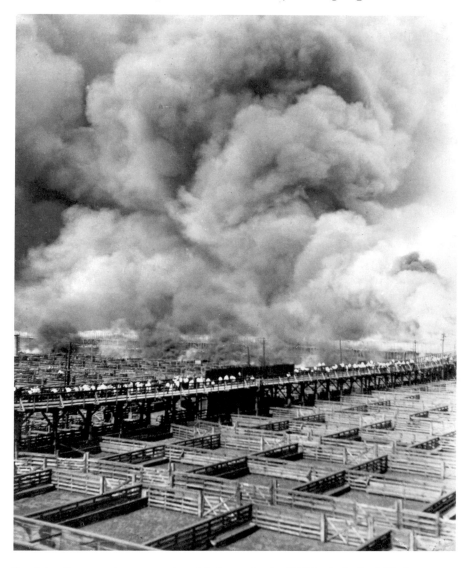

Spectators line a wooden overpass to watch the spectacular 1934 fire in the Stock Yards. Fortunately, the flames and smoke did not spread in their direction. *Courtesy of Ken Little.*

Three of its four pumps, each rated at 75 million gallons a day capacity, provided most of the water used at the scene. A fourth pump stood ready if needed. At the peak of the fire, citywide water delivery was nearing its maximum potential when it reached a rate of 1.3 billion gallons a day. At the request of officials, radio stations broadcast appeals to all city residents

141

to shut off lawn sprinklers and curtail all other non-essential uses of water. Fire department pumpers were churning out 50,000 gallons a minute. Even at that rate, streams were largely ineffective against the main points of the fire's onslaught. The intense heat was turning the water into vapor. Firemen felt as though they were spitting into a gale. Costello recalled:

> *It could be compared with nothing of which we have any record, at one instant shooting straight up in the air and seeming to go into space while in the next it shot straight down to earth and turned and twisted in every direction leaving nothing but ruin and desolation in its wake. It seemed as though countless millions of fiery imps were turned loose from hell with orders to destroy all the handwork of man and wipe it from the face of the earth.*

The initial problem faced by firemen was a scarcity of hydrants in the area where the fire broke out. This handicap was aggravated by the nearly inaccessible configuration of the pens, cramped together and removed from conventional streets that would have allowed apparatus to get close.

Within a twenty-minute span, Chief Costello had raised the fire to a 5-11 alarm with three special alarms. A total of thirty-nine engine companies were on the scene or responding. Upon his arrival at the conflagration, Chief Fire Marshal Corrigan took command, and special alarms continued until one hundred Chicago engine companies and four suburban engines were working at the fire. Corrigan acted after witnessing one company then another retreat in the face of the staggering heat. The flames were jumping streets and showering sparks up to a mile away. A pall of black smoke blanketed the South Loop. Smoke rising from the fire could be seen in Evanston, Wilmette, Glencoe and other North Shore suburbs. "[The fire] was coming at us so fast and the air was so hot no human could stand in its way," Corrigan observed. "Every few minutes I would have to give the order to uncouple the hose lines and move back."

Costello wrote of one episode that he said he would picture for the rest of his life:

> *We had a line of hose going through a driveway through one of the horse barns, suddenly from the other end there charged a ball of fire and smoke filling the entire space and rushing at us with a scream and a roar as though totally bent on our total destruction. We dropped everything and ran, just*

A History of Flame and Folly in the Jungle

barely getting away. It resembled nothing but an express train, rushing at the rate of 60 miles an hour out of the mouth of a tunnel.

The oncoming wave of heat and flame was so powerful that it caused practically instantaneous involvement of entire buildings. One of the first major structures to go was the three-story brick South Exchange Building, followed by two-story brick horse barns to the east, a large one-story hay barn and a series of brick and frame buildings owned by the colorfully named Pulverized Manure Company. Firefighters made an abortive stand along Exchange Avenue, north of these structures, but soon had to abandon their positions. At this point, Chief Costello described Exchange as impassable—"practically a tunnel of fire." The blaze spread rapidly to the new eight-story, fire-resistive, brick Exchange Building, which marked the spot of the day's most daring rescue. With all eight floors fully involved, four men became trapped in a tower on the roof. They leapt from the tower to the roof but realized all means of escape had been cut off. The stifling heat and smoke were making their predicament unbearable. They were preparing to jump when they saw the eighty-five-foot ladder of Truck 4 being raised along the side of the building. Up the ladder went Lieutenant Thomas Morrissey of Engine Company 65, followed by Firemen Joseph Reszac of Engine Company 2, John Tebbins of Truck 8 and future Fire Commissioner Robert Quinn of Truck 14. (Tebbins's son, also named John, served as leader of the firefighters' union while Quinn was commissioner. The two were not the best of friends. The younger Tebbins referred to Quinn as "Tennis Shoe Bob," a derisive reference to the commissioner's penchant for handball.) The eighty-five-foot ladder came up one story short, but the men behind Morrissey carried a rope and a thirty-pound pompier, or scaling, ladder, a single pole utilizing crossbars as rungs with hooks at the top. Morrissey looped the fifteen-foot ladder over the terra-cotta top of the roof and climbed up to the four trapped men. The lieutenant told them the plan and then went down to the floor below and positioned himself in a window. Straddling a sill, he held the pompier ladder firmly in place while the four men, aided by the other firefighters, descended. One by one, everyone stepped from the pompier onto the aerial ladder and reached ground safely. Morrissey was the last man down. All during the rescue, comrades below trained streams of water on the men to protect them from the powerful heat radiating from the windows. A life net held in readiness proved unnecessary and, in all probability, would have proved useless as well that far below.

The new Exchange Building was gutted, but its exterior fireproof construction, together with a clear space to the north, helped prevent

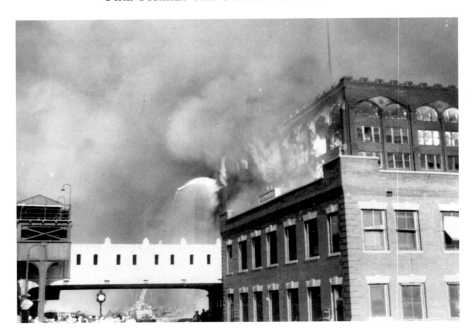

Flames raging in the new Exchange Building, where four men trapped on the roof were saved during a daring rescue by Chicago firemen and a future fire commissioner. Water Tower 1, which was singed by the intense heat, is seen pouring water on the upper floors. *Courtesy of Ken Little.*

further spreading along this path. A sudden but temporary shift in the wind, combined with preventive hose work, kept a three-story brick office building practically untouched. Firemen were also able to prevent an advance in a section to the west. They made a stand at the southwest corner of Exchange and Texas Avenues, where a sheep shed had become seriously involved. The men were able to save part of the structure and prevent the flames from spreading farther north into the most congested part of the yards, where two rows of frame, double-decked hog houses, stretching for nearly half a mile, would have provided ready fuel and a potential avenue to the city beyond.

Despite the relentless northeast swath cut by the fire, some of the flames spread to the south. Approximately one-third of the total half-square-mile area being consumed lay south of the starting point along Forty-third Street. Before the fire was stopped just beyond the Forty-fifth Street viaduct, several buildings met destruction, including a large hay barn and a section of a Pulverized Manure Company facility. Firefighters mounted a second stand to halt the spread to the northeast along Dexter Park and Exchange Avenues,

but the rushing inferno was gaining intensity. About 5:00 p.m., the flames jumped Halsted and attacked the frame buildings along the east side of the street. Corrigan said that was when he sensed the greatest danger. "That's when I thought it was headed for the lake," he admitted. The chief and others believed it not inconceivable that the fire could reach the Century of Progress grounds while sweeping wide expanses of the near South Side and possibly parts of downtown as it roared on. Here, according to Costello, the fire seemed to have reached its "highest glory." The flames seemed to reach out, he said, "with millions of hungry talons, grabbing for everything within reach. There was just one word passed up and down the line, even when things looked their worst, and that was, 'Carry on, carry on.'"

It was here that Corrigan made a strategic decision that prevented the fire from advancing who knows how far beyond the Yards District. "There was no reason to waste time or labor on a building that was lost," he determined. From his command post at Exchange and Halsted, Corrigan used messengers to communicate with his division marshals. He had them mass two-thirds of all men and equipment at the head of the fire and the remainder on the east and west flanks. His objective was to pinch in the blaze "and drench it out at its head." He later recalled:

> Our aim was to build a water curtain in front of it. We turned 30 streams on the principal point of the advancing fire. We placed [about one hundred] men with hand pumps well in advance of the fire and soaked every roof so that sparks could do no harm to them. We wet everything ahead of the blaze, and we battered down the fire with nothing but water. No dynamite or other explosives...no chemicals. Just plain lake water.

Before that could happen, Corrigan had to re-deploy forces one block east of Halsted, at Emerald Avenue, then in Union Avenue, another block east, and finally in Root Street on the north "with our backs to the wall." "We made our last stand at Root Street," the chief continued. Then firemen caught a break in the weather. "The wind had veered more to the south, and I saw we had the fire stopped at Emerald Avenue on the east. Our job was to stop it from going further north, and that's what we did."

As the fire was moving across Halsted, police ran ahead of the flames, warning residents to evacuate as quickly as possible. In scenes reminiscent of other fires, Halsted and the streets to the east soon filled with people fleeing with whatever possessions they could carry. They got out just in time. Along Emerald, four blocks fell to the flames. Meanwhile, the fire was far from

finished on the west side of Halsted, in the yards. The swell of searing heat devoured everything in its path along Dexter Park Avenue, one block west of Halsted. From approximately 5:00 to 5:30 p.m., the fire swept across large chunks of an area bounded by Forty-first on the north, Forty-sixth on the south, Halsted on the east and Racine on the west. The quarters of storied Engine Company 59, long part of the first line of defense of the yards, were themselves destroyed, along with Engines 43 and 98, working along Dexter Park, and Engines 8 and 14, which were tied to a hydrant on Exchange immediately west of Company 59's firehouse. All together, six engines were lost or badly damaged. Numbers 53 and 59 completed the list. Water Tower 1 and Ladder 15 came away badly scorched, while thirty-five thousand feet of hose and much minor equipment were destroyed. All firemen operating the burned equipment escaped with their lives. Costello recalled:

I saw one company working in the heart of the flames, their hose afire on the street, almost to the pipe. Finally, their engine went up in a blaze of flame, and without any word or order from a superior officer, they instantly ran to the nearest engine which was working, pulled off a second line of hose, and after trying to extinguish the fire on this engine led out to a section that was catching on fire and went to work as though it were an everyday occurrence, and at the same time, every man on that company was in need of medical attention.

One major building after another went down like fiery dominoes—the Drovers Journal, the Mercury Manufacturing Company, the Drovers National Bank, the Livestock National Bank (a replica of Independence Hall in Philadelphia), the U.S. Department of Agriculture, the Chicago Merchandise and Equipment Company. The famed International Amphitheater, home of the International Livestock Exposition, political rallies, boxing and wrestling matches and important national and international meetings, was reduced to a mass of twisted steel and charred bricks and mortar. The Stock Yard Inn, whose predecessor, the Transit House, burned in 1912, fell victim, as did its former tenant, the Saddle and Sirloin Club, now in its own four-story building adjacent to the Tudor-style hotel. Portraits of Nelson Morris, Philip Armour, Gustavus Swift and three hundred or so of their contemporaries watched the flames from their places of honor on the walls until the likenesses too were consumed. None of the burned structures were equipped with sprinklers. Also ruined were nearly fifty acres of wooden pens; approximately a mile and a half of single- and double-deck frame runways; three thousand feet of

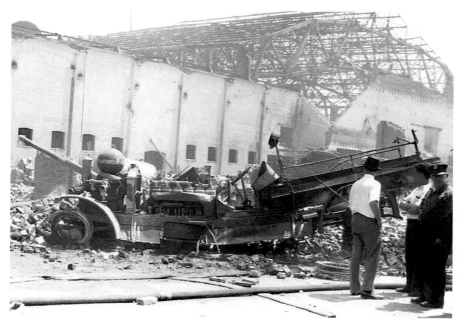

The Ahrens-Fox pumper belonging to Engine Company 98 was one of several pumpers lost to the fast-spreading flames. The gutted International Amphitheater can be seen in the background. It may be difficult to believe, but Engine 98's pumper was rebuilt and served the department for another twenty years. *Courtesy of Ken Little.*

elevated frame viaducts; between 1,500 and 2,000 tons of baled hay; thirty-five to forty wooden buildings and sheds; fourteen two-story brick buildings along Dexter Park Avenue that housed stables, clubrooms, offices, shops and other enterprises; and several hundred feet of elevated tracks extending into the yards from the Halsted Street Station, just north of Root Street. About eight hundred head of cattle were lost. Stock Yards employees drove hundreds of cattle to safety but were unable to save others. Some of these were mercifully shot by police. Since the fire occurred on a Saturday, the livestock population was significantly reduced.

With the main path of the fire blocked at Halsted and Root Streets and the principal buildings west of Halsted in various stages of involvement, the flames defied the wind and traveled farther west. By 5:30 p.m., a large, one-story frame shed, just beyond the fire's starting point at Forty-third and Morgan, became seriously involved. The shed was located close to Armour & Co.'s general offices, as well as packing plants of Armour, Swift and G.H. Hammond. The companies' private fire brigades, later assisted by city firemen, prevented the flames from attacking their properties.

Flying brands sailed nine hundred feet over the water screen thrown up along Root Street about 5:35 p.m. and ignited a vacant factory at 3939–53 South Union. Firemen confined the flames to that building, preventing any resumption of a northeasterly advance.

A little after 6:30 p.m., the wind shifted from the southwest to the south, further reducing the threat to the most vulnerable path. Then, a couple of hours later, around sunset, wind speed diminished and Corrigan knew the crisis was over. "From then on, it was just a matter of battling the fire in the area already attacked. It was bottled up and could spread no further. By nine o'clock, I was satisfied that we had the fire downed." To be safe, the chief didn't declare the fire struck out until Sunday night, more than thirty-one hours after the initial alarm.

Sometimes, potential disaster, like beauty, can rest in the eye of the beholder. Despite fears of a march all the way to the lakefront, the Chicago Board of Underwriters expressed the opinion that the direction of the wind during the fire was probably fortunate. "If the wind had been from an easterly direction," the board's official report stated, "it is quite possible that much of the congested packinghouse section just west of the Stock Yards proper would have become involved, with a much greater loss resulting." Regardless of direction, if the velocity had been greater, in the underwriters' judgment, "it is difficult to predict what proportions the fire might have reached."

As it was, the damage was staggering. An area bounded roughly by Forty-first Street on the north, Forty-sixth on the south, Emerald on the east and Racine on the west resembled scenes that followed World War II bombing runs. Damage was estimated at $8 million, approximately $6 million covered by insurance spread among as many as three hundred separate carriers. Given the spread, none of the companies experienced severe losses. The chief of the Fire Insurance Patrol calculated that $3 million damage was done to pens and various Stock Yards equipment and $3 million to buildings inside the yards, with the remainder affecting buildings outside the yards. The Drovers Bank at 4201 South Halsted circulated announcements through neighborhood churches to reassure depositors that the bank's vaults and safe deposit boxes came through the fire in good condition.

Virtually the entire fire department—1,600 officers and men operating 133 pieces of equipment—was pressed into service for the 5-11 and fourteen special calls. When conditions looked bleakest, Chief Corrigan put out a call for all off-duty and retired members of the department who were physically fit to report for assignment. He also pleaded for help from surrounding communities. At least 90 percent of the off-shift personnel responded, as did

a significant number of retirees. One of the off-duty firemen was Lieutenant Tom Morrissey, who engineered the daring rooftop rescue at the Exchange Building. The fresh troops were used primarily to relieve exhausted firefighters. Some were dispatched to firehouses left vacant by the massive callout, where they helped to oversee the influx of men and apparatus from thirty-one suburbs and northwest Indiana locations. The fire marked the first time since the inception of the two-platoon system more than fifteen years earlier that off-duty members complied with an order to report. (Off-shift firemen were ordered to work during a 1931 Sanitary District tunnel fire, but that order was rescinded after about two hours.) It also represented the first use of commercial radio to activate personnel and urge residents to reduce water consumption. On the downside, the underwriters complained that some newscasts provided "extremely exaggerated" reports of the fire.

A total of 132 firemen were treated at the scene for minor burns, eye inflammation and heat exhaustion. Of this total, 54, including Chief Costello, suffered more serious injuries and were hospitalized. He and several other firefighters sustained burns and smoke inhalation while rescuing 2 men. In the modesty associated with most firefighters, Costello never mentioned his injuries in his narrative of the fire. No one needed more than a few days in the hospital. The searing heat and smoke in the ninety-one-degree weather drove many desperate firemen to drink water from troughs intended for cattle only. About 25 became so ill that they had to leave their posts, while some 100 others incurred lesser effects. All the men who became sick were ordered inoculated against typhoid fever.

Mayor Kelly was notified of the fire at the ballpark, where the smoke already was visible. He and school board president McCahey left the slugfest and joined Police Commissioner James Allman and other officials at the scene. Chief Costello's narrative credits Kelly with issuing the request for a ninth special call at 5:26 p.m., which added five engines to the battle, but the underwriters' report lists the chief of the Sixth Battalion as the source. The mayor agreed with Chief Corrigan that the fire represented the "greatest conflagration in the city since the Chicago Fire of 1871," adding, "I feared at one time that the entire South Side would be affected." Kelly lavished praise on the firefighters and singled out the off-duty men who reported "willingly and with a smile, carrying their boots in their hands."

Also earning praise were about one hundred women telephone operators who stayed on duty in the Stock Yards telephone exchange as the fire outside raged all around them and filled their communications center with smoke. Firemen kept streams of water trained on their building to keep it from catching.

The next day, Sunday morning, May 20, workmen outnumbered remaining firemen four to one. Each group was careful not to get in the other's way. Smoldering ruins remained to be doused even as rebuilding was beginning. Some of the more than one thousand workers accepted carloads of lumber and other materials as they began construction of temporary structures and emergency headquarters while the rest of the force cleared away wreckage and debris. Yards officials sent out the word: "Business as usual. Let the cattle come."

Stock Yards vice-president O.T. Henkle gave assurances that "concrete will be used wherever practicable for permanent replacements. The portion of the Yards which are replaced will be more nearly fireproof than they were." Henkle's use of the word "practicable" provided a handy out for a subordinate a few weeks later. As reconstruction progressed, it became clear that the pens were being built of wood, same as before. Yards claim adjuster Timothy Casey said the use of concrete and steel had been considered but found to be not "practicable." Casey maintained that the constant swinging of heavy gates against the sides of the pens would easily cause concrete to chip and break. He didn't say anything about steel. The rapid spread of the fire, Casey added, "seemed more to do with the fodder and such combustible material lying about than to the actual pens themselves." The Stock Yards' position found support from the city building department. "Permits for the construction of the wooden pens are being approved...because they are entirely within the present laws," stated Deputy Commissioner Robert Knight. The notion of changing the laws apparently didn't occur to anyone, particularly the underwriters or the coroner's jury, although the *Tribune* cited firemen from other unnamed cities who came to Chicago to survey the wreckage and pointed to scores of "staggering risks" not tolerated elsewhere. The coroner's jury returned the obvious verdict of accidental death in the case of Stock Yards employee Isaac Means. The underwriters' report noted only that the combustible "open frame pen construction [allowed] the fire to pass rapidly to the wooden portions [of the yards] and beyond." Both the coroner's jury and the underwriters pointed to the need for more and wider streets and larger water mains. The insurance group also bemoaned the scarcity of hydrants near the fire's starting point. Yards official Henkle proved the most prophetic when he declared, "The rebuilt Yards will probably look a good deal like they did before the fire."

On Tuesday, May 22, three days after the fire, eleven thousand head of cattle arrived at the yards by train and truck, even as workmen continued to remove tons of debris. Brisk north winds and better-late-than-never

In 2012, a modern building used by Calmark Inc., a provider of direct mail services, occupies the site of the 1910 fire. Most of the railroad tracks have been removed from Loomis Street. Where railroad cars crowded multiple tracks in 1910, two truck trailers stand next to the Calmark building. *John F. Hogan.*

rainfall marked the return of business almost as usual. Extra police were needed to keep crowds of curious onlookers moving. No one could argue with a *Tribune* editorial that declared, "The handling of this dangerous fire by Chief Corrigan and his brave men will go down in the city's history." A sidebar in the *Chicago Daily News* offered a different perspective. A large, close-up photo of three firefighters manning a line of hose ran above a smaller panel of drawings depicting firemen in action—"fighting fires, reviving drowning victims, rescuing animals, aiding in disasters." The caption read: "For $40 A Week—When They Get It!" The heroes of the Great Stock Yards Fire of '34 hadn't been paid for two months by the Depression-wracked city administration.

The Chicago Union Stock Yards carried on, much as before, for another thirty-seven years, but the rise of slaughterhouses closer to the source made it increasingly uneconomical for livestock producers to ship their animals to Chicago. At midnight on July 30, 1971, the Stock Yards closed forever. No final ceremonies marked its demise. The bland, faceless but infinitely less combustible Stockyards Industrial Park stands in its place.

Epilogue
THE JOURNEY OF CHIEF BURROUGHS'S HELMET

A ny thoughts that Bob and Bill Chisholm, grandsons of Chief William Burroughs, harbored of becoming firefighters met swift discouragement at the strong hand of their mother, only child of the chief, and his widow, Belle Cole Burroughs. Helen Burroughs Chisholm wasn't raising her sons to suffer the same fate as their grandfather, who died with Chief Jim Horan and the others at the 1910 Stock Yards inferno. That was a memory she had spent the remainder of her seventy-two years trying to forget. Bob Chisholm recalled that he and his brother were told they would "get their pants warmed," and not by any flames, if they ever went near a fire. Boys being boys, they naturally ignored the admonition. Twice they were drawn to the spectacle of firemen battling a blaze, and each time they discovered that Mom, like all mothers, had ways of finding out about such things. Each time she made good on her warning while delivering a stern lecture on the wisdom of avoiding fires. When Bill Burroughs was serving in the military during World War II, he was called upon to fight a fire at his stateside base. His mother learned of the incident and "blew her top," according to brother Bob.

People deal with grief in many ways. "It was as if she put a concrete wall in front of the [1910] fire," said Chisholm, a retired brickyard worker. Mother and grandmother never discussed the fire with family or friends, even Burroughs's surviving comrades, their families or the survivors of the men who perished with him. "They blocked the memory out of their lives. I knew only that my grandfather was a fireman who died three days before

Christmas," when his wife was thirty-six and their daughter eleven. Despite her reticence, Helen Chisholm made one other disclosure, telling her sons that their grandfather was among those who responded to the Iroquois Theatre fire in 1903 that left more than six hundred dead, mostly women and children.

Helen's penchant for secrecy showed itself in one additional, odd way. Her husband died in the early 1930s, when Bob was only two and a half years old. She never told her sons where their father was buried, carrying her secret to the grave in 1971. Grandmother Belle, who died in 1936, when Bob was six, left final orders that her casket be placed atop her husband's in Chicago's Graceland Cemetery. Her wish was granted. Their daughter lies buried nearby.

The Burroughs women wanted to forget the fire, not the man. The family retained the chief's full uniform and badge. Around 1940, Bob Chisholm recalled, his mother had the uniform placed in storage. But money became tight during the war, and the family couldn't afford to keep it there. "After the war, we tried to keep it [at home] but it fell apart." They had to discard the uniform but kept the badge, which the fire department had presented to Burroughs's widow shortly after the fire. "It sat around in a cigar box for a number of years," Bob remembered. While in high school, he thought of a better repository. He made an aluminum box, and there the badge remained from the late 1940s until October 16, 2010, when he and his wife, Linda, presented it to the Fire Museum of Greater Chicago in a ceremony at the Fire Department Training Academy marking the 100th anniversary of the fire.

Over the years, the family assumed that Chief Burroughs's helmet had been lost amid the rubble of the Nelson Morris warehouse. Not until May 2010 did they learn otherwise. Bob found himself seated in his doctor's waiting room at Resurrection Hospital near another older man wearing a Chicago Fire Department cap. Chisholm asked the man whether he'd been a member of the department. "Yes," replied Ken Little, historian and former senior fire alarm operator. Chisholm volunteered that his grandfather had been a fireman killed in the line of duty. When he mentioned Burroughs's name, Little couldn't believe the coincidence. "I've had his helmet for the past forty-four years and recently donated it to the Fire Museum," he revealed. Little was given the helmet in 1966 by First Deputy Fire Marshal Frank Thielmann, a friend and fellow collector of fire memorabilia. Thielmann was moving and didn't want to take his full collection with him. Little says Thielmann never mentioned how he'd obtained the helmet, and Little didn't

The badge belonging to Assistant Fire Marshal Burroughs stayed with members of his family for a century. In 2010, it was donated to the Fire Museum of Greater Chicago. *John F. Hogan.*

ask. Whatever the circumstances, after a century, the fallen chief's badge and helmet were reunited at the Fire Museum.

Bob Chisholm considered himself fortunate to have been left with "a jumble of stuff"—including many photos—much of which he turned over to Ken Little for posterity since he and Linda had no children. The Chisholms, along with others in the firefighting community, had heard the

Burroughs's helmet was also donated to the Fire Museum of Greater Chicago in recent years by historian Ken Little. After a century apart, Burroughs's helmet and badge have been reunited at the museum. *John F. Hogan.*

rumors of a missing newsreel of the fire, supposedly shot by an unknown twenty-year-old cameraman. A discovery, all agree, would represent a historical bonanza. Another rumor that endures, presumably one passed down by friends of Chief Burroughs, concerns the final words between him and Chief Horan. This version has Burroughs actually ordering the doomed firefighters to retreat from their position under the canopy, only to see his directive countermanded by Chief Horan. The accuracy or inaccuracy of either tale may never be confirmed. Or, like the helmet, maybe the definitive answer(s) will turn up one day.

Bob Chisholm, a modest, soft-spoken man and true gentleman, didn't live to read these words. He died January 17, 2012, at the age of eighty-one.

BIBLIOGRAPHY

Chicago City Council. "Journal of the Proceedings of the Chicago City Council, January 30, 1911."

———. "Proceedings of the Special Council Committee on Investigation of the Chicago Fire Department," 1924.

Chicago Fire Department. "Achievement and Work of the Chicago Fire Department, 1928." Chicago: Ringley, printer, 1929.

———. "Report of the Fire Marshal to the Common Council of the City of Chicago for the Fiscal Year Ending December 31, 1923."

Costello, John. "Report of 1934 Stock Yards Fire." Unpublished, Chicago, 1934.

Cromie, Robert. *The Great Chicago Fire*. New York: McGraw-Hill, 1958.

Currey, J. Seymour. *Chicago: Its History and Its Builders*. Chicago: S.J. Clarke Publishing Company, 1912.

———. *The Story of Old Fort Dearborn*. Chicago: A.C. McClurg, 1912.

Dedmon, Emmett. *Fabulous Chicago*. New York: Random House, 1953.

Deloria, Vine, Jr. *Custer Died for Your Sins: An Indian Manifesto*. Norman: University of Oklahoma Press, 1988.

Eastman, Francis A. *The Chicago City Manual*. Chicago: City of Chicago, 1911.

Holzman, Robert S. *The Romance of Firefighting*. New York: Bonanza Books, 1956.

Jablonsky, Thomas J. *Pride in the Jungle: Community and Everyday Life in Back of the Yards Chicago*. Baltimore: Johns Hopkins University Press, 1992.

Kolomay, M.G. "Sully," ed. "Narratives of Firefighters Joseph Mackey and William Moore—1910 Stock Yards Fire." Unpublished, Chicago, n.d.

Little, Kenneth. *Chicago Fire Department Engines: Sixty Years of Motorized Pumpers, 1912–1972*. Chicago: 1972.

———. *Chicago Fire Department Hook and Ladder Tractors, 1914–1971*. Chicago: 1973.

Little, Kenneth, and John McNalis. *History of Chicago Fire Houses of the 19th Century*. Chicago: 1996.

McNalis, John. "Chicago Firefighters Who Have Been Killed in the Line of Duty." Chicago: 2010.

McQuade, James S. *A Synoptical History of the Chicago Fire Department*. Chicago: Chicago Fire Department, 1908.

Semancik, Murray. *Fire Engines*. New York: Random House Value Publishing, 1992.

Sinclair, Upton. *The Jungle*. New York: Doubleday, 1906.

Slayton, Robert A. *Back of the Yards: The Making of a Local Democracy*. Chicago: University of Chicago Press, 1986.

Turrentine, Harold, ed. *History of the Chicago Fire Department*. Chicago: Chicago Fire Department, 2007.

Wade, Louise Carroll. *Chicago's Pride: The Stockyards, Packingtown, and Environs in the Nineteenth Century*. Champaign: University of Illinois Press, 2003.

Wagner, Roy Leicester. *Fire Engines*. New York: Metro Books, 1996.

Wert, Jeffry. *Custer: The Controversial Life of George Armstrong Custer*. New York: Simon & Schuster, 1996.

ABOUT THE AUTHORS

Chicago native John Hogan is a published historian and former broadcast journalist and on-air reporter (WGN-TV/Radio) who has written and produced newscasts and documentaries specializing in politics, government, the courts and the environment. As WGN-TV's environmental editor, he became the first recipient of the United States Environmental Protection Agency's Environmental Quality Award. His work also has been honored by the Associated Press. Hogan left broadcasting to become director of media relations and employee communications for Commonwealth Edison Company, one of the nation's largest electric utilities. Hogan is the author of Edison's one-hundred-year history, *A Spirit Capable*, as well as two unpublished novels and one political history. He holds a BS in journalism/communications from the University of Illinois at Urbana-Champaign and presently works as a freelance writer and public relations consultant.

A fire buff for most of his life, Alex Burkholder began learning about the Chicago Fire Department as a youth, riding to fires on the engines and helping to extinguish the flames. Burkholder earned a BS and MS in journalism from Northwestern University. He went on to become an Emmy award–winning investigative news producer, feature news producer, field producer and news writer/reporter for WGN-TV/Radio and ABC 7 Chicago. He has conducted a number of long-term investigations that required extensive research, writing and coordination and has written a number of magazine articles for publications devoted to firefighting and economics. Burkholder is a founding member of the Fire Museum of Greater Chicago and presently works as a freelance writer.

Visit us at
www.historypress.net